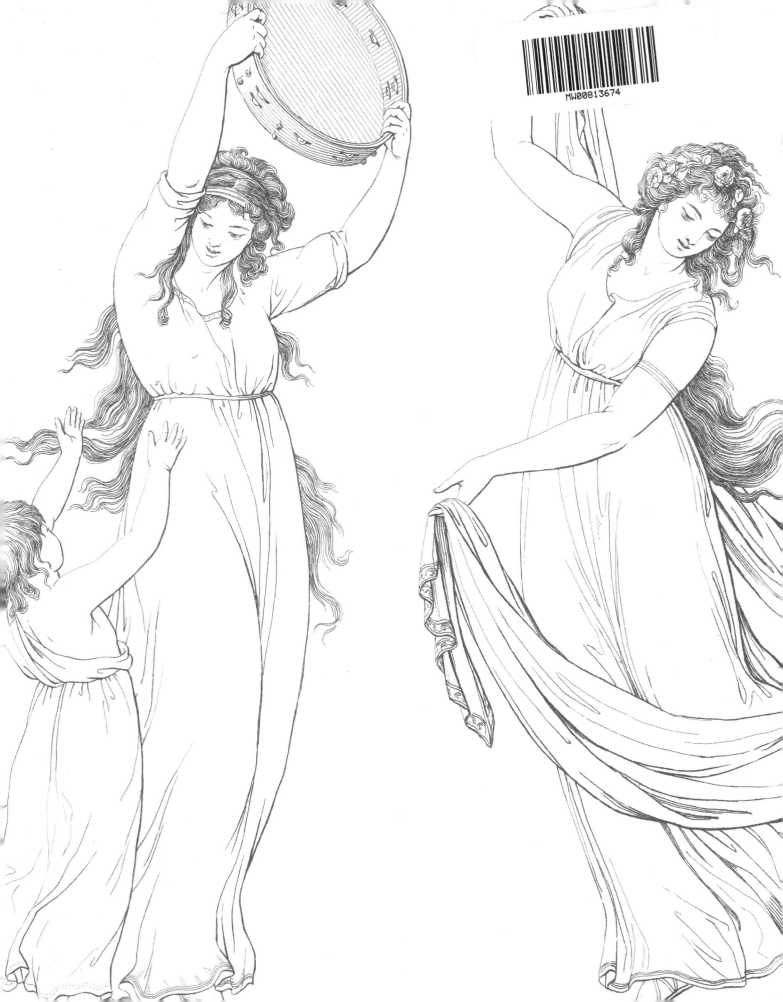

EMMA HAMILTON

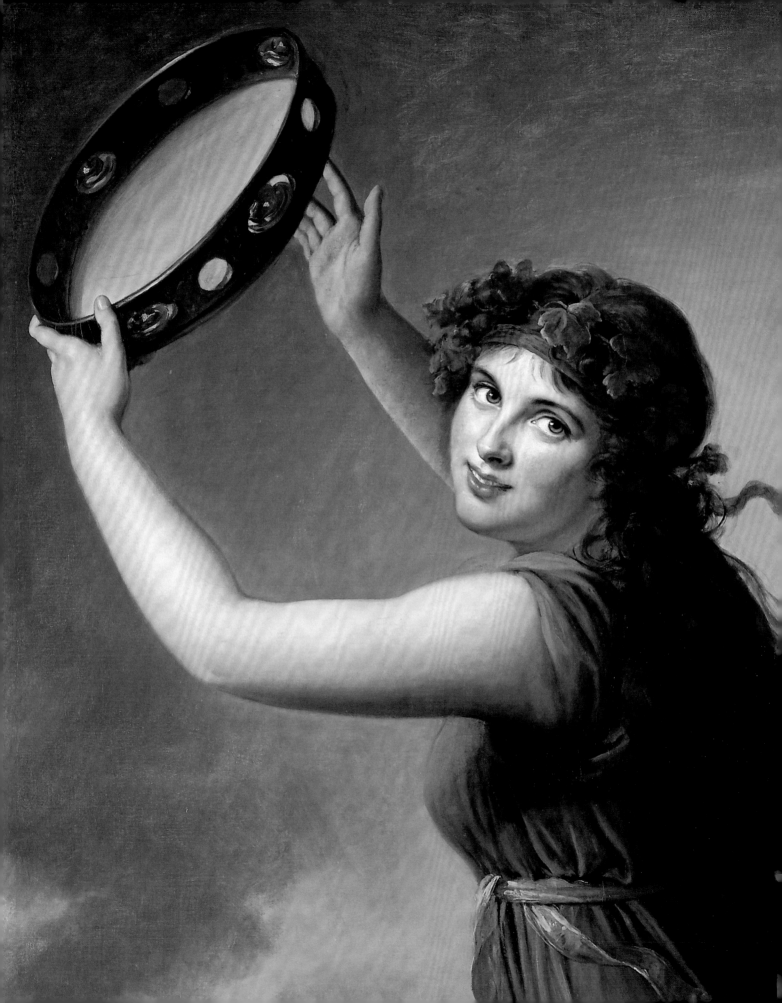

Edited by Quintin Colville
with Kate Williams

EMMA HAMILTON
SEDUCTION & CELEBRITY

Thames & Hudson

ROYAL
MUSEUMS
GREENWICH

Published to accompany
the exhibition
*Emma Hamilton:
Seduction and Celebrity*

National Maritime Museum,
Greenwich, London
3 November 2016 – 17 April 2017

Frontispiece
**Elisabeth Louise
Vigée Le Brun**
Emma as a bacchante
(detail), *c.* 1792
Oil on canvas
Lady Lever Art Gallery
LL3527

*Emma Hamilton: Seduction
and Celebrity* © 2016 National
Maritime Museum, Greenwich,
London

Designed by Adam Brown_01.02

First published in 2016 in
hardcover in the United
States of America by
Thames & Hudson Inc.,
500 Fifth Avenue, New York,
New York 10110

In association with Royal
Museums Greenwich, the
group name for the National
Maritime Museum, Royal
Observatory Greenwich,
Queen's House and *Cutty Sark*
www.rmg.co.uk

thamesandhudsonusa.com

Library of Congress Catalog
Card Number 2016931259

ISBN 978-0-500-25220-8

Printed and bound in China by
C & C Offset Printing Ltd

Contents

Foreword

As Director of Royal Museums Greenwich, I am delighted to have this opportunity to reflect on a figure who has long been a source of fascination here, albeit not always of approbation. The National Maritime Museum – one of our four sites – is privileged to hold magnificent collections relating to Emma Hamilton, from her correspondence and personal possessions to works of art that captured her image. In the public mind, of course, the Museum has always been indelibly associated with her lover, the pre-eminent naval hero Admiral Lord Nelson. His achievements and fame remain central to the activities of this institution. At the same time, though, we have demonstrated Nelson's place within much wider issues of society, culture, conflict and national identity. The evolving and inclusive vision of maritime history that this represents has, in recent years, been enriched by important scholarly work stressing the significance of women's history, female experience and female identities. In this context, therefore, it is highly appropriate that we should place Emma's extraordinary life resolutely in the foreground.

Many treasures from the Museum's collections are featured within this book, and will also be displayed in the major exhibition about Emma Hamilton that it accompanies. We have chosen the format of a stand-alone work rather than a strictly defined catalogue to emphasize the dramatic arc of Emma's fortunes. Neither the book nor the show would have been possible, however, without the generous assistance of the private collectors and public institutions who have so kindly allowed their outstanding material to be reproduced here, and who have lent to the exhibition. I would also like to thank the editor of this volume and curator of the exhibition, Dr Quintin Colville, the distinguished array of contributing authors, and our publishing colleagues at Thames & Hudson. We are indebted to the Nelson Society for its generous support of the book, and especially grateful for the wide-ranging assistance of Ms Jean Johnson Kislak, a true guardian of Emma's flame.

Dr Kevin Fewster, AM, FRSA
Director, Royal Museums Greenwich

Preface

Emma Hamilton is principally remembered for her relationship with Horatio Nelson. Many of Nelson's biographers, and some of hers, have cast Emma as a straightforward seductress, and a complication and distraction in his life of masculine accomplishment and greatness. She is presented as the frivolous to Nelson's serious, the domestic to his far-flung and the self-obsessed to his dutiful. Perhaps ironically, this book and exhibition grew from the experience of curating a gallery about Nelson and eighteenth-century Britain at the National Maritime Museum. The aim here, however, is to assist in dispelling a skewed and stereotyped assessment of Emma that Nelson never intended in life, but which his status as a Victorian icon certainly helped to solidify. Instead, it shows a woman whose association with Nelson was only one chapter in a remarkable story, and whose ambitions cannot remotely be reduced to perfecting the wiles of a temptress. The contributors to this volume reveal Emma's hunger for self-improvement, for education and, indeed, for respectability. To these powerful motivations were joined striking gifts as a performer and a determination to participate in public life.

A multitude of debts have been accrued in the course of this project. Kevin Fewster, Margarette Lincoln, Mike Sarna, Nigel Rigby and Robert Blyth have supported it from the outset, and the latter is owed particular gratitude for his many contributions. Thanks are also offered to Pieter van der Merwe, Christine Riding, Amy Miller, Melanie Vandenbrouck, Katy Barrett and James Davey from the curatorial team; and to Mary Arthur, Marianne Czisnik, Arthur Dunkelman, Genevieve St George, Alex Kidson, Amber Ludwig, Clive Richards, Lily Style, Peter Warwick and the many other external specialists consulted. This volume would never have been completed without the dedication of the commercial enterprises team, and above all Kate Mason, Kirsty Schaper, Emma Lefley, Emilia Will and Emily Churchill. Tina Warner, David Westwood, Joshua Akin and William Punter in the photography studio have ensured extraordinary image quality. The contributions of other Museum departments are also deeply appreciated, with particular mention to Rhian Alexander, Antonella Cannata, Elisabeth Carr, Clara de la Peña McTigue, Sarah Wood, and the staff of the Caird Library.

Dr Quintin Colville
Curator of Naval History and Curator of the Emma Hamilton Exhibition
National Maritime Museum

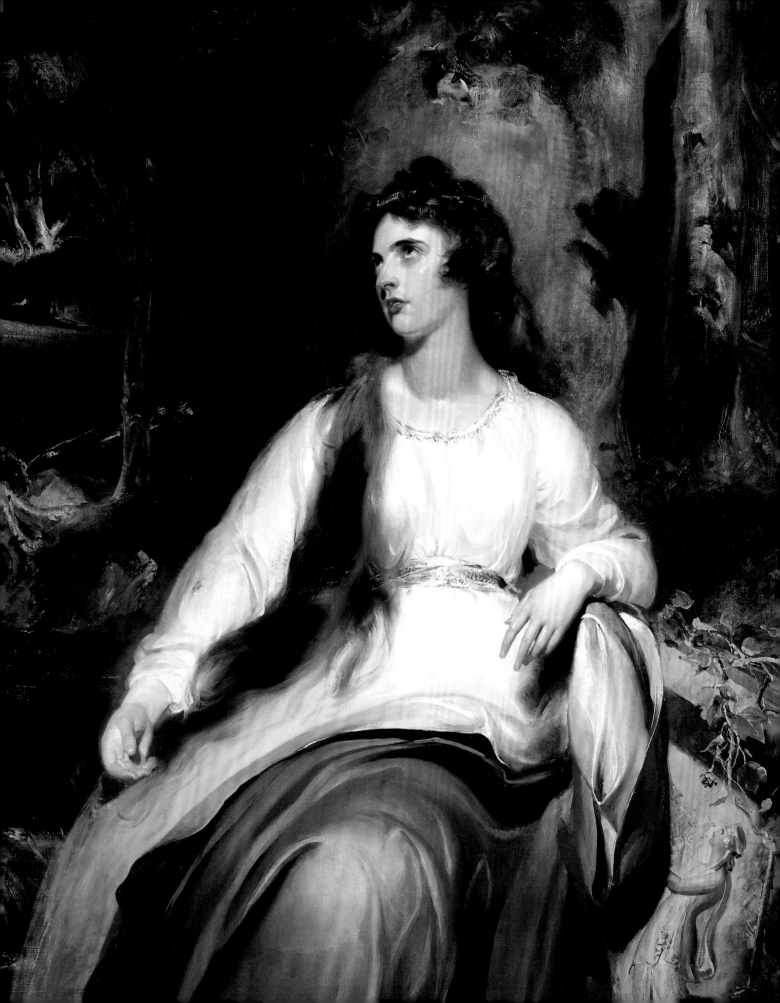

Quintin Colville

Introduction
Re-imagining Emma Hamilton

In 1931, the Royal Navy's professional journal, *The Naval Review*, published the following chilly notice about a new biography of Admiral Lord Nelson by George Edinger and E. J. C. Neep. 'There is no doubt much in this book that is true', noted the reviewer, 'especially regarding the sordid story of Emma Hamilton, but it would be far, far better if it had never been written. One is inclined to suspect, or at least to hope, that the writers are of foreign nationality.'[1]

Brief as these comments are, they reveal several of the key obstacles that impeded a clear estimation of Emma Hamilton during her lifetime, and have continued to do so since her death in 1815.[2] Inevitably and unsurprisingly, her life remains coupled with Nelson's and has often been disparaged for its impact on the reputation of a man of such unarguable eminence. With varying degrees of censure and evidence but with enduring consequence, Emma's supposedly 'sordid story' of sexual immorality has also tended to define her. Notwithstanding some impressive revisionist biographies,[3] these perspectives remain central to her place in the public mind, where Emma features principally as a temptress who captured the affections of Britain's greatest naval hero.

The exhibition that this book accompanies and the chapters that follow here illuminate the personal relationships, cultural forces and historical contexts within which Emma's life and achievements can be more securely located. Their purpose is to peer through a blizzard of moralizing criticism to recover a life of multivalent importance and periodic brilliance. Moreover, it is a life that merits analysis, not only in its own right but as a window on the opportunities and restrictions surrounding female achievement in late

Sir Thomas Lawrence
Emma as *La Penserosa*
(detail), 1791–92
Oil on canvas
Private collection

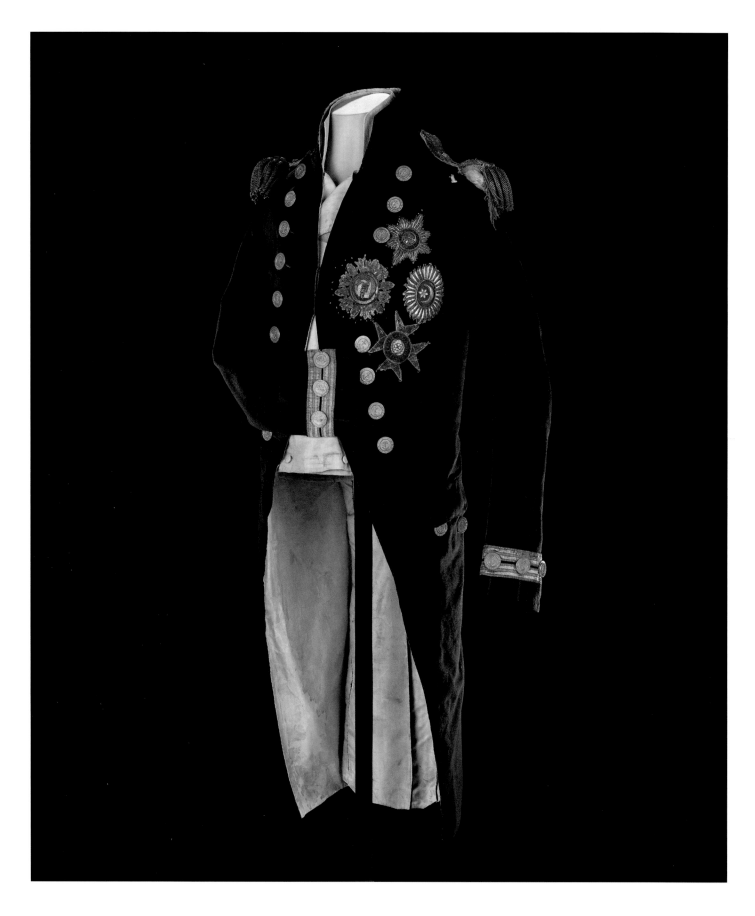

INTRODUCTION: RE-IMAGINING EMMA HAMILTON

eighteenth-century European society. As already indicated in miniature, the task of recovering reliable impressions of Emma is far from straightforward. Few historical figures are so richly supplied with distorting mirrors – during her life and in retrospect – created by artists, gossips, correspondents, biographers, naval historians and on occasion by herself. Emma's gender, class, ambitions, connections and public reputation ensured that many axes would be ground and wielded. The purpose of this introduction is to hold up some of these mirrors for closer inspection, beginning with the consequences of her connection to Nelson.

Emma Hamilton and Horatio Nelson met initially and briefly at Naples in 1793, but it was from 1798 that their paths were consistently intertwined, and from 1799 that their romantic relationship is understood to have begun. Both were married – she to Sir William Hamilton and he to Frances Nelson – and their adulterous and therefore scandalous liaison was viewed from the outset by many of Nelson's acquaintances as hazardous to his status and career. To be sure, extramarital affairs were commonplace among naval officers of the day, and this was not Nelson's first 'dalliance'. However, there was a world of difference between private indulgence and public knowledge. In the case of Emma, Nelson had visibly associated himself with a woman whose combination of high profile and humble origins had already long exposed her to scrutiny and critique. Furthermore, she entered his life at precisely the moment when Nelson's spectacular victory at the Battle of the Nile guaranteed enormous public interest in his activities.

The sense, particularly evident among higher social echelons, that their relationship besmirched propriety left its mark on Emma. The worst damage, though, was mercifully posthumous. As Britain reached the high watermark of its imperial might in the later nineteenth and early twentieth centuries, historians strove to uncover the sequence of steps that had led, apparently inexorably, to national greatness. Articulated most clearly by an American naval officer, Alfred Thayer Mahan, the keys to British exceptionalism were located in the concept of sea power, and in the pantheon of Royal Naval commanders who had wrested control of the seas from less deserving hands.[4] In this company no star shone more brightly than Nelson's, whose triumphant demise at the Battle of Trafalgar in 1805 propelled him at the time to the stature of a national deity. As a result, for many Nelson came to crystallize and epitomize a powerfully influential national myth.

The weight of retrospective expectation that then bore down on Nelson's memory had immediate and later consequences for Emma's reputation. In order to fit the template of Victorian exemplar, his character was refashioned to conceal or erase qualities – for example, emotional expressiveness and illicit passion – deemed inconsistent with this public-facing role. By these means, Nelson was also groomed to fulfil a pedagogical function instructing future generations and maintaining British pre-eminence. Whereas his late-Georgian

brother officers might have deplored his love affair as misguided and foolish, a century later it posed a direct threat to the codified ideal of heroic masculinity for which he was now the figurehead. Much was at stake, and this menace also became more relevant following the publication between 1892 and 1894 of Alfred Morrison's collection of Nelson's correspondence with Emma, which made the intimacy and sincerity of his attachment to her undeniable. The challenge that Emma therefore represented to the multitude of Nelson biographers labouring during these years has been ably explored elsewhere, but it is worth drawing out some common responses.[5]

For many authors the simplest solution lay in avoiding the subject altogether, focusing instead on salt-water narratives of action and glory. The clear implication, and one familiar from any number of contemporary hagiographies of 'great men', was that the private realms of romance, domesticity and fatherhood were entirely the wrong places to look for the lessons of a notable life. In 1932, Admiral Mark Kerr re-applied this well-worn approach in a history of Nelson whose sole reference to Emma consists of the following: 'So many people who read of him only retain in their minds the "Lady Hamilton" side of his story…In doing so, they are only learning about his small, second-best self and neglecting the great first side of his nature.'[6] Others embarked on a more frontal assault. This was not in itself new; comparably critical depictions can be found both during Emma's lifetime, and earlier in the nineteenth century. Thomas Pettigrew's 1849 biography of Nelson, for instance, quoted the bizarre verdict of the politician and historian Sir James Mackintosh that Emma was, 'a ferocious

Right
Arthur William Devis
The death of Nelson on
21 October 1805, 1807
Oil on canvas
National Maritime Museum,
Greenwich Hospital Collection
BHC2894

This work was the winning
entry in a national competition
for the best evocation of
Nelson's death at Trafalgar.

Opposite
Benjamin West
The immortality of Nelson, 1807
Oil on canvas
National Maritime Museum,
Greenwich Hospital Collection
BHC2905

The painting shows Nelson held
up to Britannia by Neptune,
symbolically completing his
journey from naval hero to
national demigod.

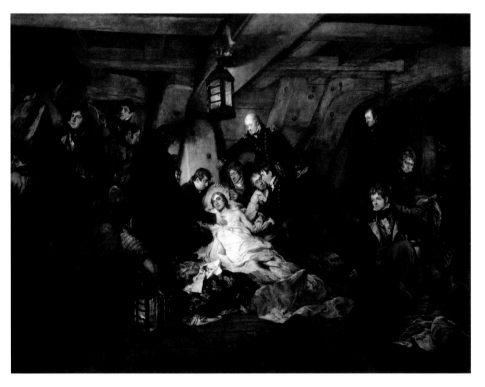

INTRODUCTION: RE-IMAGINING EMMA HAMILTON

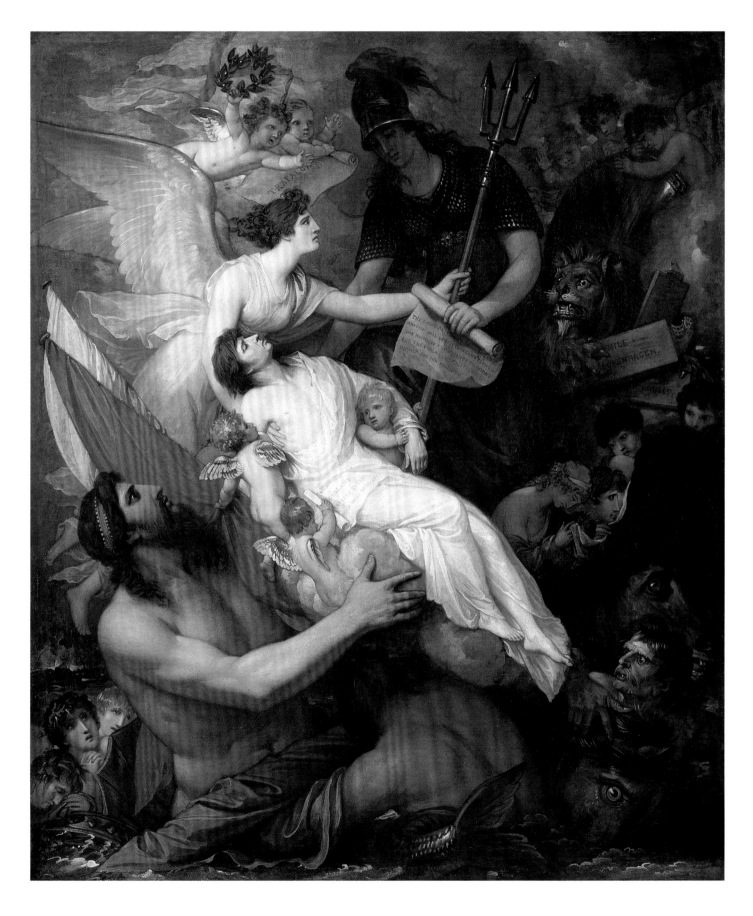

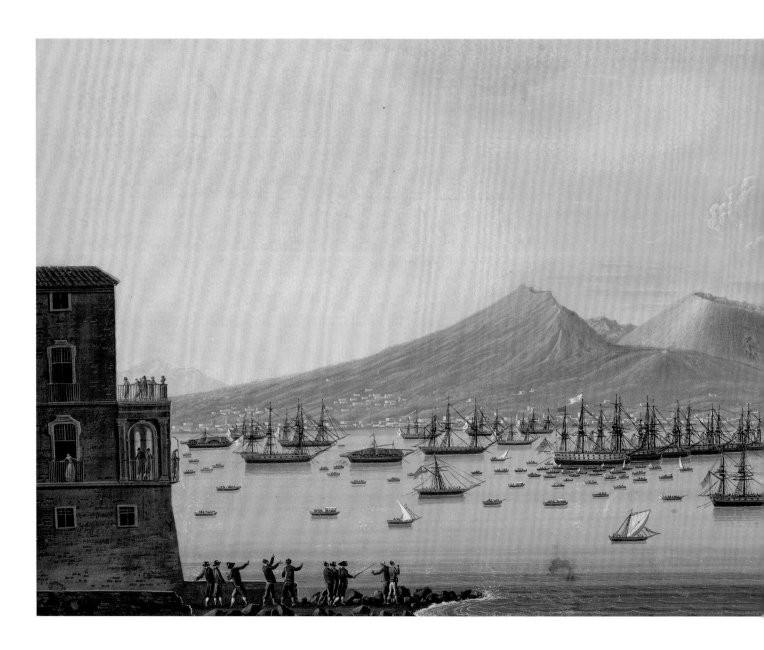

Attributed to Giacomo Guardi
Nelson's squadron at anchor in
the Bay of Naples, either shortly
before or after the Battle of the
Nile, 1 August 1798, *c.* 1800
Gouache and watercolour
National Maritime Museum
PAG9745

woman, who lowered the illustrious name of an English matron to the level of a Parisian fishwoman'.[7] However, with some exceptions, the period from the 1890s to the 1930s witnessed a more settled and consistent antipathy among Nelson scholars. Mahan's biography of Nelson, first published in Britain in 1897, described Emma as a woman 'with scarcely any moral standards – of which her life throughout shows but little trace',[8] and Marianne Czisnik has uncovered the colourful terminology attached to Emma across this era: from vulgar, empty-headed and silly to manipulative and noxious.[9]

Name-calling, though, was not sufficient. Defusing the explosive charge that Emma seemed to have placed at the heart of an icon required more delicate work. A frequent point of departure lay in the suggestion that she had set out to ensnare the celebrated admiral, whose rational self was overpowered by her fascination and female wiles. 'Unhappily', wrote Mahan, 'Nelson was not able to stand the heady dose of flattery administered by a woman of such conspicuous beauty and consummate art.'[10] In the words of Edmund B. d'Auvergne, it was Emma 'who so very nearly led Nelson astray from the path of honour and glory', and whose enchantments held him in thrall – a charge that might have amused a woman immortalized by George Romney in 1782 as the mythological sorceress Circe.[11]

This portrayal elaborated an old cultural convention of the simple sailor, stalwart in a gale but adrift when ashore. Its useful implication that Nelson was sinned against rather than sinning was also developed through the notion that Emma was a cynical predator attracted by the prospect of borrowed fame. Even one of her own biographers, O. A. Sherrard, pronounced in 1927 that 'Nelson's glory was her glory, and she loved to bathe in it, float on it, wallow in it'.[12] Describing Nelson's reception in Naples after the Battle of the Nile in 1798, Mahan offered a similar verdict: 'It is in entire keeping with the career… of the woman that she should instinctively…have resolved to parade herself in the glare of his renown, and appear in the foreground upon the stage of his triumph, the chief dispenser of his praises, the patroness and proprietor of the hero'.[13] For Mahan, Emma's intervention bordered on the sacrilegious, and was fuelled entirely by self-serving vanity.

On occasion, Emma was also deployed as a human shield. During his lifetime and beyond, Nelson's record in Naples and Palermo attracted sustained criticism – particularly his unswerving support of Maria Carolina, Queen of the Two Sicilies, and his role in suppressing the Neapolitan uprising in 1799. Occupying a position of influence both as Nelson's 'sexual temptress' and as Maria Carolina's confidante, Emma was the obvious scapegoat. 'She used her spells', wrote Edmund d'Auvergne, 'to subordinate an English admiral, and an English fleet to the interests of a base Italian despotism.'[14] Mahan's indictment is more subtly interesting, not least for its coding of Naples as female and thereby treacherous, while the fleet stands for straightforward manliness:

in daily close contact with the woman who had won his passionate love, who was the ardent personal friend of the Queen, sharing her antipathies, and expressing her hatred of enemies in terms which showed the coarseness of her fibre, Nelson was steeped in the atmosphere of the Court of Naples, and separated from that of the British fleet, none of whose strongest captains were long with him during that period.[15]

First-hand accounts from these years by Lady Minto and others describing Nelson's vanity and love of personal adornment (cardinal sins to the early twentieth-century gentleman) were similarly associated with Emma's malign influence.

However, every attempt to blame Emma for the relationship and its consequences had the equal and opposite potential to represent her as active and purposeful, and Nelson as supine and susceptible. Such a reversal of traditional roles, and the unmanly and unheroic posture that it forced Nelson to adopt, simply exchanged one problem for another. This dilemma was exacerbated by the Victorian and Edwardian determination to see male and female qualities as both fixed and distinct. Characteristics such as courage, self-control and leadership ability were presented as inherently masculine, while passivity, instability and domesticity travelled to the female side of the ledger.

Irrespective of the sensitivities surrounding Nelson's image, this intellectual framework was fundamentally ill-suited to assessing Emma's involvement with Nelson. Rather than exerting patriarchal control, Nelson celebrated Emma's spirited engagement with public affairs, such as the evacuation of the Neapolitan royal family to Palermo in 1798. Witnessing the pair on their journey back to England in 1800, the writer and diarist Melesina Trench noted that 'Lady Hamilton takes possession of him, and he is a willing captive, the most submissive and devoted I have ever seen', and yet the sting of such opinions does not seem to have reached or vexed him.[16] At the same time, Emma was never guilty of stifling his ambition. 'So far from numbing Nelson, she nerved him', wrote Walter Sichel in his remarkable biography of her, published in 1905.[17] In Czisnik's words, 'What strikes one about Nelson's relationship with Lady Hamilton is the remarkable degree to which traditional gender roles are challenged.'[18] This observation, with its recognition of their complex and creative understanding, takes us closer to Emma's intriguing personality than tales of sorcery.

From today's vantage point, we have far more freedom to evaluate Emma on her own terms, rather than as a hindrance to the mythology surrounding a supremely significant man. However, when considering how she has fared in the public eye, it should be remembered that Nelson was not the only influential man to suffer her 'blight'. The other prime example is Sir William Hamilton, British envoy to the court of Naples, who took Emma first as a lover and then as his wife. Soldier, diplomat, connoisseur of antiquities and Old Master paintings, musician and pioneering volcanologist, Hamilton was a

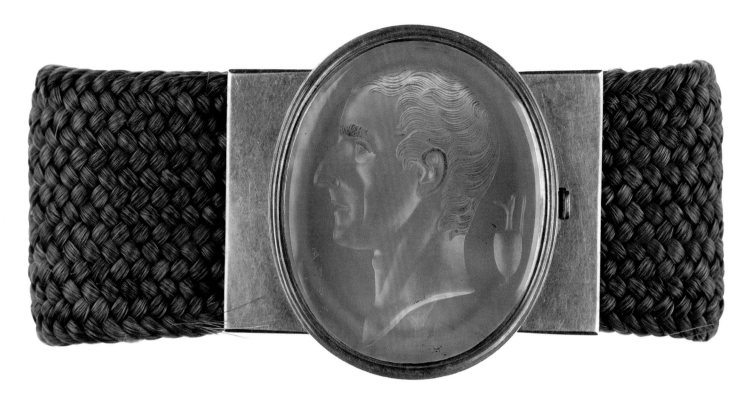

Filipo Rega
Bracelet containing a
chalcedony intaglio, late
eighteenth century
National Maritime Museum
JEW0003

The intaglio features
a portrait of Sir William
Hamilton. Depictions of an
antique vase and Mount
Vesuvius can also be seen,
reflecting his scholarly
interests. The bracelet is
woven from Emma's hair.

cultivated figure whose collections and publications brought him international
recognition. Nonetheless, following Emma's infidelity with Nelson, and with
the mischievous assistance of the caricaturist James Gillray, he became better
known as 'one of the most notoriously deceived husbands in history' and 'the
complaisant paranymph of his own wife'.[19] In the words of his first biographer,
Brian Fothergill, 'More than one hundred and fifty years would pass…
before he would be assessed on his own merits'. Under these circumstances,
we can perhaps forgive Fothergill's uncharitable description of Emma as a
'silly woman', whose 'sole capital consisted of a robust constitution and an
exceptional beauty of face and figure'.[20]

A related fate befell the great portrait artist George Romney, for whom
Emma modelled on so many occasions between 1782 and 1791. In his day,
Romney had equalled and surpassed Sir Joshua Reynolds in artistic success
and prominence. As Alex Kidson has demonstrated, however, Romney's
association with Emma 'contributed to the eclipse of his reputation' in
the moralizing Victorian era that followed.[21] Although acknowledging her
creative contribution to his work, David Cross has also noted regretfully
that 'Emma's story has played an inordinately prominent part in Romney's
biographies'.[22] While accounts such as these all offer nuanced readings of
Emma's significance, they indicate a broader frustration. For many nineteenth-
and twentieth-century commentators, her proximity had the unhappy knack
of ensuring that the right people were remembered for the wrong reasons,
while the wrong person (who should really have been forgotten altogether)
stubbornly clung to the foreground.

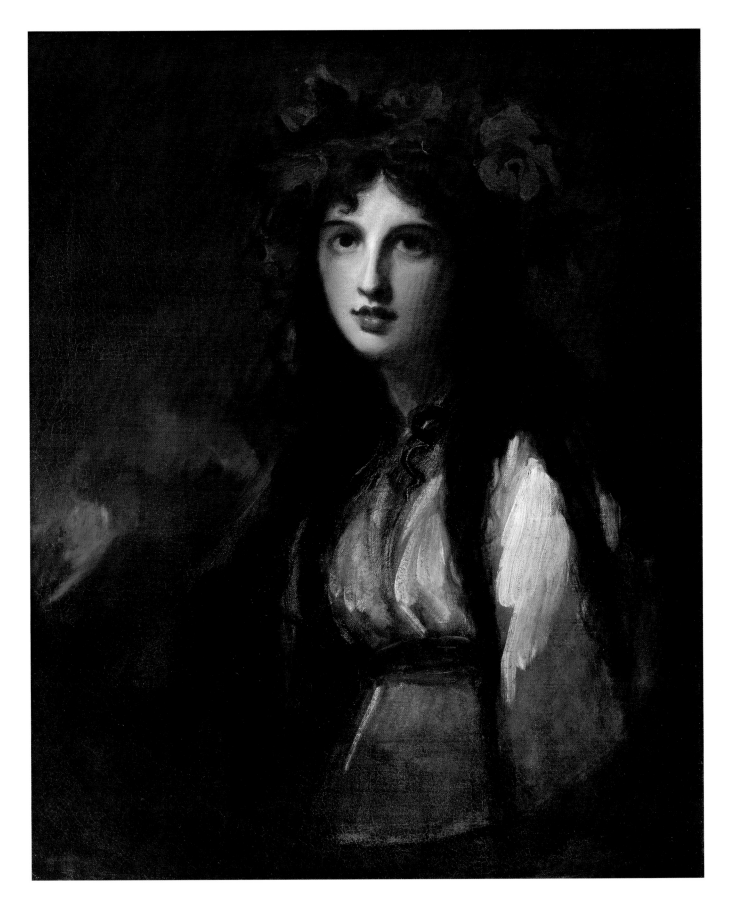

INTRODUCTION: RE-IMAGINING EMMA HAMILTON

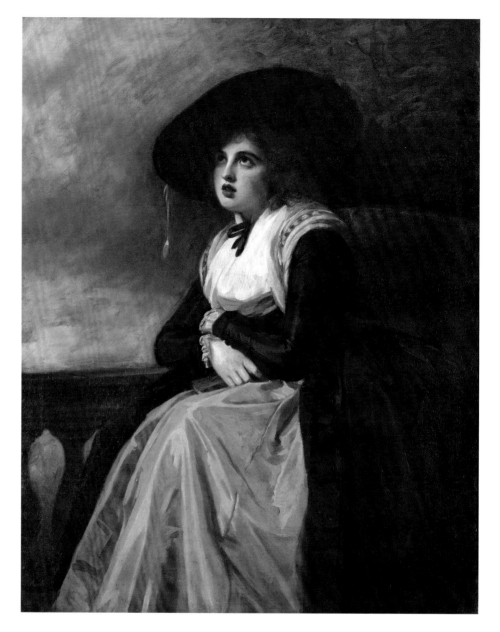

Arriving at a closer understanding of why Emma was so routinely represented as the 'wrong person' requires us to turn from her closest relationships to a wider historical canvas. To begin with, women who lived in the public eye during the eighteenth century usually exposed themselves to censure. The world of the theatre provides an instructive context. Although Emma did not work as an actress, her modelling for Romney, her singing and her famous Attitudes certainly identified her as a performer who moved far beyond the realm of private 'accomplishment'. In many respects, the period from the 1770s to the early nineteenth century was a golden age for women in the theatre, with figures such as Mary Robinson, Sarah Siddons and Dorothy Jordan at the height of their powers. However, the older association of the actress with sexual availability and prostitution was still entrenched. In Gill Perry's words, 'Whoring and acting were easily elided.'[23]

Moreover, for Emma, a history of performance was set on foundations that were certain only to intensify misgivings. Much of her early life in London was spent in the theatre district of Covent Garden, the heart of the capital's sex trade. It is probable that Emma turned in desperation to prostitution for a short period during her adolescence. Even had she not, her association with Covent Garden would still have sullied her reputation. Writing to Romney at the time of her wedding to Sir William Hamilton in 1791, Emma confided that disciplined behaviour had replenished the 'virtue' she admitted had been lost in her youth. However, a lady's honour, cautions Amanda Vickery, 'lay in the public recognition of her virtue' not in its personal and private cultivation.[24] Less sympathetic observers would have concluded that Emma's 'ruin' in girlhood and her love of 'immodest' display as an adult reflected a continuity of moral failure. A woman who modelled and performed as a bacchante was always liable to be confused with one.

For Emma's contemporaries, her problematic morality was compounded by her social origins. From her entrance into Romney's studio in 1782 – and still more following her transplantation to the Grand-Tourist destination of Naples – Emma came into contact with people from the highest rungs of British society, many of them members of the metropolitan elite known as the *beau monde*. Eighteenth-century Britain has often been portrayed as a middle-class melting pot. The gates of the *beau monde*, though, were impenetrable even to respectable gentry, let alone the impoverished labouring family into which Emma had been born.[25] In truth, there was no personal effort or transformation that could have won her membership of a coterie founded on birth. Yet, in life (and ever since), she was reproached for failing to plant her flag at the summit of an unclimbable peak. For Lady Elizabeth Foster, she was a 'handsome' woman but her pronunciation was 'very vulgar'; and the Comtesse de Boigne judged her 'a low mind within a magnificent form'. 'Take her as anything but Mrs Hart and she is a superior being', wrote Lord Bristol before concluding, 'as herself she is always vulgar'.[26]

For people such as these, status was the fixed and lifelong expression of breeding. By contrast, Emma was disconcertingly mobile. Thrust from a murky and disreputable past into the midst of an elite, her Attitudes made her the interpreter of their own cultural fascinations. Although tainted by performance, she could never be dismissed as a paid entertainer. While surrounded by lurid sexual gossip, she had unrivalled access to one of the crowned heads of Europe. It was therefore almost with a sense of zoological relief at finding an unpredictable animal for once in its expected habitat, that Melesina Trench described Emma and her mother embarking at Hamburg in October 1801, for passage to England: 'There was an end of the fine arts, of the attitudes, of the acting, the dancing, and the singing…Lady Hamilton began bawling for

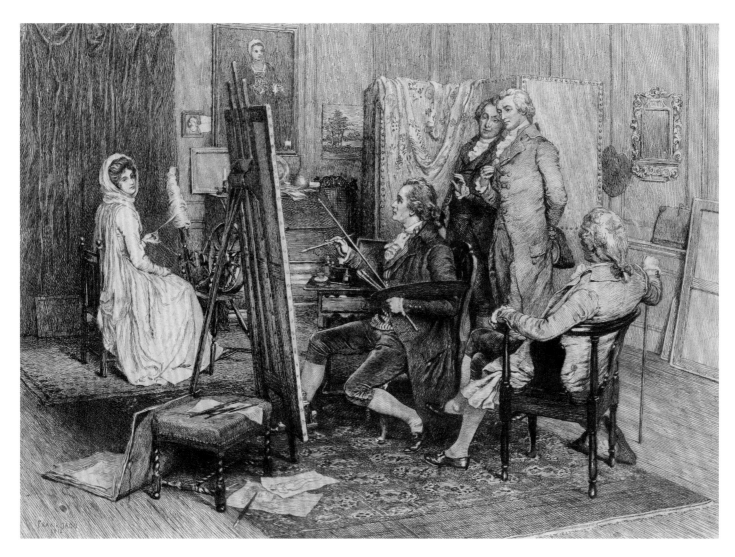

After Frank Dadd
Emma Hart sits to Romney,
c. 1912
Etching
National Maritime Museum
SUT/2

Emma is imagined here in
Romney's studio modelling for
her portrait as the Spinstress
(see p. 66).

an Irish stew, and her old mother set about washing the potatoes...They were
exactly like Hogarth's actresses dressing in the barn.'[27]

With complete acceptance permanently and corporately withheld, the best
that Emma could hope for was generous condescension. That Emma secured
this qualified approval from so many grandees is in itself remarkable: nor was
she blind to her predicament. 'We have...many English at Naples', she wrote
to Romney in 1791, 'they all make it a point to be remarkably civil to me. You
will be happy at this, as you know what prudes our Ladys are.'[28] As Jason Kelly
argues later in this book, Emma was also too aware of these social realities to
attempt a thoroughgoing mimicry of elite women. In fact, she drew creatively on
her humble origins whenever it suited her social, cultural or political purpose.

Crucially, though, the social disqualifications that faced Emma in life as a
working-class woman were rediscovered, modified and sharpened in the early
twentieth century. Once again, her relationship with Nelson and the centenary
of the Battle of Trafalgar in 1905 had a role to play, but so did a broader
resurgence of interest in Georgian Britain. One aspect of this phenomenon

was a concentration on the typically aristocratic 'beauties' of the age – women such as Elizabeth Gunning and the Duchess of Devonshire. Presenting their subjects as 'English roses', these narratives denied their social, cultural and political import, treating them instead as the decorative surface upon which male gallantry was conducted. Being gazed upon appeared to be their only real function.

'A glorious wild flower with but a few petals crushed', Emma attracted similar treatment.[29] In fact, given her humble beginnings, beauty was the only possible justification for giving her so much attention. As Edmund d'Auvergne put it: 'An ignorant, illiterate country wench, she would have lived and died the least conspicuous of mortals but for the possession of one gift. She was beyond all cavil beautiful'.[30] To him, though, this beauty was merely a passive commodity waiting to be leveraged by male brilliance. It was 'Emma's loveliness' that made Romney's 'genius burst into brightest flame'. Switching from horticulture to precious stones, Emma's lover Charles Greville had 'polished his gem with the patience of a diamond-cutter', while William Hamilton's Pygmalion had turned raw beauty into the artistry of Emma's Attitudes.[31] This perspective even prompted a rare moment of masculine responsibility: employing another suggestively inanimate metaphor, O. A. Sherrard reflected that 'If Emma is to be branded as a notorious adventuress…the potter is more to blame than the clay.'[32]

Most if not all of these sentiments would have been commonplace within the world of connoisseurs and dilettanti inhabited by Greville and Hamilton during the 1780s and 1790s. However, the products of largely male authors more than a century later reveal a modern misogyny informed by the spectre of female emancipation. For instance, it is indicative that while Emma was tolerated and complimented as a passive subject of male admiration, her assumption of any more active identity was met with vilification. In the latter eventuality, an armoury of stereotypes disqualifying women from participation in the public sphere were swiftly brought to bear. Rather than acting with manly patriotism, she was driven by a 'love of admiration', and a 'greed for flattery': instead of self-control and discipline, she craved drama and extravagance.[33] Serious matters and intellectual pursuits could hardly be entrusted to a woman of 'shallow' mind whose 'attainments were skin-deep'.[34] 'Abstract ideas – she had none', concluded d'Auvergne.[35] Steeped in female calculation and cunning, she was, according to W. H. Long, 'completely skilled in the arts of intrigue and duplicity', and a 'hapless victim of vanity and deceit'.[36] For Mahan, Emma was driven by emotion and appetite, and 'had not a shred of principle to take the place of the motive of self-interest'. The only role these writers permitted her to occupy fell somewhere on a spectrum between sexual minion and domestic pet. 'She is likeable', offered d'Auvergne, 'because of her canine fidelity to the hand that caressed her', while Mahan noted 'her capacity for development into an interesting and affectionate household companion'.[37]

George Romney
Emma as a bacchante,
1783–85
Oil on canvas
Private collection

On its completion, this work was sent to Sir William Hamilton. It is likely to have hung in his Neapolitan residence, the Palazzo Sessa, before Emma arrived there in person in 1786.

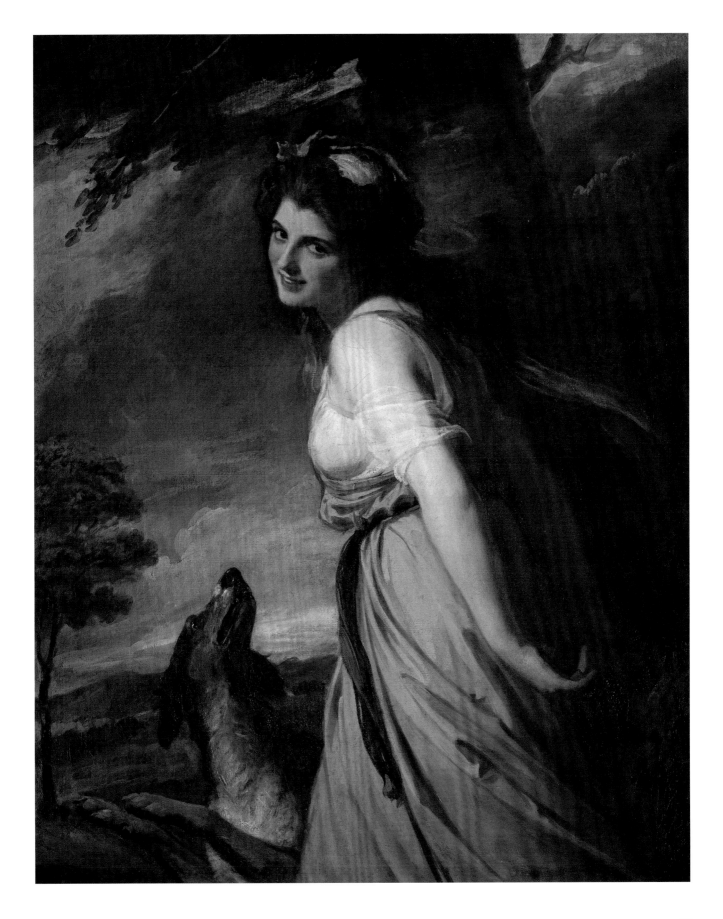

With particular reference to the much-quoted Edmund d'Auvergne, the level of invective directed towards Emma raises the question of why he and related authors embarked on her biography in the first place. His book begins with a snort of derision at the 'tendency to make a heroine and a patriot out of Lady Hamilton. If I am not mistaken, one woman writer compares her to Jeanne Darc! [Joan of Arc]'[38] After congratulating Nelson for his 'remarkable' ability to love Emma 'when her beauty had departed', he devotes the entire first chapter to a discussion of Sir William Hamilton. The narrative ultimately concludes with his assertion that '[Emma] has acquired a niche in the house of fame and played a part in great affairs to which her abilities and her qualifications by no means entitled her'.[39] Male biographers of Emma during this period may have sought to avoid accusations that they were as gripped by 'the birdlime of Emma's charms' as the unfortunate Greville, Hamilton and Nelson. Even so, the precautions taken by d'Auvergne to avoid this misunderstanding seem excessive. It is perhaps more convincing to suggest that the barely concealed central purpose of this book was to put an uppity woman firmly in her place. Brazen and meddlesome in public when she should have been silent, and unfaithful in matrimony when she should have been constant, Emma was the antithesis of a traditional womanly ideal. Rather than distilling a great male life for public edification, d'Auvergne penned a biography of deterrence and disapproval, and a polemic of female disempowerment. The considerable literature from this period concerning Emma – described by d'Auvergne as a 'mess of treacle' – is often more sensitive to Emma's probable motivations.[40] Nonetheless, more crudely misogynistic treatments have cut deeply and enduringly into her public image.

As this begins to show, a persistent strand in discussions of Emma from the late eighteenth century into the twentieth portrays her as either a passive beauty or an active nuisance. The purpose of examining these opinions is not simply to challenge them with an oppositional alternative. It would be difficult, for instance, to dismiss Mahan's contention that she was thirsty for admiration. For Mahan and his peers, though, vanity was a charge levelled at femininity in general as well as at Emma in particular: what it defined was the supposed propensity of women (unlike men) to take superficial pleasure from their own superficial allure. Emma was undeniably impressed by the power of her own beauty and conscious that it acted as her passport. However, when we explore some of the contexts in which her desire for applause is most evident – above all with regard to her painted image, her singing, her Attitudes, and her engagement with Neapolitan politics – it becomes clear that vanity is a wholly inadequate definition. Rather than merely celebrating her ability to fascinate the male gaze, Emma's satisfaction lay in the acknowledgment of what she knew to be patient, arduous application and achievement. So, instead of replacing one simplicity with another, the aim of this book is to extend the work begun by Walter Sichel and continued by Flora Fraser and Kate Williams, among

others, by asserting that while inescapably fettered by circumstance, Emma had significant agency and serious intent.

The elements of this complex and creative self-determination can be traced throughout Emma's life. For example, although her early years in London are often viewed as a victim's journey from domestic servitude to sexual exploitation, a thread of ambition is usually visible (and is all the more striking for the forces arrayed against it). It was Emma's choice to try her luck in the glittering but hazardous world of Covent Garden. The letters she wrote at this time to her lover Charles Greville reveal a girl hungry for self-improvement. When he set her the challenge of mastering a placid and respectable identity she responded with a thoroughgoing performance of virtue, in her words turning 'the wild unthinking Emma' into 'a grave thoughtful phylosopher'.[41] She seized the opportunity of her introduction to Romney in 1782, transforming what could have been a brief engagement for a busy artist into a long-standing creative collaboration and a multifaceted artistic education.

The same thirst for knowledge and experience marks her years in Naples. Sir William Hamilton's palazzo was packed with all the accessories of a cultivated mind, but her eagerness to absorb them was not supplied by the host. As Amber Ludwig puts it, she 'applied herself to learning and self-fashioning with a zealousness rarely seen outside of the eighteenth-century novel'.[42] Even Edmund d'Auvergne could not sidestep Hamilton's proud correspondence with Greville concerning Emma's rapid progress with languages, history, music and singing. Instead, he took aim and let fly with both barrels, one loaded with disbelief and the other with condescension: 'She seems to have learned Italian, the easiest of languages, very quickly.'[43]

For Emma, education was more purposeful than reflective and she directed her newfound cultural familiarities towards two ends. First, she reshaped the feminine ideal she had constructed with Greville. Rather than a persona suiting his 'retired stile', she studied the more outgoing, convivial and urbane female identity of Hamilton's elite Grand-Tourist milieu. After her marriage to Sir William, she modified this once again to reflect her altered status. We have seen that Emma could never merge seamlessly into his circle but her engagement with its mores was extremely skilful. As Hamilton put it, with an appropriately theatrical metaphor, 'She has had a difficult part to act, and has succeeded wonderfully, having gained… the thorough approbation of all the English ladies'.[44] Secondly, Hamilton's connoisseurial sophistication and Romney's artistry were woven together in the Attitudes – a performance of such enchantment that it seemed to suspend Emma momentarily beyond social critique.

Johann Heinrich Wilhelm Tischbein
A boar hunt at Persano under Ferdinand IV, c. 1792–93
Oil on canvas
Government Art Collection

A host of Neapolitan, Habsburg and British notables can be seen in this highly political painting. Emma is second from the left among the female figures occupying the carts, and has turned to look up at Queen Maria Carolina, standing behind her. Emma is portrayed wearing a red lazzarone cap, indicating her support for conservative and pro-royalist forces in Naples.

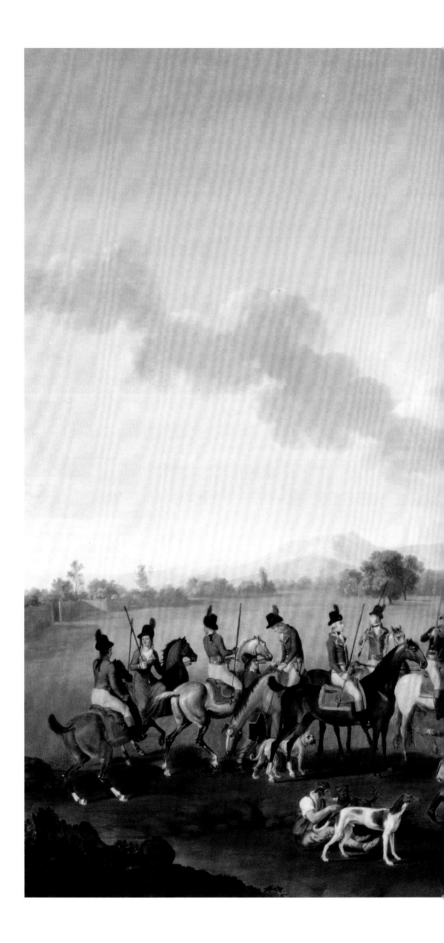

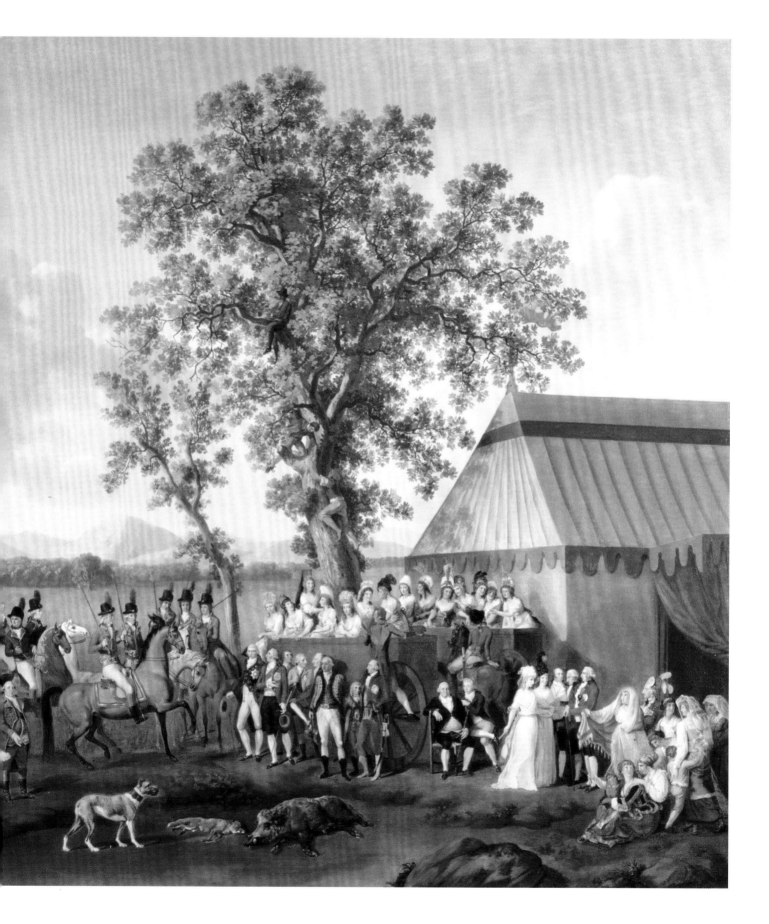

Naples June 30th 1799

Dear Sir Supplement – p 181

I take the opportunity of
Capn Hope to write a few lines
to you & thank you for your
kind letter by Capn Bowen
the Queen was much pleased as
I translated it for her & charges
me to thank you & by the
prays for your Honner & Safety
victory the is Sure you will have
we have still the Regicide Minister
here Garat the most impudent
insolent dog making the most
infamous demands every day &
I see plainly the Court of Naples
must declare war if they mean

Indeed, a performative aspect underlies so many of Emma's activities, as can also be seen in the realm of politics. Once again, for historians such as Mahan, her intrusion into this field could only be glancing and vainglorious; and, in fairness, it is only in very recent years that female engagement with eighteenth-century political affairs has begun to receive sustained attention. As the wife of an envoy, Emma automatically assumed an unofficial political dimension. As she confided in a letter to Greville in 1795, 'Send me some news, political and private for against my will owing to my situation here I am got into politics'.[45] Her friendship with Queen Maria Carolina supercharged this reality and opened the door to what Sichel termed Emma's 'implanted instinct...of needing and aspiring to play a grand part on a great stage'.[46]

The French Revolutionary War presented her with an unrivalled stage, just as it did to many of her male compatriots, and Emma placed herself at the heart of turbulent events from before the flight of the Neapolitan royal family in 1798 to the restoration of the monarchy the following year. It is quite clear that she conceived her role, albeit a self-appointed one, as advancing the interests of Britain, the Royal Navy and her 'much loved Queen', as well as bringing fame to herself. Beyond persuasion, the tools at her disposal were theatricality and fashion. Mahan describes how Nelson came ashore at Naples following the Battle of the Nile. Emma 'obliged' him to enter her carriage, and 'with characteristic bad taste and love of notoriety paraded...[him] until dark through the streets of this neutral capital, she wearing a bandeau round her forehead with the words, "Nelson and Victory"'.[47] In fact, Emma's actions and calculated appearance were a virtuoso performance of female political intervention, as illuminated in a wider British context by Elaine Chalus.[48] They broadcast a powerful message of support for Britain at a moment when neutrality prevented Maria Carolina (who loathed Revolutionary France) from more overtly showing her hand.

This is not to say that Emma's talents as a performer always brought success. In many respects, her final stage was Merton Place, the house in Surrey that she shared with Nelson. Adorned by her with symbols and souvenirs of their combined renown, its interior was designed to persuade and impress. However, as Amber Ludwig has convincingly suggested, the home undermined its own purpose by forcing visitors who might have tolerated a decorously veiled infidelity, 'to reconcile Nelson's adulterous behaviour with his valiant reputation'.[49]

Beyond this, a life constructed through a succession of informal and transient performances was inherently precarious. For all their creative ebullience, each reinvention reflected Emma's fundamental inability, as a lowborn woman, to settle her destiny in a world controlled by powerful men who seldom felt obliged to change at all. Moreover, as successive generations have weighed her significance, there has never been an obvious category in

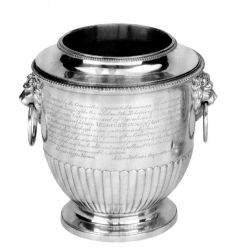

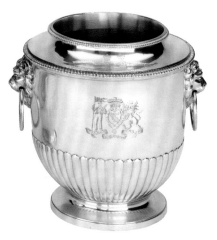

William Hall
Pair of silver ice pails,
1801–02
National Maritime Museum,
Greenwich Hospital Collection
PLT0096; PLT0097

These are items from
a silver service presented
to Nelson by the Corporation
of Lloyd's after the Battle
of Copenhagen, and were
used at Merton Place.

which Emma belongs, and categories comprising a single person are easily dismissed or misrepresented. We could say that she shared many qualities with her contemporary Mary 'Perdita' Robinson, described by one biographer as an 'actress, entertainer, author, provoker of scandal, fashion icon, sex object, darling of the gossip columns'.[50] Robinson, though, will always be understood by that first word, 'actress'. Notwithstanding its dubious connotations in the eighteenth century, it is an occupational label that places her within a community and a lineage of talent, and that consequently makes a sturdier claim to the respect of posterity.

By contrast, Emma's work was in many respects her own life, and that will always require a larger leap – if not of faith then of willingness – to foreground. Her determination to fashion and refashion that life in the public eye was prodigious, and an incident in 1787, not long after her arrival in Naples, brings it into focus. Emma's correspondence records that she paid a social visit to a nun called Beatrice Acquaviva. She was good company, and Emma described her glowingly to Sir William as a 'pretty whoman [*sic*]', 'charming', and 'amiable'. However, the seclusion of Acquaviva's convent existence produced an almost visceral response. 'I wondered', wrote Emma, 'how she would be lett [*sic*] to hide herself from the world...how cruel!'[51] For someone who gravitated towards energy, creativity and involvement with other people, such a reaction was profoundly in character. Visibility and participation were always preferable to her than concealment or passivity, but she would pay a heavy price for demanding a place in the public sphere.

Sir Thomas Lawrence
Emma as *La Penserosa*,
1791–92
Oil on canvas
Private collection

This remarkable portrait
demonstrates Emma's
determination to reconfigure
her public image following
her marriage to Sir William
Hamilton. One of the most
fashionable artists of the
day was engaged to speed
her transition from youthful
bacchante to a figure of
contemplation, authority
and respectability.

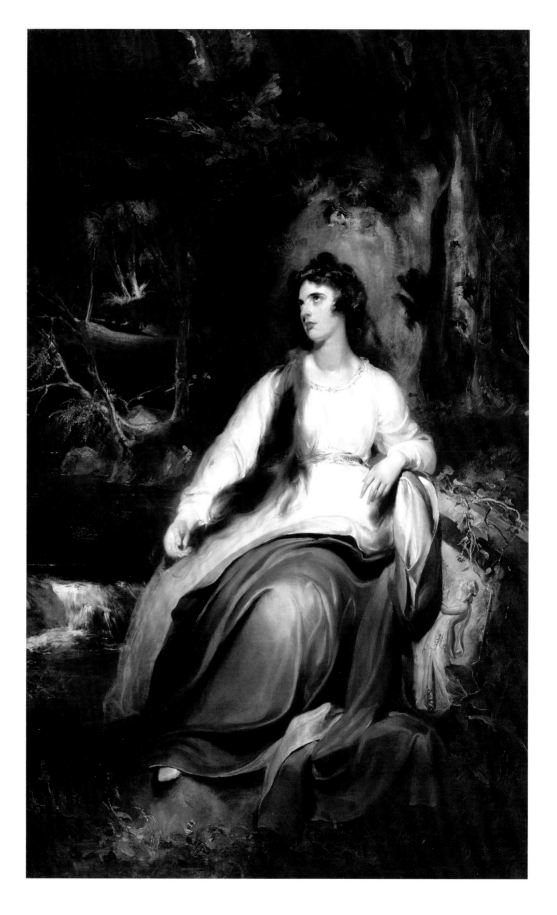

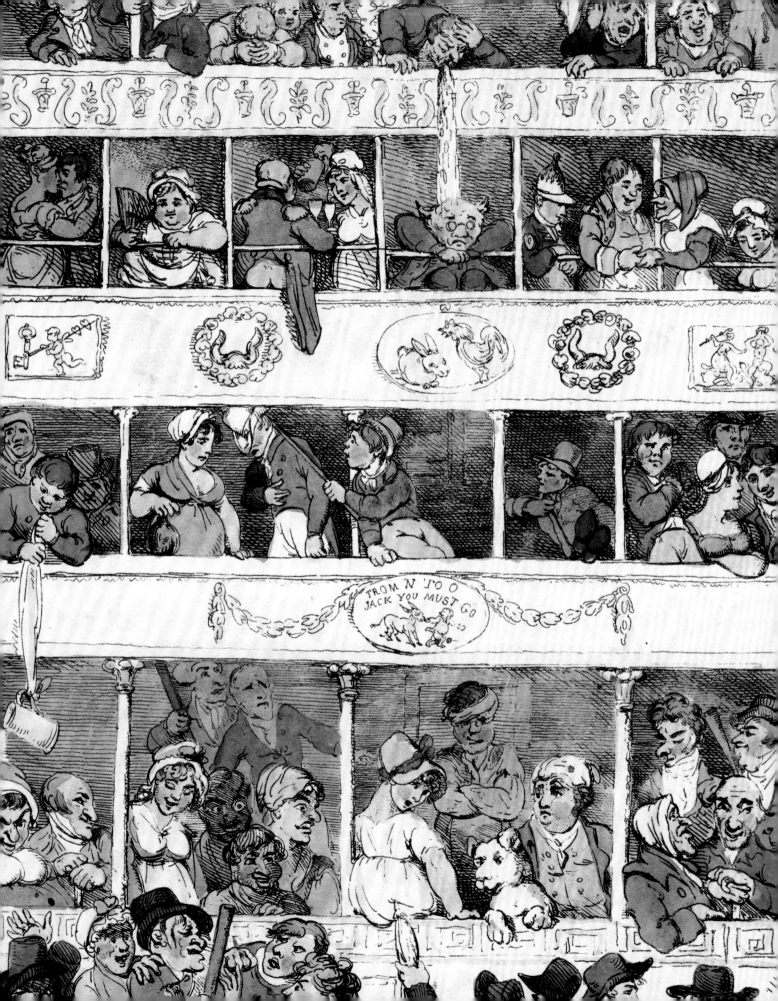

FROM N TO O
JACK YOU MUST GO

Vic Gatrell

Early Years
Sexual Exploitation
and the Lure of London

1

We know very little about Emy Lyon's life before her mid-teens, and nothing that hints at her later celebrity as Emma Hamilton. Born in an impoverished Cheshire mining village in 1765, she was the daughter of an illiterate blacksmith and a strong-minded and supportive mother. Her parents christened her Emy but she was variously called Amy, Amyly, Emly, Emyly or Emily until 1782, when she settled for 'Emma Hart' on her then-keeper Charles Greville's instructions: thus she remained until she married Sir William Hamilton in 1791, when she signed the register as Amy Lyon. Her father died when she was an infant, so her mother took her to grow up in her grandmother's cottage in the village of Hawarden in Flintshire, its poverty emblematic of her early life.

Emma seems to have come to London with her mother in 1777–78, in her thirteenth year.[1] The next three years are as scantily documented as her childhood. We depend on the much later memories of a couple of detractors and acquaintances, so the legends that have accreted must be treated with caution. Only in 1781 did she enter something like the public record. An astonishing beauty, she was taken up by the rake Sir Harry Fetherstonhaugh, then appropriated by Greville, who later passed her on to Hamilton, his uncle in Naples, and so to marriage, wealth and Nelson. That is where the familiar drama lies, but Emma's hidden years were important. They fashioned her view of the world and its opportunities, and speak volumes about her resilience and luck. They also implanted in Emma an ineradicable confidence in her own beauty. Not a single account denies that the teenaged country girl turned heads in the streets.

Emma probably arrived in London with a character reference from the Hawarden surgeon's family for whom she had worked as nursery-maid, but

her prospects were not encouraging. She was one among thousands of illiterate or barely literate country girls who flocked annually into London to make exiguous livings in domestic service, or to prostitute themselves if their hopes misfired. Like their male counterparts, most gravitated to the central 'town' of Covent Garden and the Strand. Lodgings were cheap there, trades and shops were many, and the vegetable market in the piazza would employ them if all else failed. The parish of St Paul's, Covent Garden, was more heavily populated by women than men for decades yet, and was also London's most glamorous playground. Here stood the two great theatres of Drury Lane and Covent Garden, and here young bucks took their pleasures, artists and writers filled the coffee-houses, and fashionable ladies shopped in the Strand.

Covent Garden Piazza and its ring of stately streets were designed for aristocrats by Inigo Jones in the 1630s, as architect to the Duke of Bedford. But they were encircled by the ancient timbered and rat-infested courtyards and alleys along Drury Lane, St Martin's Lane and the Strand that belonged to an older and poorer London. Henry Fielding, the novelist, had lived in the 1740s not far from Drury Lane in Old Boswell Court and moved to Bow Street as a magistrate, so he had these neighbouring warrens in mind when he described London as 'a vast wood or forest, in which a thief may harbour with as great security, as wild beasts do in the deserts of Africa or Arabia'.[2] They harboured most of Covent Garden's street-women, and they had profound effects. 'The People of Fascination', Fielding wrote, were being driven westwards to the developing West End by the incursions of 'the enemy' – i.e. the vulgar.[3] Large houses were subdivided, lodgings multiplied and rents fell. In came craftsmen, shopkeepers, artists, actors, writers, musicians, printers, courtesans, pornographers, tavern-keepers and rakes with unpleasant tastes. The last titled ratepayer left Inigo Jones's arcaded piazza in 1757.

Richard Horwood
Plan of the Cities of London and Westminster the Borough of Southwark, and Parts adjoining Shewing every House (detail showing Covent Garden and the Strand), 1792–99
Engraving
MOTCO Enterprises

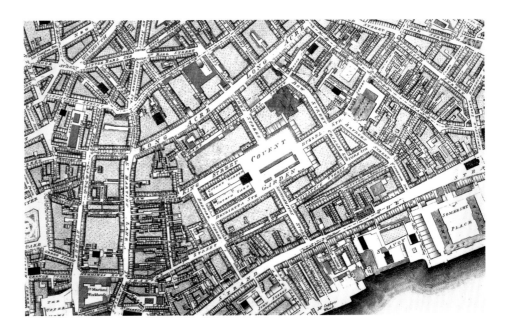

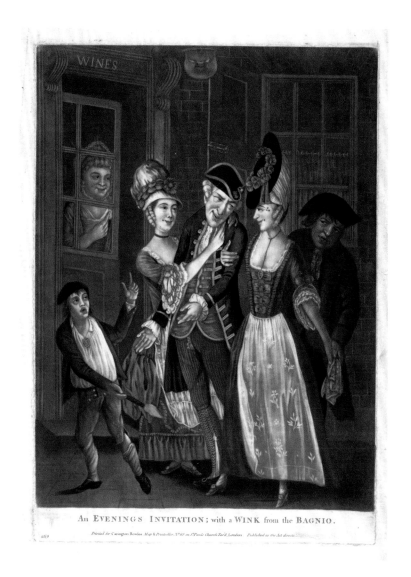

An EVENINGS INVITATION; with a WINK from the BAGNIO.

Printed for Carington Bowles Map & Printseller, N.º 69 in St Pauls Church Yard, London. Published as the Act directs.

The cultural gain was enormous. What developed in Covent Garden's square half-mile in the second half of the century was the world's first creative 'bohemia'. Most of the nation's leading artists, writers and playwrights lived and worked in that compacted space, and the atmosphere was electric. What we now call 'Georgian culture' – artistic, theatrical and literary – was hatched there. Its growing sleaziness was legendary. Coffee-houses, taverns, gambling dives and brothels multiplied, and pickpockets were everywhere. Rakes patrolled the piazza by night and artists found that nude models were easily come by. In chandeliered bordellos and bagnios (bath-houses) courtesans waited for grandees to pay for their nights in guineas, while simpler men picked up girls like the one James Boswell knew, who in her white-thread stockings, 'tramps along the Strand and will resign her engaging person...for a pint of wine and a shilling'.[4] Prostitutes were the subject of scores of prints and publications. Most prints were more amused than condemnatory; some simply applauded their exceptional marketplace beauty, just as Hogarth had celebrated his *Shrimp*

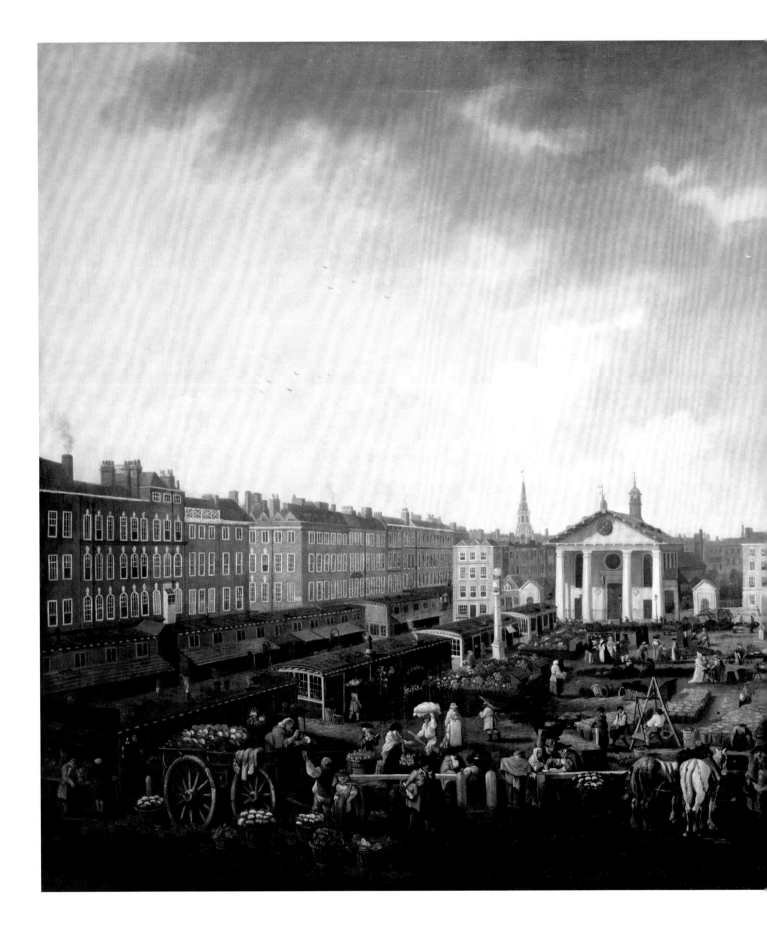

EARLY YEARS: SEXUAL EXPLOITATION AND THE LURE OF LONDON

John Collet
Covent Garden Piazza,
Market and St Paul's Church,
1771–80
Oil on canvas
Museum of London
55.72

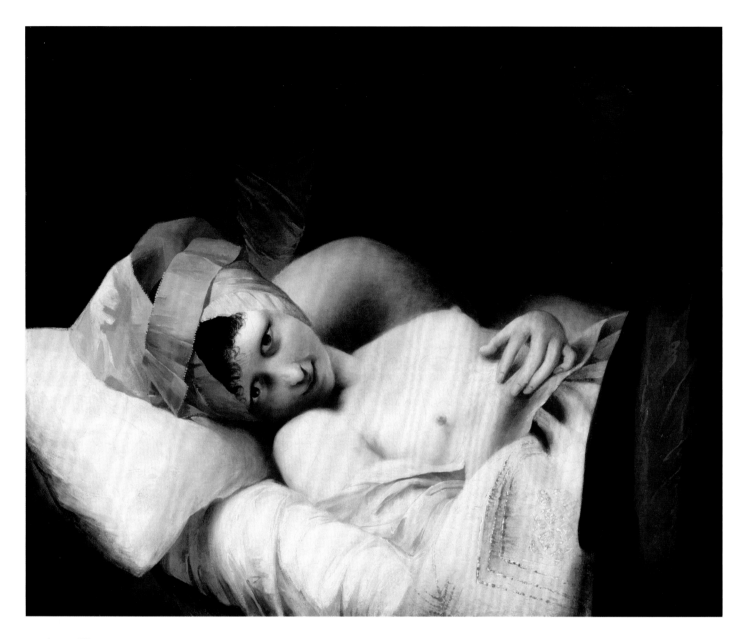

Matthew William Peters
Lydia, *c. 1777*
Oil on canvas
Tate, London
T04848

This frankly sexual depiction
of a courtesan was painted by
Peters at the time of Emma's
first arrival in London.

EARLY YEARS: SEXUAL EXPLOITATION AND THE LURE OF LONDON

Girl and as Emma would herself soon be acclaimed. *Harris's List of Covent Garden Ladies* annually updated its descriptive catalogue of the healthier girls, while a year after Emma's arrival the anonymous *Nocturnal Revels: or, the History of King's-Place, and other Modern Nunneries* (see p. 51), detailed aristocratic depravities and the glitzier bordellos, including the one in which some said Emma later worked. However, it did not deny the miseries of the 'unfortunate strumpet who had been starving in a garret all day, whilst she had been washing her only and last shift' as she hoped to meet an apprentice boy who would 'treat her with a mutton-chop and a pot of porter'.[5] The satirist James Gillray illustrated precisely this scene in his double-edged *The Whore's Last Shift*: judgmental or pitying, who can say? Emma must have seen it on sale in its publisher William Humphrey's printshop window at 227 Strand. This was round the corner from Norfolk Street, where she later worked.

All girls like Emma knew how far they could fall should they slip. But a youngster of her looks and temperament would look on the bright side, for the fashionable world was more visible than the destitute one. It helped that she found her first employments in professional homes. Domestic service was cruel drudgery but it gave her a sense of what good living might look like. First she worked as a nursery-maid in the house of Richard Budd, the physician of St Bartholomew's Hospital, who lived prosperously in Chatham Place off the new Blackfriars Bridge.[6] Then, sometime in late 1778, she became a maid in the house of the composer and musical impresario Thomas Linley.

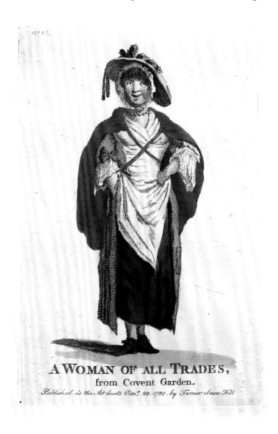

A WOMAN OF ALL TRADES,
from Covent Garden.

Published as the Act directs Octr. 28. 1782. by Turner Snow Hill

William Turner (publisher)
A Woman of all Trades, from Covent Garden, 1782
Hand-coloured engraving
Library of Congress
PC 3–1782

James Gillray
The Whore's Last Shift, 1779
Hand-coloured etching
British Museum
1868,0808.4586

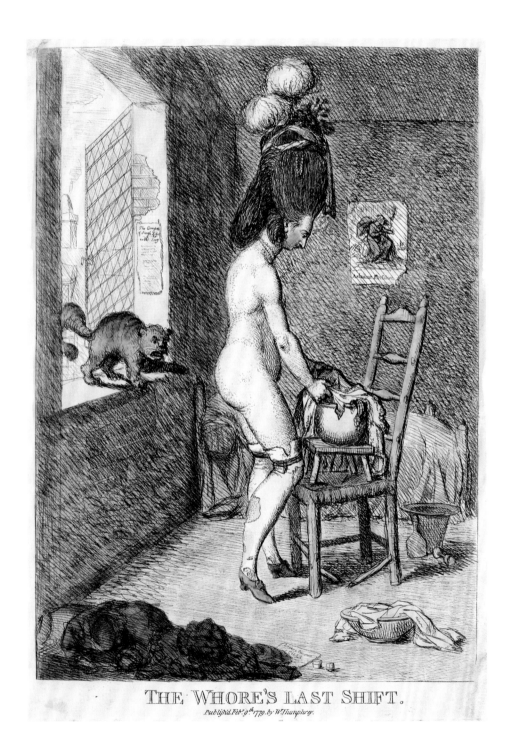

EARLY YEARS: SEXUAL EXPLOITATION AND THE LURE OF LONDON

Above
Mather Brown
Henry Charles William
Angelo, *c*. 1790
Oil on canvas
National Portrait Gallery
NPG 5310

Right
After an unknown artist
The Old Theatre, Drury Lane,
1794
Engraving
Yale Center for British Art
B1977.14.18568

We are relatively certain about this last appointment thanks to Henry Angelo's *Reminiscences*. Angelo's father was a fashionable fencing master who was an intimate of the Linleys. Indeed, he knew everyone who was anyone and his godfather, by a strange coincidence, was Emma's William Hamilton. Angelo often made up or embellished his anecdotes, but he swore to the truth of his memories of Emma and his personal connections may have ensured that they are more reliable than most.

If so, new worlds opened to Emma at the Linleys'. Their house in Norfolk Street, south of the Strand to the east of Somerset House, was a few minutes' walk from the Drury Lane and Covent Garden theatres. Moreover, Linley's daughters were famous oratorio singers, and one of them married the playwright Richard Brinsley Sheridan. In 1776, Linley and Sheridan bought from David Garrick the major shareholdings in Drury Lane, with its splendid classical façade, just completed by the Adam brothers on Brydges Street. Linley became the theatre's musical manager and his wife its wardrobe mistress. According to Angelo, Emma was the channel of communication between Mrs Linley and the Drury Lane actresses: she 'used to bring her word at the theatre to her private box'.[7] Emma now had new ways of being in her sightlines.

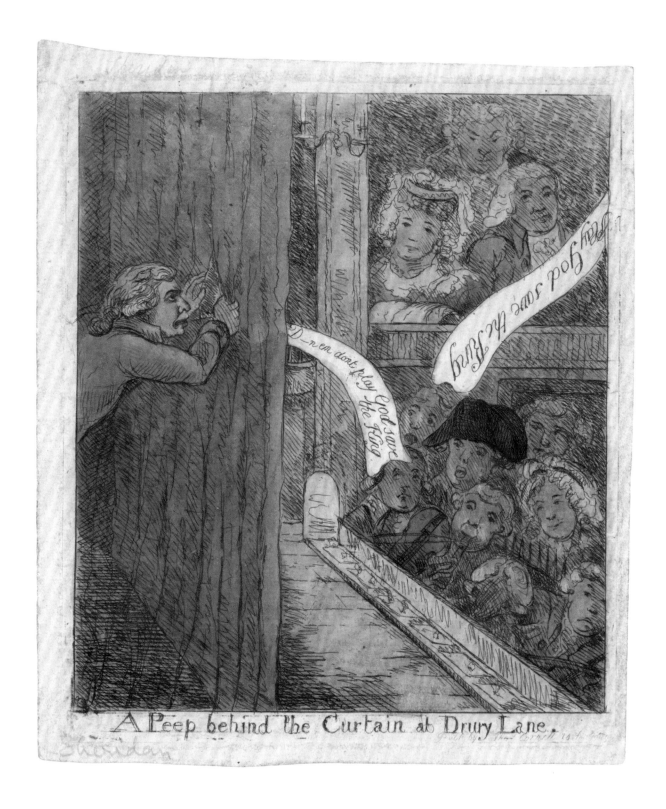

James Sayers
A Peep behind the Curtain
at Drury Lane, 1780
Hand-coloured etching
Victoria and Albert Museum
S.4200-2009

EARLY YEARS: SEXUAL EXPLOITATION AND THE LURE OF LONDON

She already knew about theatre and how it might elevate a girl. A fellow servant at Dr Budd's was one Jane Powell, who was to debut at the Haymarket theatre in 1788 and have a Drury Lane career thereafter.[8] But any country girl coming to town would have been bedazzled by the theatre. It was a popular as well as a genteel passion, fuelling the celebrity culture of the age as well as countless genial promiscuities. Theatre lobbies were sexual marketplaces where grandees picked up pretty women and vice versa. And if the gentry ogled each other from the front boxes, the back boxes and pit were full of excited servant girls like Emma. Add the courtesans and their protectors and clients to the mix, and performance conditions could be riotous. Angelo's friend Thomas Rowlandson did not exaggerate when he depicted the audience's turbulent jollity in his later print, *The Boxes*. Actresses were frowned upon in salon culture but in Covent Garden's *demi-monde* that mattered nothing, for manners were free and easy. In theatre, cross-dressing for 'breeches parts' was done with ease – 'Perdita' Robinson was famous for it – and Rowlandson's joyous sketch of the dressing-room displays of breasts, urinations and tippling rings true, despite the caricature (see pp. 46–47). (He enjoyed privileged access through his friend Jack Bannister, the actor.) Everyone understood, too, that the borders between prostitution and free-loving were hazy. Actresses crossed those borders habitually, hoping to marry or be kept by money. The bohemian values of a libertine age flourished here, and talented men and women could easily reinvent themselves. Since uncouth origins and a regional accent were of no account, girls like Emma flourished, too.

In and out of the dressing-rooms bustled actresses great and small. In Emma's time, Frances Abington, Mary 'Perdita' Robinson and Elizabeth

John Nixon
A Peep behind the Scenes:
Covent Garden Theatre, 1802
Watercolour
Museum of London
93.85

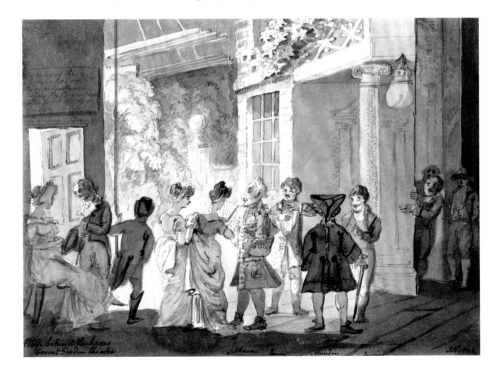

Farren led the way. Each was beautiful and very sure of herself; each was painted by the likes of Joshua Reynolds (Abington several times), Thomas Gainsborough (Robinson) or Thomas Lawrence (Farren); and the first two were famous for their vivid sexual lives. How could Emma not ponder the luck of Frances Abington, for instance? Born and raised in the Drury Lane alleys, her mother long dead and her father running a cobbler's stall in Vinegar Yard opposite the theatre, Fanny had first sold flowers and sung songs for halfpennies in the piazza, interspersing that with spells of prostitution in Leicester Fields. She set about bettering herself by working first for a French milliner in Cockspur Street (where she learned French) and next as a kitchen-maid for a Drury Lane actor, which opened her way onto the stage there in 1756. By the time Sheridan wrote the part of Lady Teazle for her in *School for Scandal* (1777), she was the Marquess of Lansdowne's mistress.

Elizabeth Farren was a little more chaste and better-born than most, but she managed to marry the comically short and portly Earl of Derby. Likewise, while Perdita Robinson was acting in *The Winter's Tale* in 1779, the seventeen-year-old Prince of Wales chose to fall in love with her. Soon 'Florizel' and 'Perdita' were bedding each other. He persuaded her to leave the stage by paying her off

Right
After Michael William Sharp
Mrs. Powell, 1807
Stipple engraving
British Museum
Y,6.260

Powell is shown here as
Matilda in *The Curfew*,
a play by John Tobin.

Opposite
Thomas Rowlandson
The Boxes, 1809
Hand-coloured etching
Lewis Walpole Library
809.12.12.01

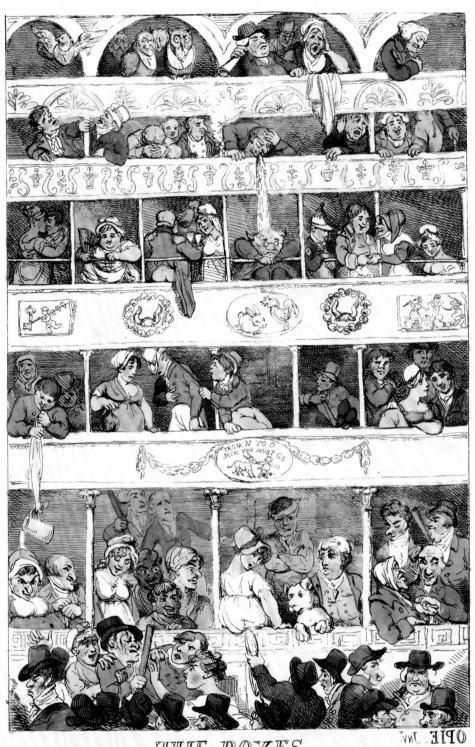

THE BOXES.

O woe is me, I have seen what I have seen
Seeing what I see. Shakespear.

Pd Decr. 12 1809
by T Rowlandson
at James S. Adelphi

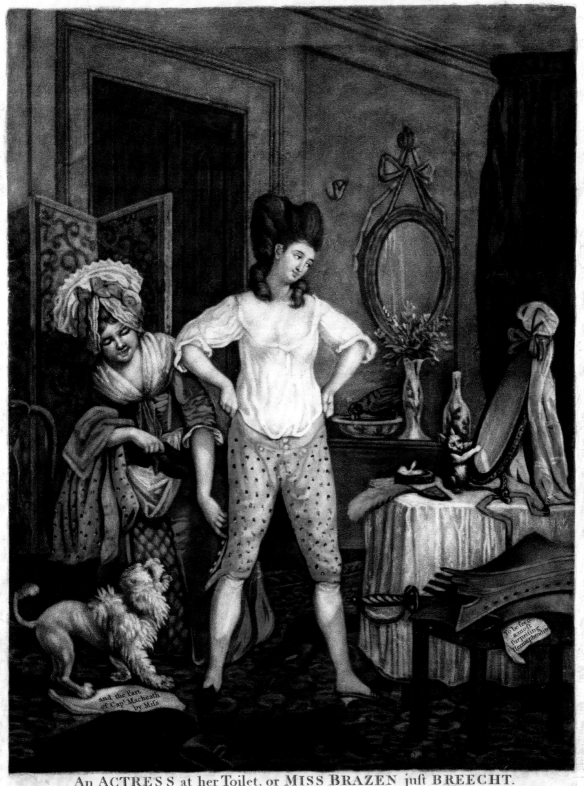

An ACTRESS at her Toilet, or MISS BRAZEN juft BREECHT.

From the Original Picture by John Collet, in the poffeffion of Carington Bowles.

403 *Printed for & Sold by* CARINGTON BOWLES, *at his Map & Print Warehoufe N°69 in S¹ Pauls Church Yard* LONDON. *Publifhed as the Act directs, 24 June 1779.*

with a luxurious establishment and a £20,000 bond to be honoured when he came of age – a faint hope given his dire relations with his father, George III. In December 1780, he dropped her for the courtesan Elizabeth Armistead, silencing Perdita with a mere £5,000 a year. Perdita, now wealthy despite everything, variously consoled herself by being painted by Gainsborough, Reynolds, Romney and John Hoppner, by outdoing the Duchess of Devonshire as a fashion plate, and by touring London 'in an absurd chariot with a device of a basket likely to be taken for a coronet, driven by the favoured of the day, with her husband and candidates for her favour as outriders'.[9] These were all remarkable things to do for one so erratically raised.

Mrs Armistead was herself an actress but was better known as one of the great courtesans of the century. By 1776 she was being hailed in the *Town and Country Magazine* as the conqueror of 'two ducal coronets, a marquis, four earls

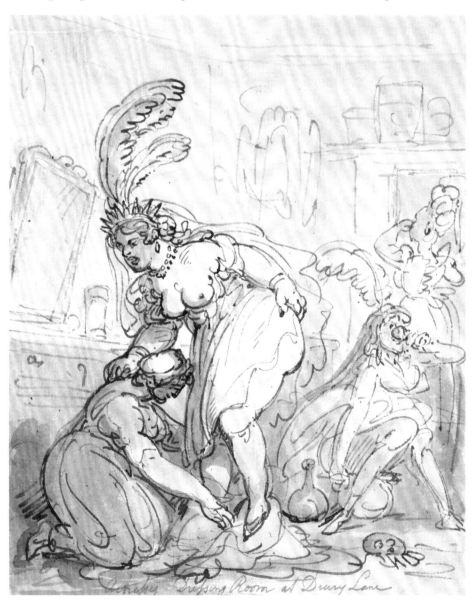

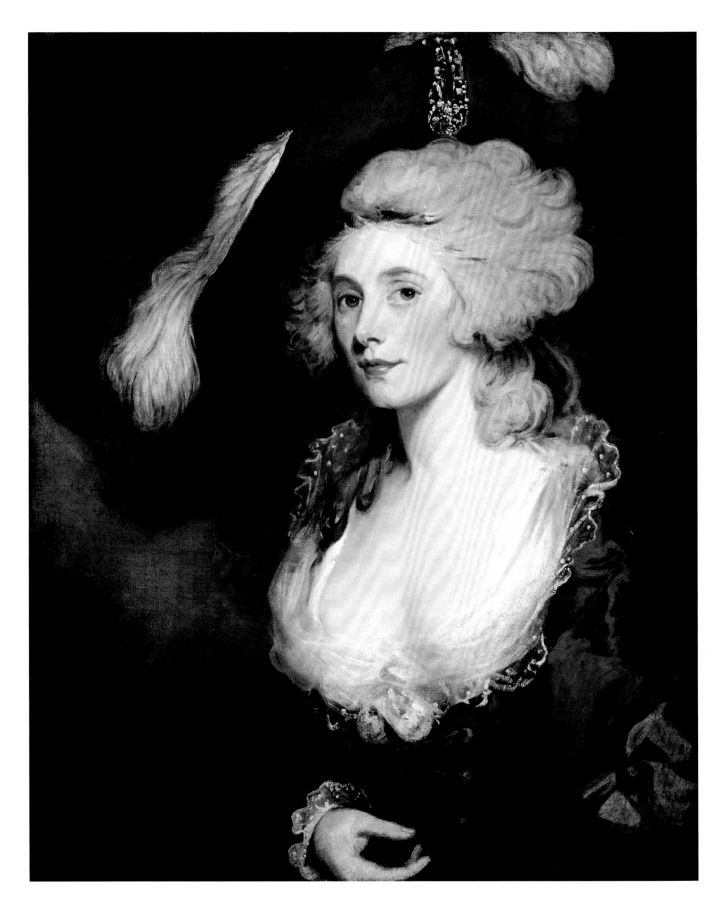

and a viscount'.[10] After her long dalliance with the Prince of Wales, she married
the rakish Whig Party leader Charles James Fox – again, a spectacular rise for
a woman of wholly unknown parentage.

All these stories and more were excitedly commented on in newspapers and
satirical prints. Emma would have been very familiar with them, as everyone
was. The careers they documented were not uncommon in Covent Garden; they
stretched back to Nell Gwyn and other actresses of the age of Charles II. That
is probably why Emma's re-enactment of them was taken for granted and so
scantily documented.

Was it in these months that Emma learned to refine her singing and practise
the postures for which she was to be famed? Did she act, however briefly? We
only know that disaster struck. Suddenly, she left the Linleys. Mrs Linley told
Angelo that the girl was overcome by grief when one of the Linley sons died.
It is just as likely that she fell pregnant by her supposed first seducer, the Royal
Navy captain John Willet Payne – who quickly left her – but there is no hard
evidence for any of this.

We have only two more or less reliable vignettes that speak for the impact
of hard times on Emma. Many years later, the artist Elisabeth Louise Vigée Le
Brun wrote in her memoirs that the Prince of Wales told her that he had seen
Emma 'at that time in wooden shoes at the stall of a fruit vendor, and that,
although she was very poorly clad, her pretty face attracted attention more'.[11]
More dependably, Henry Angelo reminisced that one day in New Compton
Street he was 'powerfully excited by the figure of a young woman, meanly
attired'. Her name, she said, was Emma. He asked if she would be there again
that night. 'With a deep drawn sigh, she replied, "Yes".' When they met, she
declared her misery and told him that she had not eaten that day. He gave her
some biscuits. Whatever else he gave her goes unrecorded (he was publishing
demurely in 1830) but he became besotted with the girl. She dodged their
ensuing assignation, however, and they next met accidentally in Kensington
Gardens. Now she was accompanied by two *élégantes*, as he called them; she
was cheerful and 'in all the grandeur of fashion'.[12] She told him that she was
living at Mrs Kelly's in Arlington Street, St James's – and he saw her several
times in that lady's coach. Then, except for a brief later meeting after she
became Greville's mistress, he lost sight of her.

Mrs Kelly, otherwise known as Charlotte Hayes, was the madame who
presided over the fashionable King's Place 'nunnery' that had been publicized in
Nocturnal Revels. Among other delights, she was known for exhibiting 'a dozen
beautiful Nymphs, unsullied and untainted...who breathe health and nature
and who will perform the celebrated rites of Venus, as practised at Tahiti'.[13]
Gentlemen could join in. Angelo might have associated Emma with Mrs Kelly
out of lazy convenience, since Mrs Kelly's was a memorable name. Yet Emma's
lapse into prostitution is not in question, nor is the neediness that caused it.
In 1791, she referred to both when she defended herself to George Romney, the

painter. Necessity had caused her fall from virtue, she told him, but she had kept her purity of heart:

> You have seen and discoursed with me in my poorer days, you have known me in my poverty and prosperity, and [you know that] I had no occasion to have lived *for years* in poverty and distress if I had not felt something of virtue in my mind. Oh, my dear friend, for a time I own through distress my virtue was vanquished, but my sense of virtue was not overcome.[14]

That might have been so, for Emma had other, more performative, talents to trade on.

And so to the most persistent of all legends – one so wonderful that many biographers have almost willed themselves to believe it. The tale goes that

NOCTURNAL REVELS:
OR, THE
HISTORY
OF
KING's-PLACE,
AND OTHER
MODERN NUNNERIES.

CONTAINING THEIR

MYSTERIES, DEVOTIONS, and SACRIFICES.

Comprising also, The

ANCIENT and PRESENT STATE of PROMISCUOUS
GALLANTRY:

WITH THE

PORTRAITS of the moſt CELEBRATED
DEMIREPS and COURTEZANS of this PERIOD:

AS WELL AS

Sketches of their Profeſſional and Occaſional Admirers,

By a MONK of the ORDER of St. FRANCIS.

IN TWO VOLUMES.
VOL. I.

THE SECOND EDITION, CORRECTED AND IMPROVED,
WITH A VARIETY OF ADDITIONS.

Il vero eſt, quod ego mihi puto palmarium,
Me reperiſſe, quo modo adoleſcentulus
Meretricum ingenia & mores poſſit noſcere:
Mature ut cum cognorit, perpetuo oderit.
TER. EUN. Act 5. Sc. 4.

LONDON:
Printed for M. GOADBY, Pater-noſter-Row.
1779.

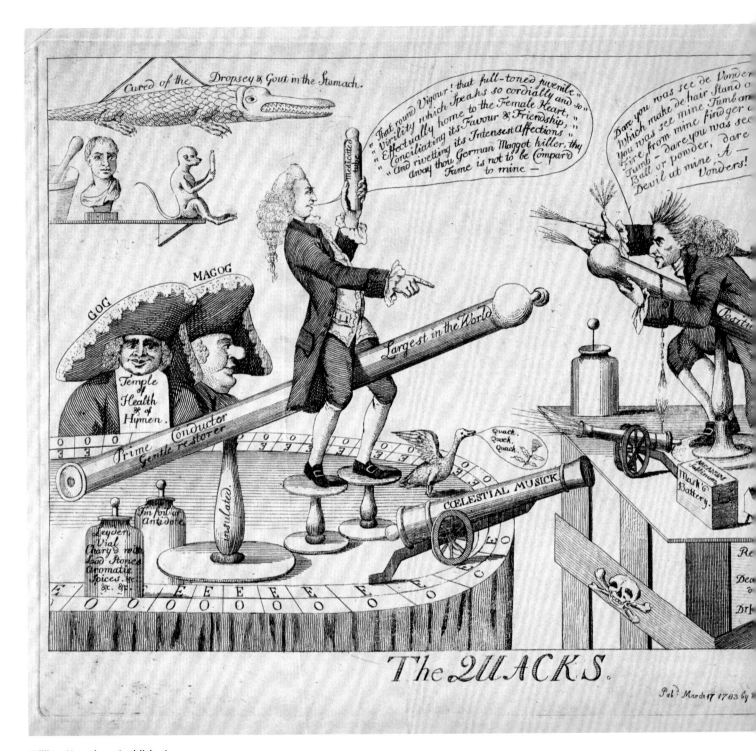

William Humphrey (publisher)

The Quacks, 1783

Engraving

Wellcome Collection

V0016204

This satire shows James Graham
(on the left) competing with a rival
practitioner to demonstrate the
efficacy of his cures for impotence.

within the speech bubble (illustration):

Vorld,
Dare
nogar,
rs on mine
Fire viddout
see de
Vonders!
ll Vonders!

away with it my Dear Son Ill find fire eternally for you.

Thunder House.

Aurin Boreal

•227 Strand.

Emma first seriously exhibited her talents when Dr James Graham employed her to pose in the flimsiest of drapery as 'VESTINA, the ROSY GODDESS of HEALTH!' He advertised the deity in these terms in every London newspaper on 31 October 1780, adding that she 'presides at the Evening Lecture, at the Temple of Health, Adelphi, and assists at the display of the Celestial Meteors, and of that sacred vital fire over which she watches, and whose application, in the cure of diseases, she daily has the honour of directing'. Was this deity really (at some point) Emma?

Graham was a true oddity.[15] Dismissed as a quack in his own time as well as in ours, he lectured high-paying clients of both sexes on electricity, sexual health and mud-bathing, and on female anatomy with a naked girl beside him. To his male audiences he recommended the daily cold washing of the genitals, not only to 'lock the cock and secure all for the next *rencontre*', but also to

[improve] certain parts which next morning after a laborious night would be relaxed, lank, and pendulous, like the two eyes of a dead sheep dangling in a wet empty calf's bladder...[B]y the frequent and judicious use of the icy cold water, [they] would be[come] like a couple of steel balls, of a pound apiece, inclosed in a firm purse of uncut Manchester velvet.[16]

Horace Walpole thought Graham's 'the most impudent puppet-show of imposition I ever saw, and the mountebank himself the dullest of his profession, except that he makes the spectators pay a crown apiece'.[17] Yet Graham's purposes were not intrinsically foolish in that scientifically curious era. He shared his sexual rationality with many, including the likes of William Blake, and had consulted Benjamin Franklin on the medical uses of electricity. He favoured vegetarianism, moderate eating, fresh air, loose clothing, and the conservation of the sperm the better to disseminate it in mutually enjoyable sex. And although Rowlandson, as ever, mocked the mud-bathing that Graham demonstrated in his alternative establishment in Panton Street (where he lectured his audience while naked and half-buried in a mud hole), even this made sense when so few of the rich regularly washed themselves: the sluicing down that followed undoubtedly cleaned them up a little.

What titillated most then, and titillates still, was that Graham advertised among other pleasures the curative powers of his 'Grand Celestial Bed'. He unveiled this fertility-inducing contraption when he moved from the Adelphi to Schomberg House, Pall Mall, in April 1781. Measuring twelve feet by nine, it was supported by forty pillars of exquisitely worked glass and surrounded by magnetic and electrical machines, mirrors, perfumes and musical accompaniments, its pleasures enhanced when jiggled about by concealed helpers turning hidden cranks. For £50 a night, affluent couples could disport themselves on it to make the babies so necessary for passing on property. Graham added to the sensation by exhibiting naked statues outside the house, for which he was threatened with prosecution.[18]

Thomas Rowlandson
Dr Graham's mud-bathing
establishment, late
eighteenth century
Watercolour, pen and graphite
Yale Center for British Art
B1975.3.116

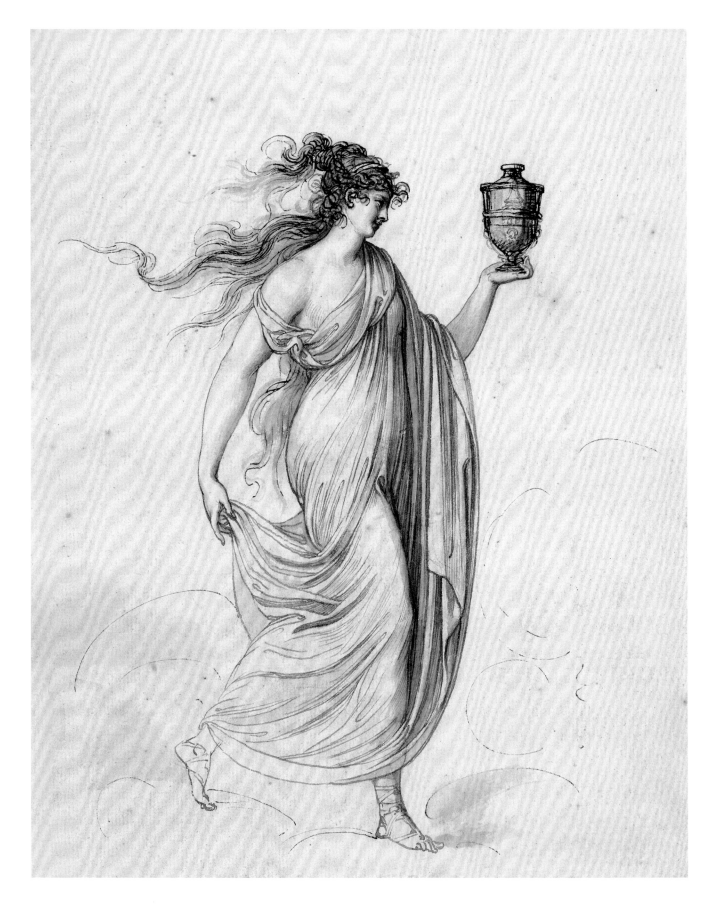

Graham made himself famous, though not rich: his expenses were enormous. The likes of Perdita Robinson, the Prince of Wales, the Duchess of Devonshire and Charles James Fox attended his lectures. Mrs Robinson might well have been influenced by the goddess Vestina when she set a new fashion in 1782 by attending the opera in a 'Grecian' muslin gown that revealed the figure without the help of hoops or pads. Angelo remembered the carriages outside Graham's brilliantly lit houses, with 'crowds of gaping sparks on each side, to discover who were the visitors; but the ladies' faces were covered, all going *incog*'.[19] The press reported of the Adelphi Terrace:

> [It] is now so crouded with patients and carriages, that it is difficult to get either in or out of the Temple of the Rosy Goddess...The number of foreign Ambassadors, and of the Nobility of the first rank who attend the evening exhibitions of the apparatus, is so great and brilliant, that it is now become the most polite – the most fashionable place of public resort.[20]

The claim that Emma struck gauzily under-clad poses to advertise these enterprises is not beyond belief. She had theatrical talents but failed to get on the stage, she needed to escape the bordello, and no doubt she hoped to meet moneyed men. To delight Sir Harry Fetherstonhaugh's friends she was later said to have danced naked on his dining-room table at Uppark, and years after that she struck her famous gauzy Attitudes for Hamilton's friends. All these talents could well have been cultivated under Graham's aegis. The case seems to strengthen when we add apparent corroboration in the form of an elegant drawing by Richard Cosway in pencil, ink and wash, which shows a flimsily draped and robust young woman striking a 'Greek' attitude while holding a Greek-looking urn. On its back, an inscription reads: 'Emma Hart afterwards Lady Hamilton as the goddess of health while being exhibited in that character by Dr Graham in Pall Mall by R Cosway.' Alas, wishful thinking almost certainly operated here. The evidence is inconclusive. The drawing has been in the collection of the National Maritime Museum since 1935, after being purchased at an antiques fair and later donated. It may have been at this point that its title was invented.

It is true that Cosway was producing 'stained' or 'tinged' portrait drawings of this kind in the 1780s to sell at the same price as his miniatures (£30). Moreover, he and his wife also moved into Schomberg House in 1784, replacing Graham's occupancy when the latter fell into debt. Like most of fashionable London, Cosway therefore knew all about the goddesses, but most of his stained drawings date between 1790 and 1810.[21] If his drawing is of Emma, it might have been drawn in the 1790s to depict her Attitudes, even though it is admittedly in a simpler style than most of Cosway's drawings at that time. Even if it is from around 1780, however, it could be of someone else, despite the apparent likeness. Emma was not well known then, and Graham employed several women to disport themselves as the goddess Vestina. One ended up in a brothel in Long Acre, Covent Garden, where in 1789 she was shot in the head by a drunken client.[22]

Such textual evidence as there is for Emma's posing for Graham is not helpful either. Contemporary newspapers referred to Emma as the 'Goddess of Health' but it is difficult to establish whether this was a teasing nod to a shadowy past or a title drawn from real knowledge of a career with Graham. A more confident claim that she did so pose first appeared in 1815 in a scurrilous account of her life in the anonymous *Memoirs of Lady Hamilton*. We know now that it was written by Francis Oliver, Sir William Hamilton's secretary and later Nelson's. He was convincingly close to his subject but after Nelson's death he quarrelled with and tried to blackmail Emma, and his sermonizing book, remarkably empty of detail, settled his grudges by representing her as a promiscuous fortune-hunter. He merely alluded to a rumoured connection with Graham in order to deplore it, and cited as his source an unnamed 'person of the highest literary character, twenty-four years ago'.[23]

Pompeo Batoni
Sir Harry Fetherstonhaugh, 1776
Oil on canvas
National Trust
138269

EARLY YEARS: SEXUAL EXPLOITATION AND THE LURE OF LONDON

Most Victorian biographers took Oliver's hints at face value,[24] and many modern biographers have followed them. Walter Sichel (in 1905) favoured the middle view that Emma might have sung in the mock-oratorios and cantatas that Graham composed to attune the souls of the faithful. Against that, however, Emma's, Hamilton's and Nelson's correspondence seems never to have alluded to any employment by Graham. Perhaps most significantly, the relatively knowledgeable Henry Angelo, who had followed Graham's career as well as Emma's, twice refuted the story: 'As to her having been the Goddess of Health, that is impossible. In a very few days after our meeting [see above], she was at Mrs Kelly's, and that only for a very short time; from thence she was removed many miles off' to Fetherstonhaugh's Uppark.[25] So whether or not Graham did 'deify' Emma remains an open question.

In 1781, young, healthy and blooming, Emma was 'found' at last: she was sixteen years old. Sir Harry Fetherstonhaugh whipped her off as his mistress and utterly changed her prospects. Whether he picked her up in a bordello or at Dr Graham's, we cannot say. Either way, the aristocratic acquisition of needy girls was common practice and easily achieved. Soon, to entertain his friends, she was dancing on his table at Uppark in Sussex. In her few months there she learned all manner of social graces, and horse-riding. Surrounded by wealthy and powerful men, she doubtless felt that she had made it.

Fetherstonhaugh was a witless playboy. He made the Grand Tour in 1775–76, but passed most of it in sexual and hunting adventures. He was painted by Pompeo Batoni in Rome and he bequeathed to Uppark its library, engravings and a broken telescope that delighted young H. G. Wells when his mother was housekeeper there a century later. However, one doubts whether he preferred books and pictures to his hounds. He became the MP for Portsmouth (1782–96) but never once spoke in the Commons. He employed Humphry Repton to lay out his gardens but the beneficiary of that was the Prince of Wales who visited Uppark in 1784. Mrs Elizabeth Montagu reported that 'they had races of all sorts, fine horses, ponies, cart-horses, women, and men in sacks, with various other divertimenti for children of six foot high'.[26] The prince thought 'the Newmarket races were dull in comparison'. When Fetherstonhaugh at last settled down, it was by marrying his eighteen-year-old dairy-maid. He was by then in his seventies.

Such was the man who betrayed Emma. He made her pregnant, got tired of her, turned her out, gave her no money and ignored her pleading letters.[27] Emma faced destitution. She returned home to Hawarden in Cheshire to give birth to 'Little Emmy' in early 1782.

It was a hard fall but Emma played her weak hand with the needy bravado she had displayed at Uppark. Heavily pregnant in January 1782, she wrote a poignant letter to Charles Greville begging for help. This is the first time we meet her in her own words. She could write, if not spell:

Printed for & Sold by Carington Bowles,

No.69 St. Pauls Church Yard, London

THE PRODIGAL SON REVELLING with HARLOTS.

He wasted his substance with riotous living. St.Luke Ch.XV. verse 13.

619

Published as the Act directs 1 Aug 1791.

Plate 2

Yesterday did I receve your kind letter. It put me in some spirits, for, believe me,
I am allmost distracktid. I have never hard from Sir H[arry], and he is not at
Lechster now, I am sure. What shall I dow? Good God! what shall I dow? I have
wrote 7 letters, and no anser. I can't come to town for want of mony. I have not
a farthing to bless my self with, and I think my friends looks cooly on me.
I think so. O G[reville], what shall I dow? what shall I dow? O how your letter
affected me, wen you wishd me happiness. O G., that I was in your posesion or
was in Sir H. What a happy girl would I have been! – girl indeed! what else am
I but a girl in distres – in reall distres? For God's sake, G. write the minet you get
this, and only tell me what I am to dow. Direct same whay. I am allmos mad.
O, for God's sake, tell me what is to become on me. O dear Grevell, write to me.
Write to me. G. adue, and believe [me] yours for ever, Emly Hart.

Don't tel my mother what distress I am in, and dow aford me some
comfort...Once more adue, O you dear freind.[28]

Emma had achieved some intimacy with Greville at Uppark, possibly sexual.
He was, Sichel noted, 'considerate, and composed; good-looking, prudent,
and ever liberal – in advice'.[29] His reply to her letter hints that he paid her
coach fare to Cheshire. He also rebuked her for a recent spell of 'giddiness
and dissipation', and dictated his conditions for his future protection.
His terms were harsh. She was to surrender Little Emma, shun all past
connections except her mother, discard the disgraced name Lyon (whence
'Hart', possibly suggested by the Uppark village of South Harting) and
never to show 'ingratitude & caprice'. She was at his mercy. 'Oh Greville,' she
pleaded later, 'you don't know how I love her, endead, I do.' But she appealed
in vain. The baby was placed into its great-grandmother's care and then given
to foster parents in Manchester for her schooling. Emma met her now and
then and loved her ('her eys is blue and pretty. But she don't speak through
her nose but she speaks countryfied, but she will forget it').[30] Then the child
all but disappears from history.

Emma and her own mother moved into Greville's modest villa off the still
semi-rural Edgware Road (as a younger son, albeit of the Earl of Warwick,
he was far from affluent). In April 1782, he introduced Emma to George
Romney, who, smitten, painted the first of his seventy or so portraits of her
– as 'Nature'. While the women kept house for Greville, Emma proved her
sexual worth. Hamilton met her at Greville's in the summer of 1783, after his
first wife's death. He thought her 'better than anything in nature' and 'finer
than anything that is to be found in antique art'.[31] When Greville passed her
on to Hamilton three years later, he hardly needed his nephew's reassurance
that she was 'the only woman I ever slept with without having ever had any
of my senses offended, & a cleanlier, sweeter bedfellow does not exist'.[32] The
rest, one can hardly avoid saying, is history. For a quarter-century more, the
admiration and luxury she craved never again waned, until Nelson was killed
at Trafalgar.

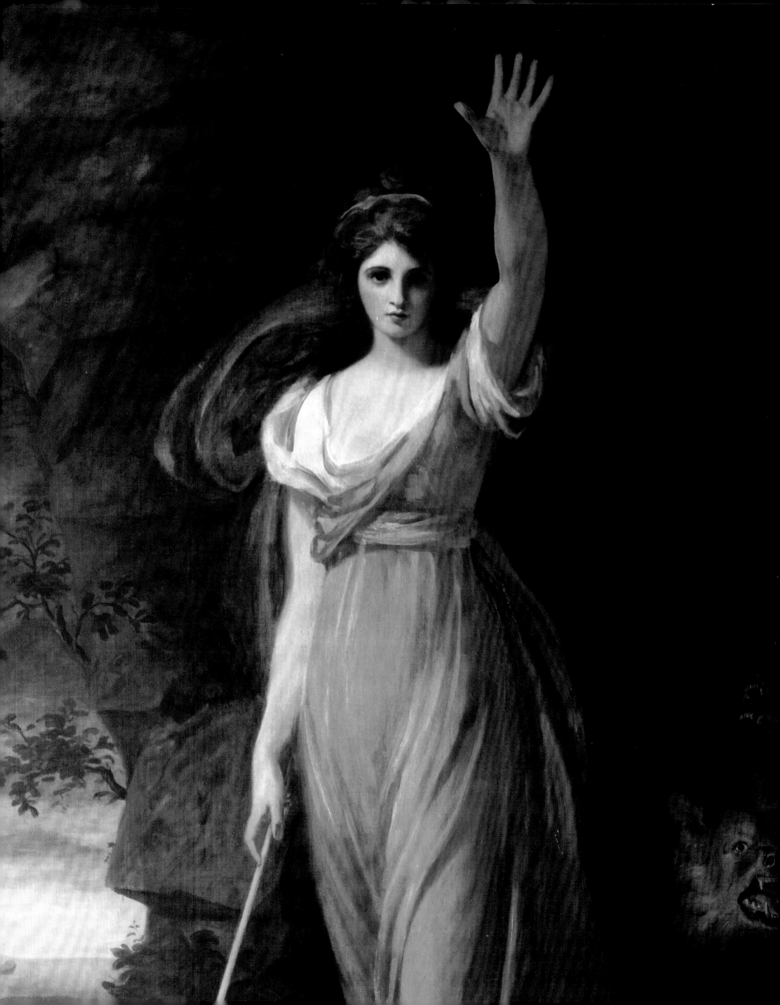

Christine Riding

Romney's Muse
A Creative Partnership in Portraiture

2

Her features, like the language of Shakespeare, could exhibit all the feelings of nature and the gradation of every passion with a most fascinating truth and felicity of expression.
William Hayley, *Life of George Romney*, 1809

In April 1782, Charles Greville, long-standing friend and patron of George Romney, brought his new mistress Emma Hart to the artist's house in Cavendish Square, London. Emma was sixteen years old at the time and an unmarried mother, and was thus largely unacceptable in polite society. As Greville's *protégée*, however, she increasingly became an object of attention, both for her beauty and her theatrical ability, and would achieve social acceptance following her marriage in September 1791 to Greville's uncle, Sir William Hamilton. A major driver for this transformation in circumstances was her relationship with Romney, and her initial exposure to his artistic milieu and the friends and patrons he counted among his intimate circle. These included the playwright Richard Cumberland, the poet and biographer William Hayley and the sculptor John Flaxman. In 1894, Romney's biographer Hilda Gamlin suggested that Greville brought Emma – 'for whom he was at that time providing, and also educating her sharp intellects' – to have her portrait painted by Romney, as a way of both occupying her time with a respectable activity and broadening her mind.[1] Keen to discard her humble origins, Emma would prove a willing and able pupil. At the same time, she became Romney's artistic muse – his 'Divine Emma' (as he referred to her) – and his personal obsession.[2]

By the time of their first encounter, Romney was regarded by many as the premier portrait painter in Britain, eclipsing even Sir Joshua Reynolds, the first President of the Royal Academy. His growing ambitions as an artist had

63

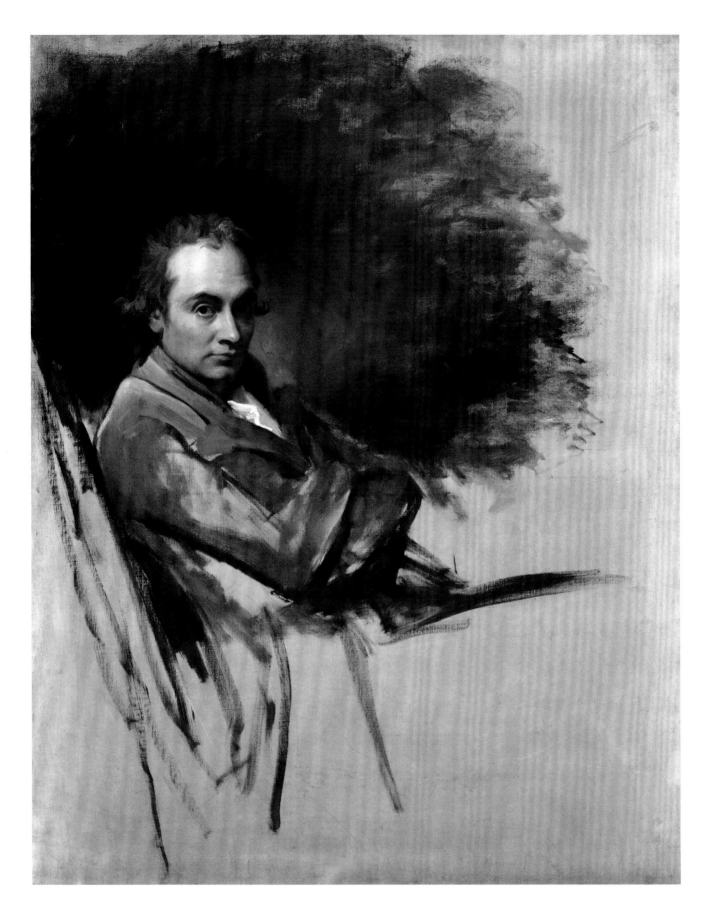

resulted in an extended trip to Italy in 1773–75, where he immersed himself, as many British artists had done before him, in classical antiquity and the work of Italian Renaissance masters. On returning to London in July 1775, he took a lease on a grand town house on the south side of Cavendish Square, described in a contemporary advertisement as 'a large and commodious residence, with an elegant suite of five rooms on the first floor, and coach houses and stabling'.[3] This had formerly been the studio and home of the successful portrait painter Francis Cotes, and Romney clearly aimed to capitalize on such associations in establishing his own fashionable portrait practice. Within a few years, Romney's portraits were, to quote Horace Walpole, 'in great vogue'.[4] However, his aspirations, re-ignited by his experiences in Italy, to combine portraiture with subjects from literature and of the imagination, fell away under the pressure of more conventional portrait work.[5] Given these circumstances, Greville's decision

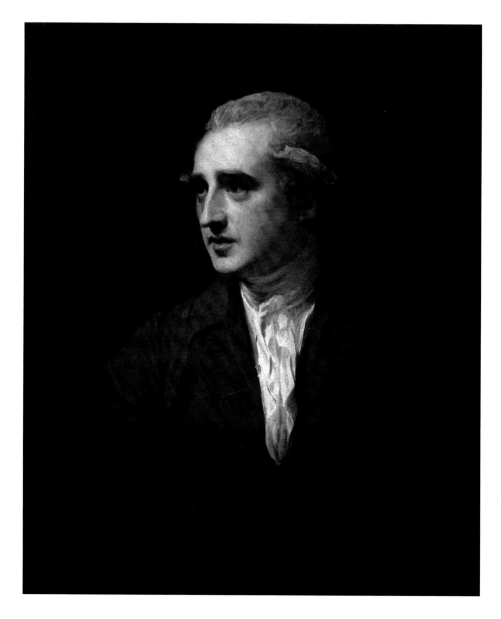

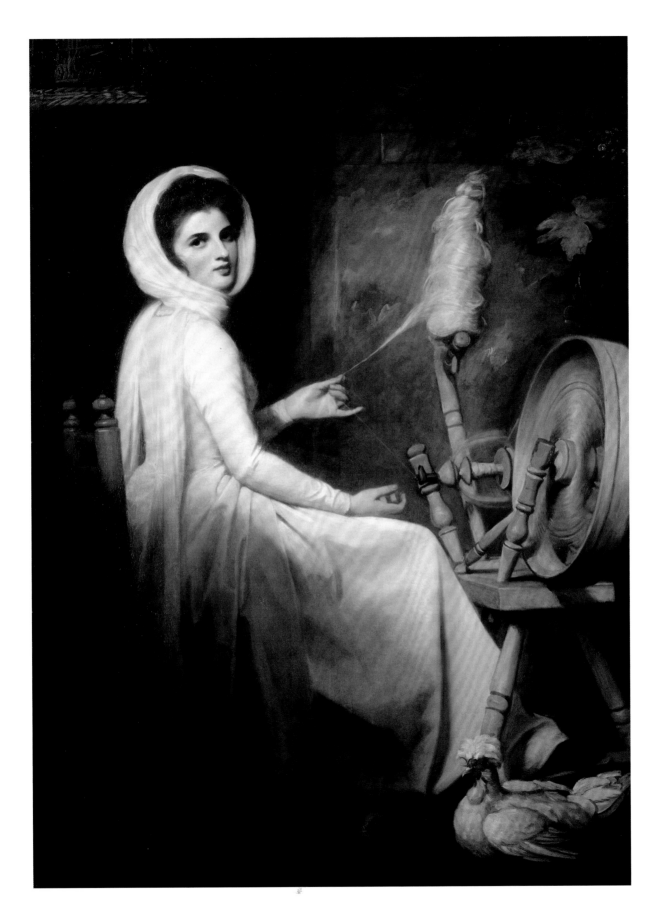

ROMNEY'S MUSE: A CREATIVE PARTNERSHIP IN PORTRAITURE

to introduce Emma to Romney was indeed timely and undoubtedly as much for the artist's benefit as hers. It worked: over and above her physical attractions, Emma's experiences at Drury Lane had awakened a flair for assuming theatrical poses and expressions. This chimed with Romney's own conception of picture making, allowing him to use her availability and versatility as a sitter to explore the emotional and the spontaneous to a far greater degree in his portraits and, by extension, his subject paintings. In turn, via the numerous sittings she attended in his studio over a nine-year period, Romney encouraged and nurtured Emma's talents – which she was to use

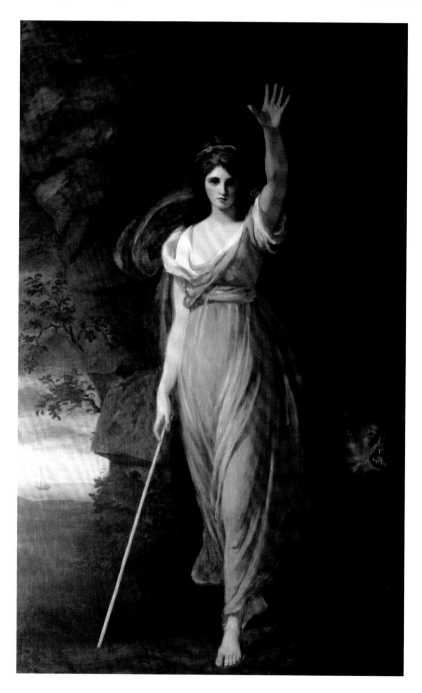

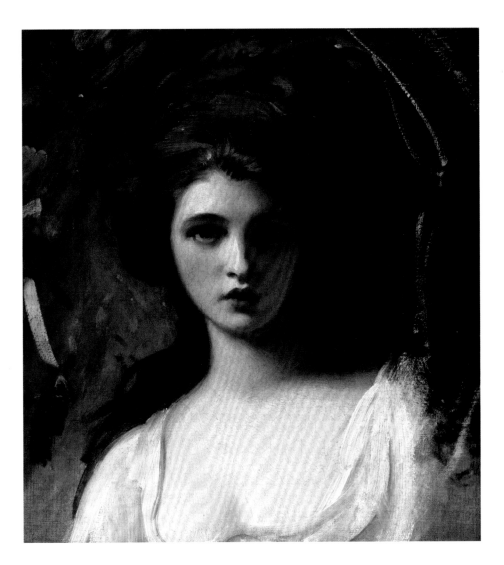

to such dramatic effect with her famous Attitudes – and at the same time exposed her to the cosmopolitan (if select) world of a successful London artist. The result was a series of more than seventy paintings that together are remarkable for their breadth, ambition and diversity, and among which *Emma as the Spinstress* and *Emma as Circe* (see pp. 66–67), to name but two, are some of Romney's most celebrated works.

The portraits of Emma fall into four main categories: society portraits, 'in character' representations, rapid 'unfinished' sketches, some of which are preparatory studies for larger-scale works (for example, the study of *Emma as Circe* above), and finally her portrait incorporated into subject or history paintings. These include the Shakespearean-themed paintings, *Titania, Puck and the Changeling* and *The Tempest*, in which Emma appears as Titania and Miranda respectively. While her impact across these different categories was, for Romney, profound, his representations of Emma also built upon the artist's existing portrait practice and responded to major interrelated trends in British art and culture at the time. The most important among these were, first, the

focus within elite culture on classical Greece and Rome; second, the strategic employment of actors, actresses and courtesans as sitters or characters in works of art; and third, the burgeoning celebrity culture, which was encouraged by the blatant publicity afforded by public exhibitions, press notices and reviews and the ever-expanding market for print reproductions.

Most of Romney's work in the 1770s followed Reynolds's theories, relayed in his annual Discourses, concerning generalized dress as a way of elevating portraits of contemporary sitters to the levels of history painting, then understood to be the most intellectually and technically demanding of all genres of art, and the most venerated, given its association with European Old Masters. It was, however, far less lucrative for contemporary British artists in comparison to portraiture. When looking at Emma in classical dress or assuming the role of a literary or mythological character, it is important to remember that the taste for classical art and culture brought an intellectual credibility to such images,

both for the artist and the sitter. This was garnered and reinforced by the Grand Tour, with Rome as its *locus classicus*, which was an elite and predominantly male cultural phenomenon that, importantly, overlapped with a more general interest in theatre and theatricality. Reynolds's ambitious pair of group portraits, painted in 1777–78, showing members of the Society of Dilettanti (including Greville and Sir William) examining antique gems and vases and toasting the recent scholarly achievements of Sir William himself, have come to define the eighteenth-century Grand Tour, both as a homosocial entity and as an intellectual enterprise – that is, in the case of the Dilettanti, in promoting Greek and Roman art and new work in the style.[6] One might suggest that Emma's oval face, with her large eyes, straight nose and perfectly shaped lips, framed by luscious auburn hair, not only conformed to eighteenth-century notions of female beauty but, along with her above-average height and statuesque physique, embodied the classical ideal in contemporary form, certainly in the minds of Romney, Greville, Sir William and others in their circle.

Timelessness in dress allowed artists like Romney to position themselves as modern exponents of a revered tradition. But it also allowed them a degree of licence, both in terms of the staging and accoutrements surrounding the sitter, such as classical urns, pillars and, more controversially, with the sensual and suggestive potential of classical dress. This was aligned with gestures and poses, often based on classical figures whether sculpted or painted, the use of which could be modulated according to the sitter's social status or indeed profession. As an example, Romney exhibited an austere portrait in 1771, *Mrs Mary Yates as the Tragic Muse*. The actress is shown in simple robes personifying Melpomene, the classical muse of Tragedy, whose attributes of the cup and the dagger she holds. It is an ambitious full-length image of a public figure and clearly anticipates Romney's representation of Emma as Circe, the beautiful goddess of magic and the enchantress of Homer's *Odyssey*, which was painted over a decade later.[7]

Romney's encouragement of the fashion for looser, more flimsy and diaphanous costumes in female portraiture – what was called the 'Grecian' style – also allowed him to accentuate the shape of the bodies beneath. While this would be used to provocative effect in *Emma as a bacchante* (see p. 23) and *Emma as Calypso* (1791–92), the wider appeal of this mode of representation is clearly demonstrated by Romney's more restrained and thus 'polite' classical portrayals of Lady Anne Gower in *The Gower Children* (c. 1777), and *Elizabeth Warren as Hebe* (c. 1775), both executed after his trip to Italy, and prior to meeting Emma. In appraising *Emma as Circe*, therefore, it should be noted that Romney had previously tackled the portrayal of Circe in a portrait of Mrs Forster dated 1776, which remained in his possession, and that Reynolds had painted Mrs Mary Nesbitt as Circe, in 1781.[8] It was this transference between idealized and contemporary worlds, between portraiture and history painting, and between

ROMNEY'S MUSE: A CREATIVE PARTNERSHIP IN PORTRAITURE

the theatre, polite society and the *demi-monde* that was vital to the power and success of the classicizing idiom. Furthermore, the examples above remind us that it was not only *who* the sitter was representing that mattered, albeit that it would be rare indeed for a member of polite society to be represented as a bacchante (as Emma was on at least five separate occasions) but *how* the sitter was being represented in that role, through pose, dress and expression, whether they be Circe or Hebe, ancient priestess or a female votary of Bacchus.

Using the fame and notoriety of actresses and courtesans to enhance an artist's reputation and career prospects (and vice versa) was well established in this period, and was exploited by the likes of Reynolds from the 1750s onwards. His straightforward society portraits of the celebrated courtesans Nelly O'Brien and Kitty Fisher, which were widely disseminated as images through engravings, were more than a hint for Romney in his comparable portraits of

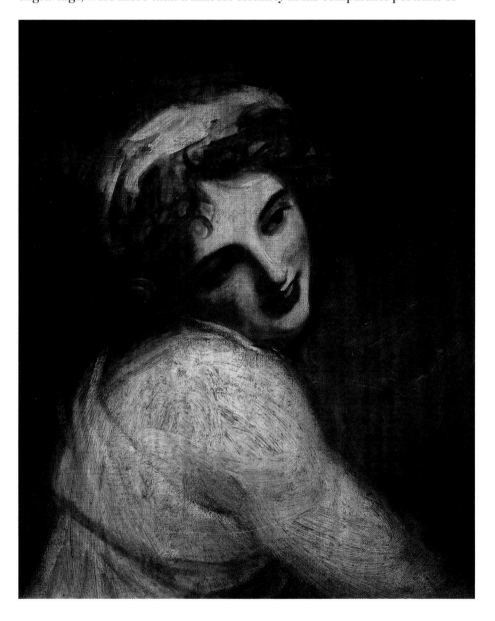

Emma; for example, that of her in a fashionable straw hat, painted for Greville, and another in morning dress (see p. 19), bought by Sir William Hamilton in 1786. As Nadia Tscherny has suggested, such portraits may in turn have influenced commissions from more respectable sitters with, of course, the sexuality and seductiveness of Emma's portraits significantly 'toned down'.[9] However, Reynolds's *Kitty Fisher as Cleopatra Dissolving the Pearl* (1759) underlined the artistic potential of aligning a contemporary figure with the allure of a seductress from ancient history. While Romney would have been familiar with this portrait (it was engraved twice in 1759), in the case of *Emma as Circe,* painted in 1782, he had more contemporary and directly relevant examples by Reynolds to respond to.

The first of these is the aforementioned portrait of Mrs Nesbitt as Circe. The sitter, whose life was shrouded in mystery and scandal, was at the time of Reynolds's portrait a widow and the mistress of Augustus John Hervey, third Earl of Bristol. These circumstances are alluded to via her representation as the enigmatic seducer of Odysseus. Looking out towards the viewer, she is attended by a docile leopard, monkey and domestic cat, signifying the powerful men she has transformed through magic into captive animals. The other painting is *Thaïs,* which had enjoyed a *succès de scandale* at the Royal Academy annual exhibition in 1781. The public furore surrounding the painting was, first of all, based on Reynolds's daring full-length representation of the famous Athenian courtesan and lover of Alexander the Great. Thaïs is shown stepping forward, her classical dress provocatively clinging to her body and falling away to reveal her thigh, with her bare arms aloft, one holding a flaming torch, as she calls out for the ancient palace of Persepolis to be set alight (the subject was taken from Dryden's poem 'Alexander's Feast'). Appearing tousled and euphoric, the figure represents the very antithesis of what would have been considered appropriate at the time for an aristocrat and arguably even an actress.

The assumption, therefore, that such a flagrantly exposed and seductive figure represented a contemporary Thaïs – a name then in popular use to denote a prostitute – resulted in speculation surrounding the identity of the sitter herself. This was Emily Bertie Pott (also known as Emily Warren and Emily Coventry) who had been Greville's mistress before Emma. According to the novelist and diarist Fanny Burney, who had seen *Thaïs* on display in Reynolds's studio, it had been painted for Greville, and he certainly acquired it from the artist in about 1786–87.[10] Romney had produced a significantly more chaste society portrait of Emily in 1781, commissioned by her new lover and protector Robert Pott.[11] But this complex and literally 'show-stopping' image by Reynolds must have struck Romney as an exemplar in just how far one might push the boundary between portraiture and history painting.[12] Thus it is highly likely that Romney's *Circe* was conceived as a kind of companion painting or (given his professional rivalry with Reynolds and given that both sitters were associated with Greville) as a deliberate and spirited riposte to *Thaïs.* Both

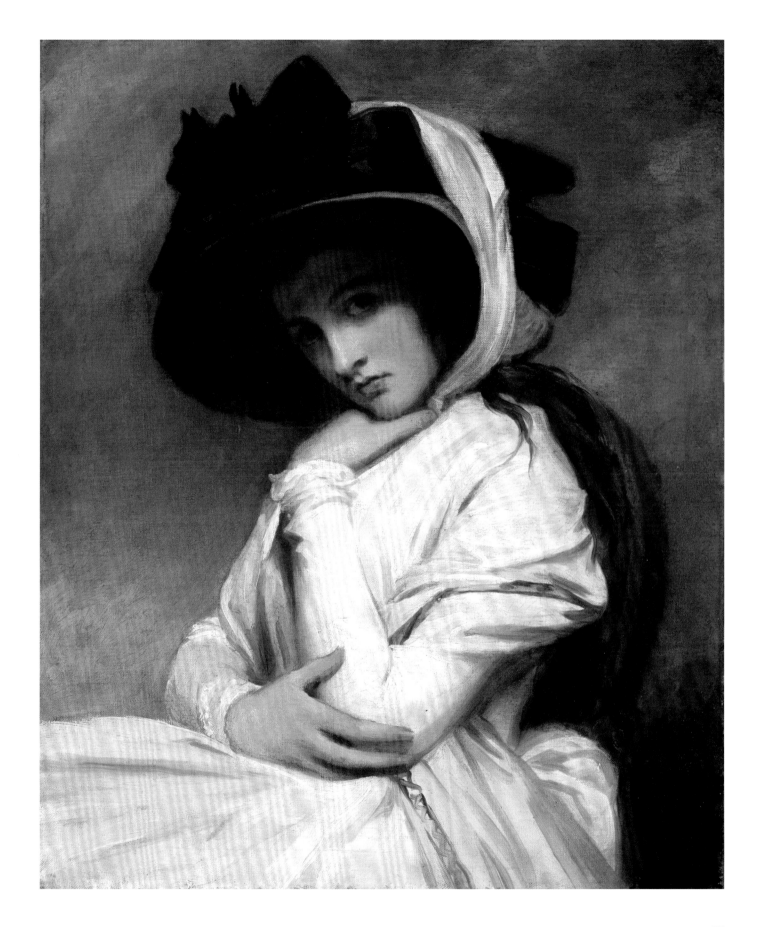

figures are full-length, monumental and striking. Emma too steps forward, her body outlined by the folds of her diaphanous gown. With one arm extended, she makes a gesture suggestive of casting spells, while the other arm holds a wand pointing towards the ground. She stares straight ahead, seemingly mesmerized by her magical powers. Unlike Reynolds's *Thaïs*, Circe is in command of herself and in control of the viewer.

Importantly, *Circe* was Romney's first portrait of Emma as a figure from literature and mythology, and was executed at a time when very few people would have known who Emma was. While the portrayal of actresses and other public figures often played on the existing fame and thus familiarity of the sitter, Romney's early portraits of Emma did the reverse. In the case of print culture, as Tim Clayton has noted, 'generally, sitters became celebrities and then prints were made of them'. 'Very occasionally', he continues, 'the print made the celebrity. This was the case with the prostitute Emma Hart…who made her "celebrity" début through prints.' The images in question were after Romney's *Emma as Nature*, his first portrait of her and at this time owned by Sir William, who had also commissioned *Emma as a bacchante* from Reynolds (see p. 111). John Raphael Smith engraved both paintings in 1784 (see the first on p. 96), issued in similar formats and sizes, so as to invite direct comparison and encourage the purchase of the two as paired images.[13] In the meantime, as Greville's mistress, Emma was tucked discreetly away off Edgware Road, the house he provided for her in 1782–86, which was then a semi-rural location on the outskirts of the city. Her personal isolation from society juxtaposed with her display in various guises through Romney's paintings (and the comparatively few prints made after them) would have intrigued and tantalized a contemporary audience, just as the identity of Emily Pott as Thaïs had done in 1781. Whereas actresses were by their very nature accessible to the public, the clandestine world of the 'kept woman' was relatively hidden and thus encouraged speculation.

This apparent contradiction in Emma's visibility within society had as much to do with Romney and the manner in which he conducted his career as it did with Greville's desire to manage Emma's public profile and his personal affairs. In fact, while Romney's professional life mirrored other successful artists at the time, it differed in several important ways. First and foremost, this is demonstrated by Romney's absence from public exhibitions after 1772. This is striking given how proactive other artists were in this arena. For example, between 1760 and 1790, to use Martin Postle's calculations, Reynolds exhibited 268 works in public exhibitions, 243 of these at the Royal Academy.[14] Thomas Gainsborough exhibited thirteen paintings at the Royal Academy alone in 1778, and eleven in 1782. In striking contrast, Romney exhibited fifteen works at the Free Society of Artists between 1763 and 1769, ten at the Society of Artists from 1770 to 1772, and not one at the Royal Academy. Furthermore, Romney never became a Royal Academician and, uncommonly at the time, he was largely indifferent to having his paintings translated into print format.[15] Thus

Sir Joshua Reynolds
Thaïs, 1781
Oil on canvas
Waddesdon,
The Rothschild Collection
(The National Trust)
2556

ROMNEY'S MUSE: A CREATIVE PARTNERSHIP IN PORTRAITURE

he did not actively seek a public role through exhibitions and reviews, through membership of the Royal Academy, or through the publicity afforded by the lucrative print market, in the same way as did his contemporaries and rivals Reynolds, Gainsborough and others. Therefore, none of Romney's paintings of Emma were exhibited in any public exhibitions during his or her lifetime, including at the Royal Academy. Since its establishment in 1768 under the presidency of Reynolds, this had become the premier contemporary art forum in Britain, and its annual exhibition was one of the leading social events in the London calendar. In contrast, Reynolds's *Emma as a bacchante* (see p. 111), commissioned by Sir William in 1783, was exhibited at the Academy in 1784. Romney's only exception to his general public absence was his large-scale history painting, *The Tempest*, which was exhibited in the Boydell Shakespeare Gallery in Pall Mall between 1790 and 1805, and for which Emma (as well as William Hayley as Prospero) was a model.

That exhibiting was integral to the role of an artist is suggested by the following comment, published in the *Public Advertiser*, which states that 'Romney, as of late he has always affected to be, remains absent from his duty. This is either a monstrous affectation, absurd perverseness, or erroneous timidity.'[16] Even so, his friends, William Hayley and John Flaxman, the sculptor, thought that membership of the Royal Academy would be too taxing for Romney's temperament. For it was an arena of direct and fierce competition

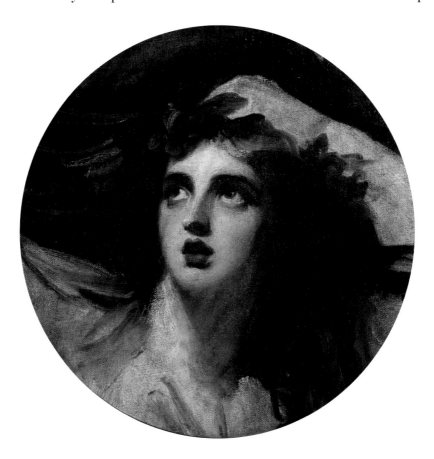

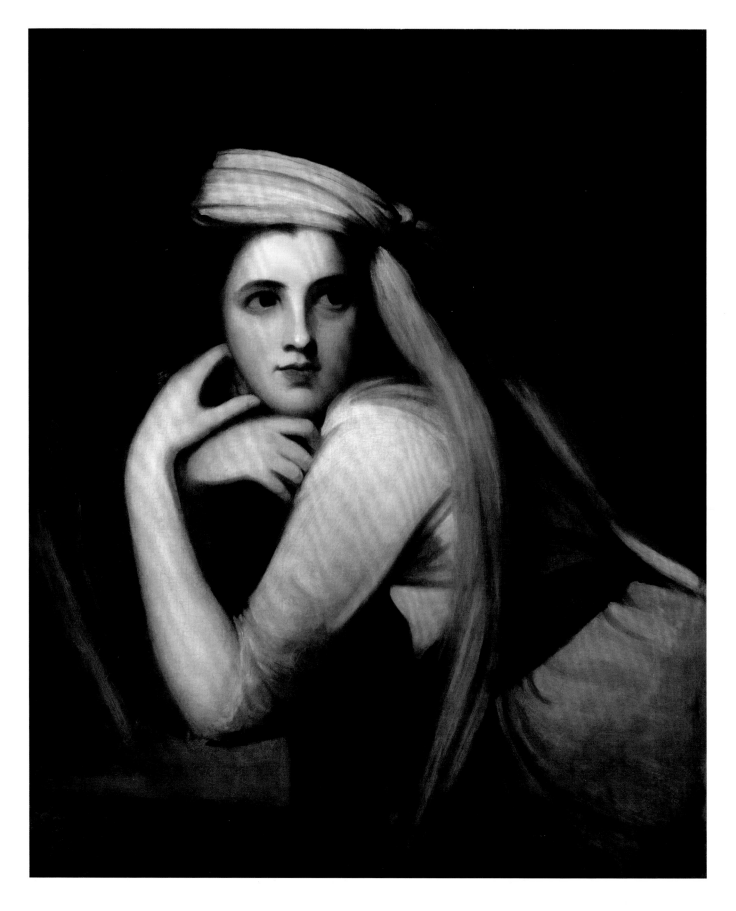

ROMNEY'S MUSE: A CREATIVE PARTNERSHIP IN PORTRAITURE

with fellow artists, and entailed the added potential pressure of playing an official role within it, all problematic for Romney given his susceptibility to periods of depression. While Romney painted a number of self-portraits, it is the one painted in about 1782 and now in the collection of the National Portrait Gallery (see p. 64) that reveals so much about him. Indeed, the art historian Alex Kidson has described the image as 'fearlessly honest in its self-exposure of a man moody and suspicious, withdrawn and defensive.'[17] This extraordinary candour is perhaps explained by the fact that the portrait was not painted as a public statement but for his intimate friend Hayley, and (according to John Romney, the artist's son) was left unfinished at Hayley's request. Consequently, the viewer's eye is drawn emphatically towards the more finished head and expression of the sitter, which in turn seems to add to the psychological intensity of the whole image.

A telling episode in Romney's life in this regard, which occurred not long after meeting Emma, concerns an unfinished portrait of the Queen of Tragedy, Sarah Siddons. As the 1782–83 London theatre season was coming to an end, Siddons – the most fêted actress in London – decided to capitalize on her newly found celebrity by having her portrait painted by a London-based artist. Romney was the first she approached for what was meant to be a grand, full-length portrait. By mid-March 1783, newspaper reports began to appear, needling the artist over the portrait's non-appearance. Perhaps feeling pressured by the attention his newsworthy sitter drew, who may also have insisted on another full-length portrait and, furthermore, for one or both to be exhibited at the Royal Academy, Romney seems 'to have developed stage fright' and failed to finish either of them.[18] No doubt exasperated, Siddons then moved on to Reynolds, whose *Sarah Siddons as the Tragic Muse* caused a sensation at the Royal Academy in 1784; and the year after that, Thomas Gainsborough also completed his glamorous society portrait of Siddons. In comparison with the demanding and formidable Sarah, Emma must have seemed a tonic to such a temperamental and introverted artist, since she was by nature lively, uncomplicated and 'keenly sensitive to the needs and demands of every man she came into contact with'.[19] At the same time, she was an isolated figure, not a public figure like Siddons, which was a distinct advantage (and no doubt a relief) to the artistically ambitious but socially disconnected Romney.

Given all this, the burning question of the moment is how would a wider public have engaged with Romney's multiple images of Emma? Or was this extraordinary artistic enterprise an essentially private affair between the artist, Emma herself, and close acquaintances, above all Charles Greville and Sir William Hamilton? As previously noted, contemporary prints (albeit relatively few in number) were available, for example, after *Emma as Nature* and *Emma as the Spinstress*. In his honest assessment of Romney taking on a more public role as an artist, Hayley had concluded that he would be better off 'confining the display of his works...to the circle of his own domestic gallery'.[20] This is indeed

what happened: Romney's house and studio not only operated as a powerful sign of confidence in his own ability and status, but also as a retreat, where he could manage more effectively his own exposure to the public gaze. Considering that the majority of his encounters with Emma occurred in this space, we can assume that it was of primary importance to their relationship, personal and professional, and by extension to Emma's wider education and 'rehabilitation' into society. It would be completely false, therefore, to view an artist's house during the eighteenth century as a private space, and it was commonplace for a fashionable portrait painter to have an impressive studio (or painting room) that functioned both as a place of work and as a semi-social location.[21] Romney's house itself had a large studio and a private gallery in which casual visitors, sitters attending appointments and prospective clients – often accompanied by family members and friends – could view completed works and collections of engravings. Elsewhere in the house could be seen Romney's *Providence Brooding over Chaos* and his copy of Raphael's *Transfiguration*. Furthermore, like many of his contemporaries, Romney collected copies of Old Masters, in his case after Rembrandt, Raphael, Titian, Veronese, Poussin, Murillo, Rubens and Van Dyck. By 1783, no fewer than sixteen portrait painters exhibiting at the Royal Academy were to give their addresses as Cavendish Square. Romney's presence nearby would have been part of the location's attractions, as well as its proximity to a wealthy clientele.[22]

Although most significant artistic figures would have had similar establishments, Romney's socially insecure and exhibition-shy character may have had its advantages (intended or otherwise) in the crowded and competitive London art world. As Alex Kidson has argued, what Romney offered at Cavendish Square was an alternative, more exclusive relationship with sitters and patrons, that some may well have found appealing.[23] Even Romney's indifference to having his works engraved would have added to this air of exclusivity. Perhaps as time went on and public awareness of the beautiful and mysterious Emma Hart grew, there would have been an added frisson for visitors to his house, when they encountered her in person or on canvas within a high-status but essentially domestic setting. This would be in direct contrast to her image being available for all to see, but competing with hundreds of other works of art, on the walls of the Royal Academy and elsewhere. All of Romney's paintings of Emma would have been displayed in his house at some point, whether as finished articles or works in progress. In 1792, for example, he wrote to Emma, when she was in Naples, informing her that George, Prince of Wales, had asked the artist Benjamin West to visit his studio to inspect the prince's two commissions, *Emma as Calypso* and *Emma as a Magdalene*.[24] A number of other works remained with Romney for many years, or until his death in 1802. The latter category includes *Emma as Absence*, *Emma as a bacchante*, *Emma at prayer* and *Titania, Puck and the Changeling*. It also includes *Circe*, along with its associated portrait sketch, now in the Tate Collection. In his biography

of Romney, published in 1809, Hayley quoted a letter from the poet Anna Seward, who, during a visit to the artist's house in August 1782, described the 'very powerful impression made by this picture on a party who then surveyed it'.[25] Given this response, one can imagine how the accrual of Emma images over time might have led to their visual dominance within the house. Some measure of the impact of such a display is suggested by an account published in *The World* in 1787 concerning 'studies of Emma Hart', when she was at this time in Italy, staying with Sir William. 'The female heads of Romney', the writer noted,

> are in general touched with a very tender and bewitching hand. Wherever his subject will carry he can go very far indeed. To exemplify let us take (as we wish we could without paying) any of the dozen portraits he has done of Mrs. Hart – with the hat

tied under her chin, with the spinning wheel, with the loose hair and uplifted eye – or the new picture now in the room. They are full of captivation, and of captivation independent of the portrait. Of these any might have gone abroad with Sir W. Hamilton and answered his purposes full as well as the piece he has taken with him, a piece more cumbrous and chargeable than any of the foregoing.[26]

Importantly, Romney's house was not only the focus of his artistic practice but also (as Hayley later described it) 'a favourite scene of general resort'.[27] During the 1780s, for example, both Hayley and Richard Cumberland performed readings from new literary works to select companies at Cavendish Square, and it seems likely that Emma, too, would have participated or even performed at such a gathering prior to her engagement to Sir William.

The idea of Emma being 'improved' by such company is perhaps best demonstrated by Hayley's *Triumphs of Temper*, which was written and published in 1781. This mock-epic poem tells the story of Serena, whose sweet temper and good humour sustains her through a series of tribulations for which she is rewarded with a happy marriage. The poem was extremely popular, running into six editions within eight years. The author's wider ambitions, to teach adolescent girls how to become accomplished wives, were set out in the preface, where Hayley comments that his work represented 'the most delicate raillery on Female Foibles' but hoped that it might 'also aspire to delineate the more engaging features of Female Excellence'.[28] 'On these principles,' he continues, 'I have endeavoured to paint SERENA as a most lovely, engaging, and accomplished character; yet I hope the colouring is so faithfully copied from *general Nature* that every man, who reads the Poem, may be happy enough to know many Fair ones, who resemble my Heroine.'[29] Romney painted a number of responses to Hayley's poem, including *Serena in the Boat of Apathy* (1784–85) with Emma as the model. In 1791, now Lady Hamilton, Emma wrote to Romney saying, 'Tell Hayly I am allways reading his *Triumphs of Temper*; it was *that* that made me Lady H., for God knows, I had for 5 years enough to try my temper, and I am affraid if it had not been for the good example Serena taught me, my girdle would have burst, and if it had I had been undone, for Sir W. minds more temper than beauty.'[30] Given Emma's talent for role-playing and the parallels one might draw between her character and that of the fictitious Serena, it is unsurprising that there has been some slippage between their identities in Romney's paintings. *Emma reading the gazette*, which was given by the artist to Hayley in 1798, has in the past been described as representing Serena, in part because the intense expression of her face was deemed more appropriate to a subject painting than a society portrait. In fact, this animated sketch most likely represents Emma, wearing fashionable day dress, during a visit to Romney's house.

As the author of *The Triumphs of Temper*, the fact that the painting was eventually in Hayley's possession may equally explain this slippage. In any case, such interrelated identities and circumstances neatly underscore the

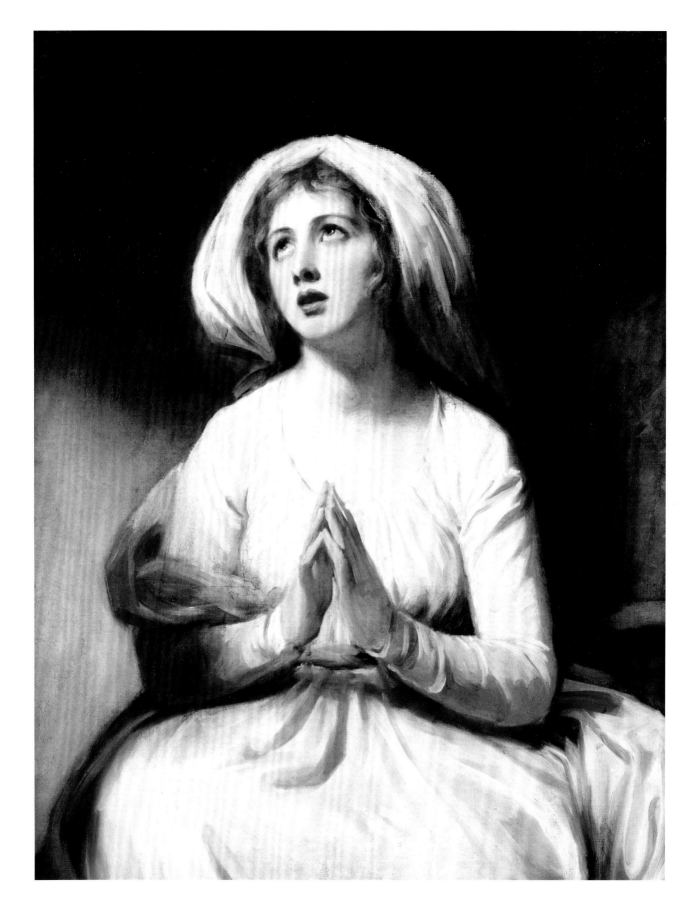

collaborative nature behind many of Romney's images of Emma. Hayley later claimed to have influenced the gestation of another work that he was to own, *Emma as Sensibility*, which was probably painted prior to Emma leaving on her first departure to Naples in 1786. 'During my visit to Romney in November,' Hayley writes,

> I happened to find him one morning contemplating by himself, a recently coloured head on a small canvas. I expressed my admiration of his unfinished work in the following terms:– 'This is a most happy beginning: you never painted a female head with such exquisite expression; you have only to enlarge your canvas, introduce the shrub mimosa, growing in a vase, with a hand of this figure approaching its leaves, and you may call your picture a personification of Sensibility.'[31]

While Hayley's comments offer us insights into *Sensibility* as a kind of joint venture between friends, there is very little evidence to suggest how *Emma as the Spinstress* (see p. 66), arguably Romney's most celebrated (and certainly his most enigmatic) image of Emma, was created. Commissioned by Greville

Right
George Romney
Emma reading the gazette, 1780s
Oil on canvas
Albright-Knox Art Gallery
A389651

Opposite
George Romney
Emma as Sensibility, 1780s
Oil on canvas
Jean Johnson Kislak Collection
1989.015.00.0001

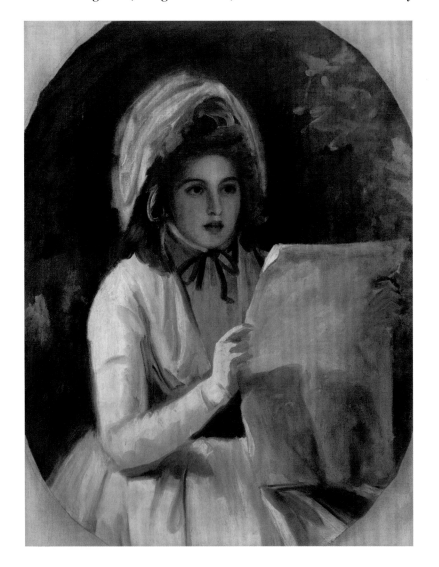

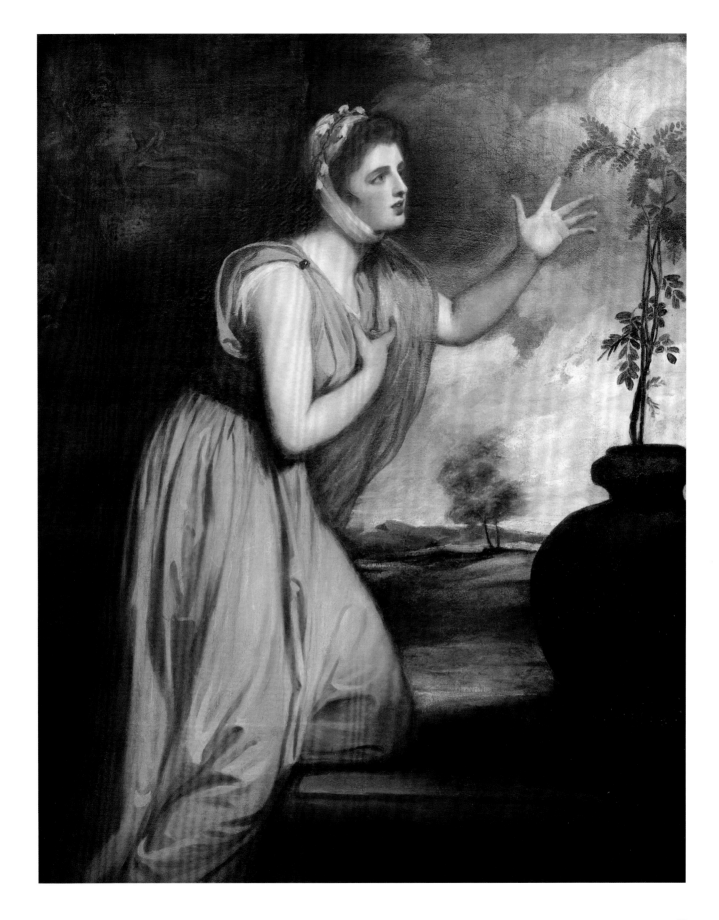

in about 1784, the painting allegedly came out of the only recorded visit Romney made to Emma's house, with its small garden, off Edgware Road. This may (as suggested by Alex Kidson) have been simply an invitation to breakfast with Emma, her mother and Greville, rather than a formal sitting. Certainly the interior, the hen and chicks in the foreground and the occupation of spinning, collectively suggest a rural location, as does (at Greville's insistence) Emma's social isolation and 'frugal existence of exemplary domestic virtue'.[32] While her dramatic white dress and demurely arranged headscarf seem to chime with the vogue for timelessness in contemporary paintings, the play between the chaste and the alluring – exemplified by her ambiguous expression and the potential sexual innuendo of her hands gently fingering the thread – also links the canvas to Dutch seventeenth-century genre painting and more contemporary domestic scenes by French artists such as Jean-Siméon Chardin and Jean-Baptiste Greuze. Equally, the image may recall Emma's humble beginnings, at the very point at which her role in life and art was being crafted and transformed.

That the *Spinstress* came out of a discussion between Greville, Hayley, Romney and perhaps Emma, is suggested by a pencil and wash sketch now in the British Museum. Emma, seated to the right with a spinning wheel, looks back at Greville (standing), Hayley (seated) and Romney (seated and sketching). The composition has the look of an eighteenth-century conversation piece and has reminiscences of Romney's earlier portrait of his brothers, Peter and James (1766), shown in an artist's studio discussing Euclid, with classical busts and figures displayed nearby. Both images play on pictorial conventions then associated with connoisseurs and intellectuals, such as the portraits of the Society of Dilettanti already mentioned. Here it is Emma, however, as the living embodiment of an aesthetic ideal, who is the object of conversation. Given that in the finished painting, Emma's pose and glance over her shoulder

Emma Hart

Account book, 1784–85
Jean Johnson Kislak Collection
1990.035.00.0003

This ledger recording her expenses demonstrates Emma's attentiveness to the injunctions of her lover, Charles Greville, that she should adopt habits of parsimonious and blameless domesticity in the house he provided for her off the Edgware Road.

is similar to Greville, Hayley and Romney's viewpoint of her in the sketch, we, too, can imagine ourselves in the roles of the artist, protector and connoisseur.

The specific meaning of *Emma as the Spinstress* may well remain a mystery and as such encapsulates the private and privileged world that created it. It also demonstrates Emma's facility in taking on different roles and characterizations, and the licence with which Romney – in dialogue with Greville and others – capitalized on both her talents and her ambiguous position in society. Despite living in relative seclusion under Greville's protection, Emma had already acquired a reputation among male connoisseurs of female beauty. This would continue, both through the transferral of her physical self from Greville to Sir William, from London to Naples, and of her image, whether in painted or engraved form. *Emma as a bacchante* and *Emma as Nature,* for example, hung together in Sir William's house, the Palazzo Sessa, in Naples, and in 1810, *Emma as Calypso* and *Emma as a Magdalene* were given by the Prince of Wales to his friend Francis, third Marquess of Hertford, a renowned art collector and debauchee.

Although Romney would continue to paint Emma from memory, *Emma as the Ambassadress* (see p. 136) was the last portrait for which she sat prior to her departure for Naples in 1791. Every inch the fashionable society lady and bride to be, Emma's future is no longer the confined existence of the Edgware Road, symbolically represented in the *Spinstress,* but the very public and dynamic world of Naples, symbolized in the picture by Vesuvius erupting. As a sign of just how far she had come, it is highly appropriate that the painting should have been created as a gift for Mrs Cadogan, Emma's mother. While Emma would always be grateful to Romney, there is no doubt that by 1791 she had

George Romney
Group drawing, *c.* 1784
Pen and ink with wash
and graphite
British Museum
19,140,216.10

The figures are usually
identified as (from left
to right): Charles Greville,
William Hayley, George
Romney and Emma Hart.

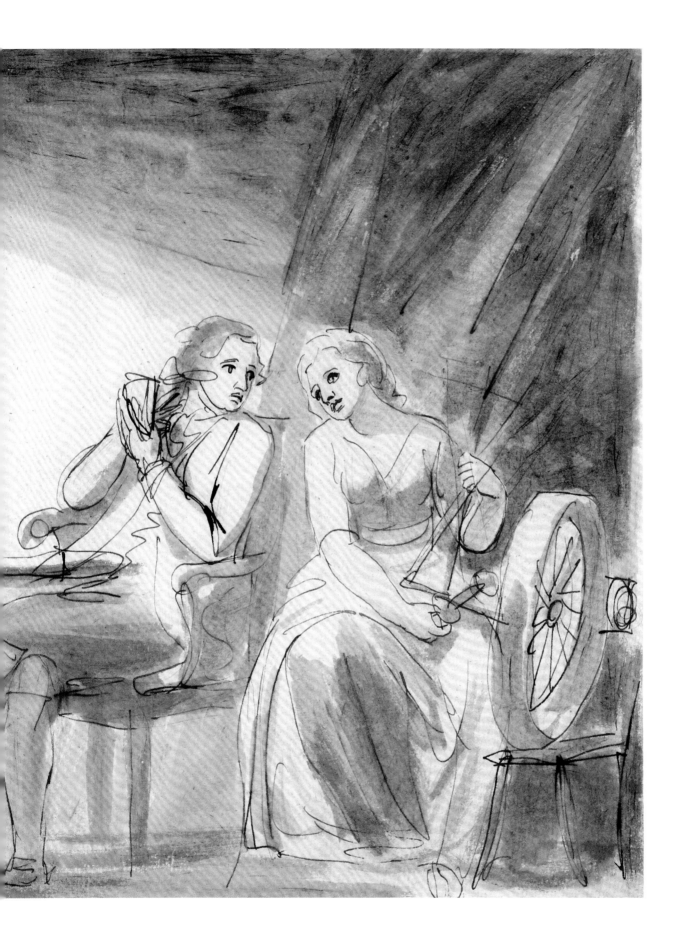

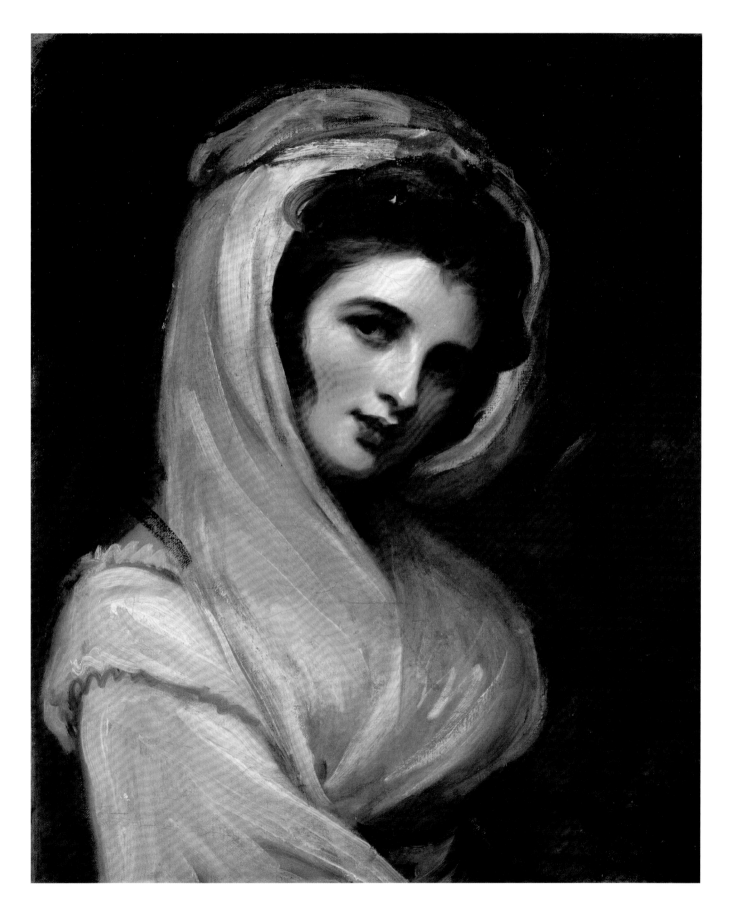

ROMNEY'S MUSE: A CREATIVE PARTNERSHIP IN PORTRAITURE

moved on from their relationship and could now exercise, to a degree, self-will and determination. Romney's infatuation with Emma sprang from and centred upon their meetings in his studio at Cavendish Square, and her reduced dependency and prolonged physical absence from his life undoubtedly caused him personal anguish. At the same time, however, he seems to have felt genuine pride in her transformation, in which he had, of course, played an integral part. In a letter to Hayley, Romney described a social gathering held in August 1791, just prior to Emma's marriage. 'She performed in my house last week', he writes:

> singing and acting before some of the nobility with the most astonishing powers: she is the talk of the whole town, and really surpasses every thing both in singing and acting, that ever appeared. Gallini offered her two thousand pounds a year, and two benefits, if she would engage with him, on which Sir William said pleasantly, that he had engaged her for life.[33]

Picturing Personas: Emma, George Romney and the Portrait Print

Emma Hart met George Romney in April 1782: she was sixteen and a statuesque beauty; he was forty-seven and reaching the height of his powers. Over the next four years, Romney painted Emma in scores of finished and unfinished portraits, responding to her allure and extraordinary ability to translate a range of different allegorical, mythological and literary personas into legible and dramatic form. As Romney's captivating muse, Emma became the artist's principal focus, sometimes to the cost of other commissions, but the portraits of her were among the most vivid of the later part of his career. Although Emma's departure for Naples in 1786 hit Romney hard, he continued to paint her. The two were reunited, albeit briefly, when she travelled back to London in 1791 for her marriage to Sir William Hamilton. Romney's last portrait of Emma, on this occasion as the Ambassadress, signalled her move into a different world with a new role and a further set of guises. Returning to Naples as Lady Hamilton, she left Romney for the last time; surrounded by Emma's likeness in his studio, he would never see her again.

While Romney's portraits of Emma delighted her wealthy admirers and those enchanted by the artist's fashionable style, her image was also brought within the grasp of a much wider public through prints. Although Romney did not court the print market with the enthusiasm of some of his artist contemporaries, many of his works were reproduced in this medium, and doubtless appealed across a wide spectrum of taste. Indeed, as a chameleon-like figure Emma defied easy stereotypes. Amid the continental views, classical landscapes and bawdy caricatures displayed in printsellers' windows, Emma jostled with actresses, admirals and aristocrats to catch the appreciative gaze of a discerning buyer or the roving eye of a man about town. Through prints, her face became famous; only later, with the growing reputation of the Attitudes and her intriguingly elevated social status as Lady Hamilton, did Emma's celebrity move beyond her image to encompass a public interest in her life.

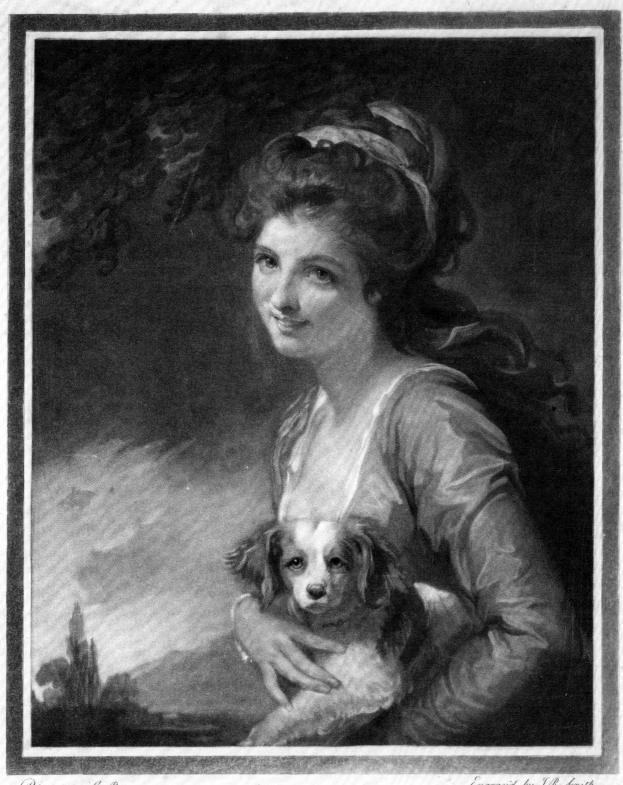

Painted by G. Romney

Engrav'd by J R Smith.
Mezzotinto Engraver to his Royal
Highness the Prince of Wales.

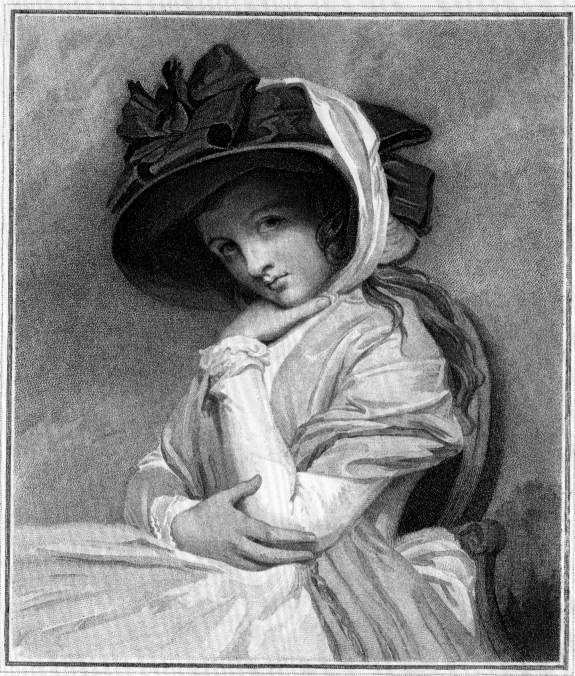

Painted by G. Romney.

Engrav'd by Jn.º Jones.

EMMA.

London Pub.d as the Act directs, Dec.r 1, 1785, by J. Jones, N.º 63, S.t Portland Street.

George Romney. Pinxit.

PICTURING PERSONAS: EMMA, GEORGE ROMNEY AND THE PORTRAIT PRINT

Rich.ª Earlom Sculpsit.

Left
**Richard Earlom after
George Romney**
Emma as Alope, 1787
Stipple with etching
National Maritime Museum
PAJ4032

Overleaf, left
**George Keating after
George Romney**
Emma as St Cecilia, 1789
Stipple engraving
National Maritime Museum
PAG6643

Overleaf, right
**Richard Earlom after
George Romney**
Sensibility, 1789
Stipple with etching
National Maritime Museum
SUT/2

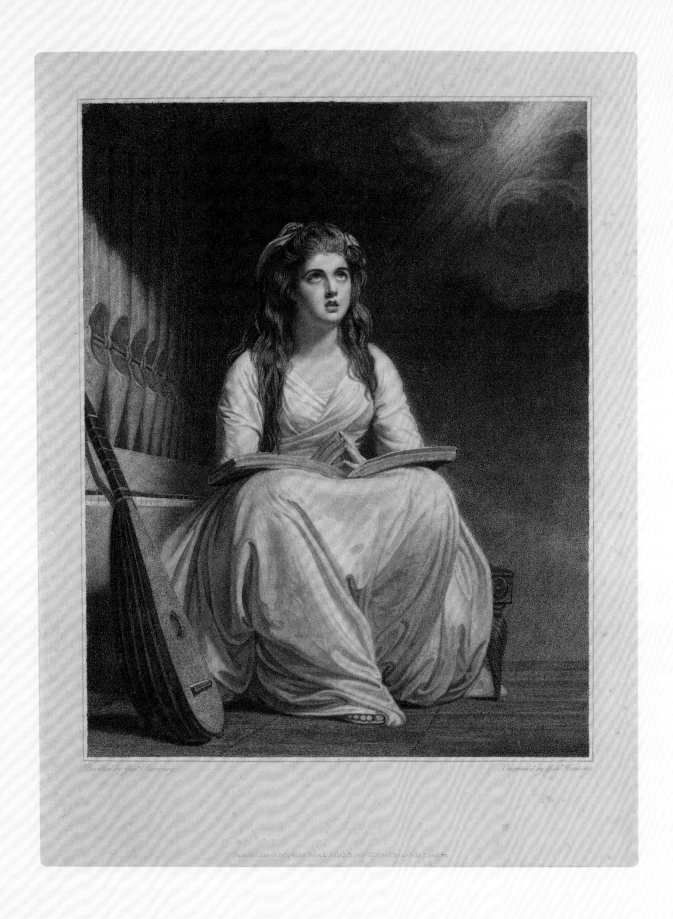

Painted by Geo.ᵉ Romney Engrav'd by Geo.ᵉ Keating

Published March 25.ᵗʰ 1794 by John & Josiah Boydell Cheapside London

Painted by George Romney.　　　　　　　Engrav'd by R.d Earlom.

SENSIBILITY.

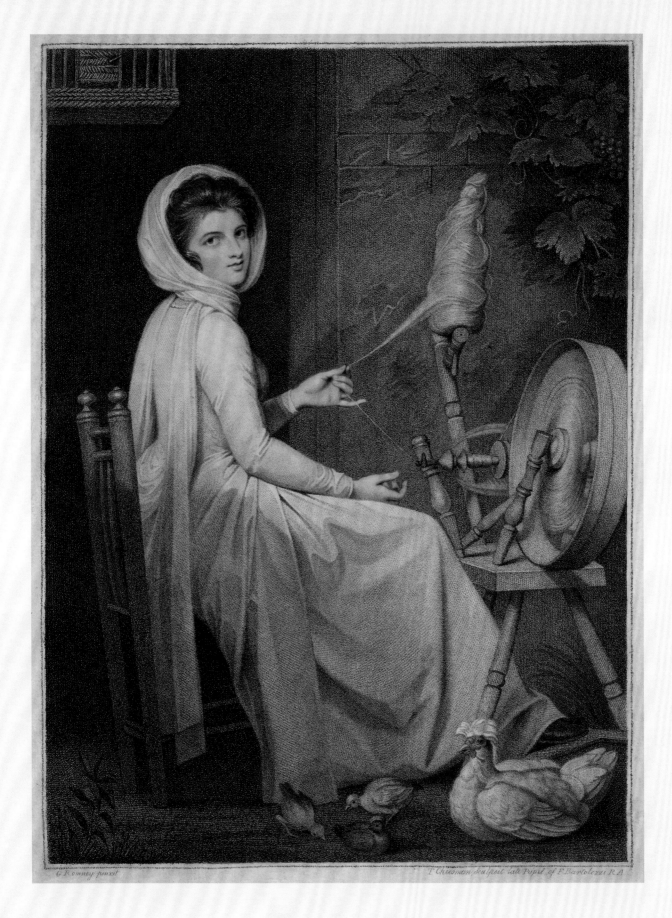

G Romney pinxt

T Cheesman Sculpsit late Pupil of F.Bartolozzi R.A.

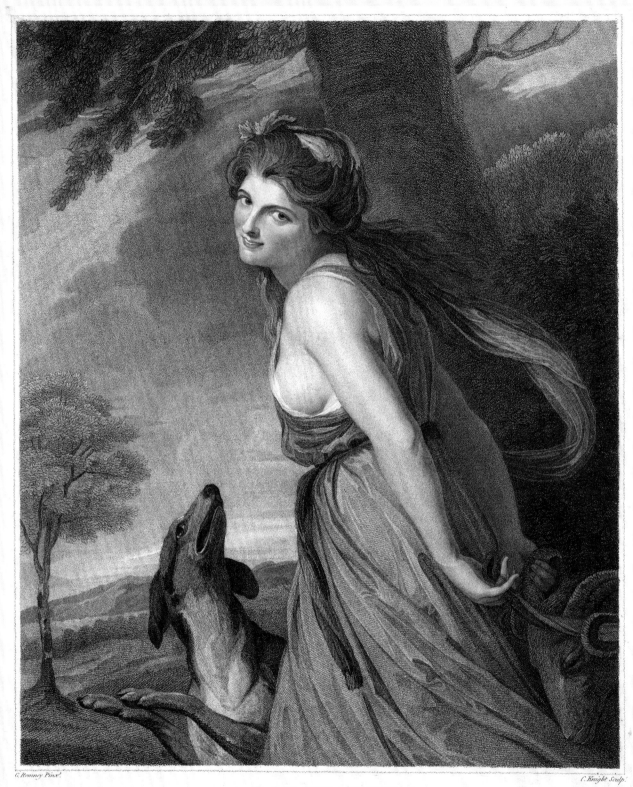

G. Romney Pinx.^t C. Knight Sculp.^t

BACCHANTE.

Engraved from a Picture in the Possession of S.^r W.^m Hamilton.

London, Pub. by C. Knight at M.^r Bradshaw's Brewer Street.
June 17, 1797.

J. Paget

Preceding pages, left
Thomas Cheesman after
George Romney
Emma as the Spinstress,
late eighteenth century
Stipple
National Maritime Museum
SUT/2

Preceding pages, right
Charles Knight after
George Romney
Bacchante, 1797
Stipple engraving
National Maritime Museum
PAG6663

Below
Benjamin Smith after
George Romney
Shakespeare nursed by
Tragedy and Comedy, 1803
Stipple engraving
National Maritime Museum
PAG6659

Opposite
Caroline Watson after
George Romney
Cassandra, 1809
Stipple engraving
National Maritime Museum
PAF3632

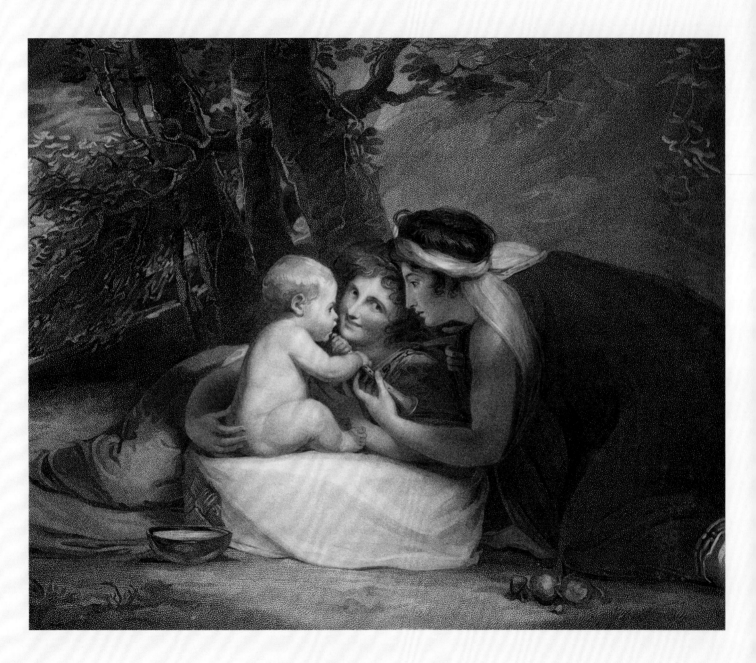

PICTURING PERSONAS: EMMA, GEORGE ROMNEY AND THE PORTRAIT PRINT

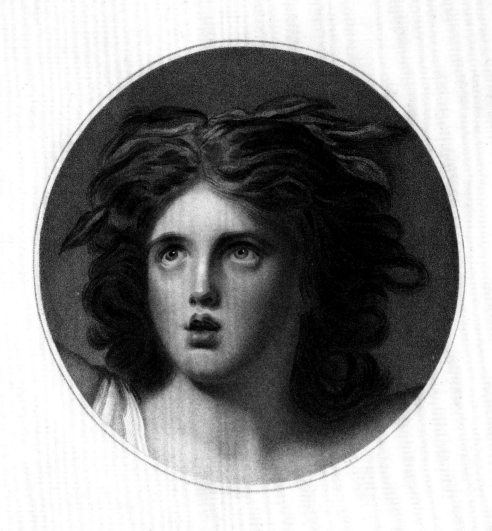

Cassandra

Engraved by Caroline Watson (engraver to Her Majesty) from the original Picture.

Published April 14th 1809 by Thomas Payne, Pall Mall

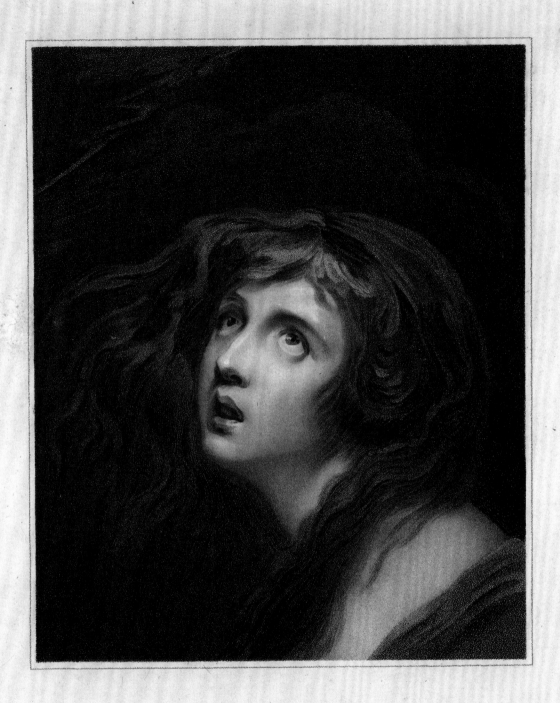

Miranda

Engraved by Caroline Watson, (engraver to Her Majesty) from the original Picture.

Publifhed April 14th 1809, by Thomas Payne, Pall Mall.

Opposite
**Caroline Watson after
George Romney**
Miranda, 1809
Stipple engraving
National Maritime Museum
PAD3234

Above
**Edward Scriven after
George Romney**
*Titania, Puck, the Changeling
from Shakespeare's
A Midsummer Night's
Dream*, 1810
Stipple engraving
National Maritime Museum
PAG6660

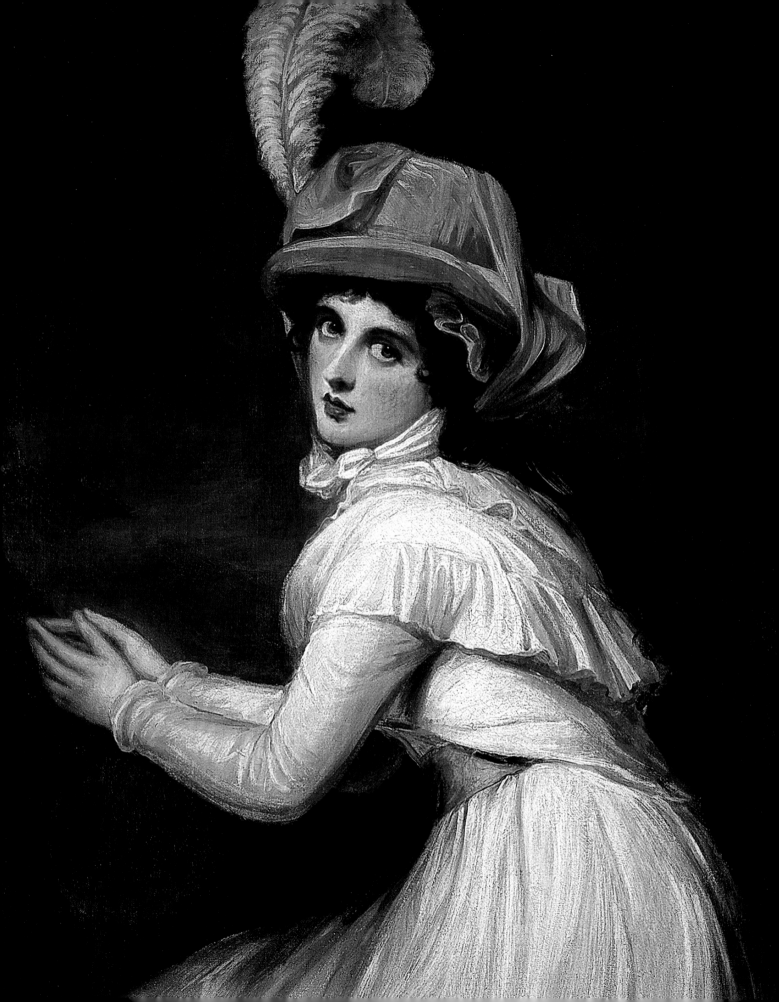

Jason M. Kelly

A Classical Education
Naples and the Heart of European Culture

3

Emma Hart arrived in Naples on her twenty-first birthday, 26 April 1786. Travelling with her mother, Mary Cadogan, their journey had taken them over a month. Now, they were at the home of Sir William Hamilton, with whom they intended to stay for five or six months more. Hamilton, the British Envoy Extraordinary to the Kingdom of the Two Sicilies, was the uncle of Emma's lover, Charles Greville, who had sent the pair to Naples under the pretence that he would soon join them. His plan, however, was much more nefarious: he intended to abandon Emma, handing her over to his uncle with the expectation that she would become Hamilton's temporary mistress.[1]

It took only a few days for Emma to understand that she had been duped. She implored Greville to come to Naples and asserted that Hamilton could 'never be my lover'.[2] Greville did not reply. In late July, she wrote again, 'I...beg of you for God's sake to send me one letter, if it is onely a farewell.'[3] She puzzled over the reasons for his silence. She knew Greville's friends 'have long wisht me ill' – most likely because of her working-class origins and tendency to challenge the boundaries of elite propriety.[4] As she waited for Greville, Hamilton showered her with gifts and toured her through the region. She felt the pressure to succumb to his advances; but, she questioned Greville, 'Shall he perhaps live with me for a little wile like you, and send me to England. Then what am I to do? What is to become of me?' Emma was living on the knife's edge of abandonment, of destitution and poverty, a world she knew too well. Moreover, the man she loved had deserted her. 'My heart is intirely broke,' she wrote.[5]

When Greville finally did respond, he encouraged her to 'go to bed with' Hamilton. This was too much. She lashed out in anger: 'If I was with you, I would murder you and myself boath.'[6] But Emma knew how to survive.

A CLASSICAL EDUCATION: NAPLES AND THE HEART OF EUROPEAN CULTURE

Opposite
Sir Joshua Reynolds
Sir William Hamilton, 1777
Oil on canvas
National Portrait Gallery
NPG 680

Right
Sir Joshua Reynolds
Emma as a bacchante,
1783–84
Oil on canvas
Private collection

Hamilton had already met and admired Emma in London, and this portrait was sent to his Neapolitan residence some time before she arrived in person. Sir William had simultaneously commissioned a painting of Emma as a bacchante from George Romney (see p. 23).

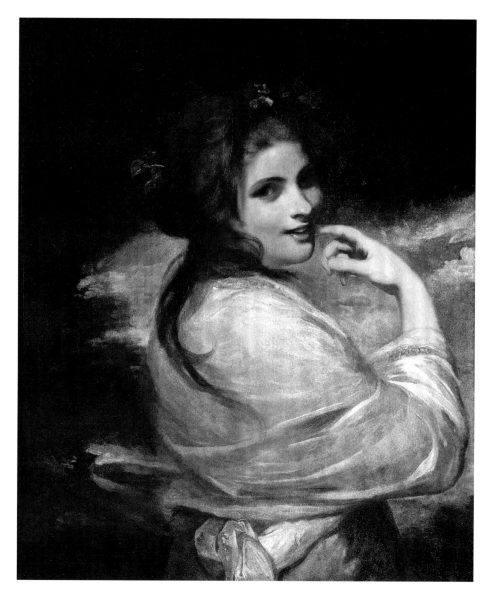

Having been doted on by wealthy men in both London and Naples, even receiving admiring attention from King Ferdinand himself, she recognized her power over them. Knowing that Greville's fortunes relied on an inheritance from Hamilton, she threatened: 'it is not to your interest to disoblidge me, for you don't know the power I have hear, onely I never will be his mistress. If you affront me, I will make him marry me.'[7] A marriage with Hamilton might bring a son, and a son would mean that Greville would lose his inheritance.

By the time of her arrival in Naples in 1786, Emma had already managed a meteoric rise in social standing, which only a few women of the working classes were able to accomplish in the eighteenth century. However, for all of her success, Emma's capacity to shape her destiny was limited. To paraphrase Marx, Emma made her own history, but she did not make it as she pleased. Dismissed to Naples, she was once again forced to imagine the limitations of her agency. She lived in a world in which her background, as the daughter of a blacksmith

and a servant, placed severe restrictions on her social movement. She may have attended parties with elite men and women but they would always have seen her as an outsider. Her accent betrayed her lowly origins. It was cause for comment in gossip, highlighted in diaries. Her manners were unseemly at times. The wealthy women with whom Greville and Hamilton expected her to socialize regularly snubbed her. They were, after all, more interested in policing the boundaries of class than establishing gender solidarity. Men imagined her as an object to be acquired and controlled. Hamilton, for example, was concerned that men on the Grand Tour would make it a sport to cuckold him. Contemporary commentators portrayed Emma as just another object in Hamilton's collections. They joked that Hamilton was a modern Pygmalion, bringing one of his statues to life. In these circumstances, Emma had few options. She could return to England, to limited opportunities, since no respectable family would have hired her as a servant and the life of a courtesan was fraught with uncertainty and danger. At least playing the mistress to Hamilton assured some stability. He had been a loving husband to his first wife, and she could hope that this ageing man might treat her with some care and perhaps even respect.

In the end, she decided to stay. By late December 1786, she was writing of her love for him and alluding to their sexual relationship. It is unclear to what extent her feelings were genuine. A letter that Emma wrote to Greville in 1794 about these early days is telling: she claimed that Hamilton had recently professed that 'he loved me better than ever & had never for one moment repented'. She followed this with a reflection: 'Think of my feelings in that moment when I cou'd with truth say the same to him.'[8] It seems that her earlier expressions of passion may have been more performative than heartfelt.

Emma, as she had done elsewhere so many times in the past, quickly adapted to life in Italy. With some 400,000 residents, Naples was the third largest city in Europe, after London and Paris. It was a region of extremes, of poverty and wealth cheek-by-jowl, of entwined ancient and modern landscapes. Walking on the beach, one might discover a starfish and sea urchins, or fragments of crumbling ancient buildings coughed up by the sea. The eighteenth-century German poet Johann Wolfgang von Goethe described the romance of the place:

> [It was] the most astonishing landscape in the world; treacherous ground under a pure sky; ruins of unimaginable luxury, abominable and sad; seething waters; caves exhaling sulphur fumes; slag hills forbidding all living growth; barren and repulsive areas; but then, luxuriant vegetation, taking root wherever it can, soars up out of the dead matter, encircles lakes and brooks, and extends its conquest even to the walls of an old crater by establishing there a forest of noble oaks.[9]

As the resident envoy to the Kingdom of the Two Sicilies since 1764, Hamilton had connections and wealth, though the latter was modest in British aristocratic terms. Because of this, Emma lived in luxury. Given the less prudish mores of the Neapolitan elite, she was able to take apartments in Hamilton's main house,

Fan showing Neapolitan
scenes, late eighteenth
century
The Fan Museum, London

With its views of Naples
harbour, Mount Vesuvius
and classical artefacts,
this object is typical of the
commercial goods created
for the tourist market.

Giovanni Battista Lusieri
A view of the Bay of Naples
seen from Sir William
Hamilton's residence, the
Palazzo Sessa, 1791
Watercolour, gouache,
graphite, pen and ink on paper
J. Paul Getty Collection
85.GC.281

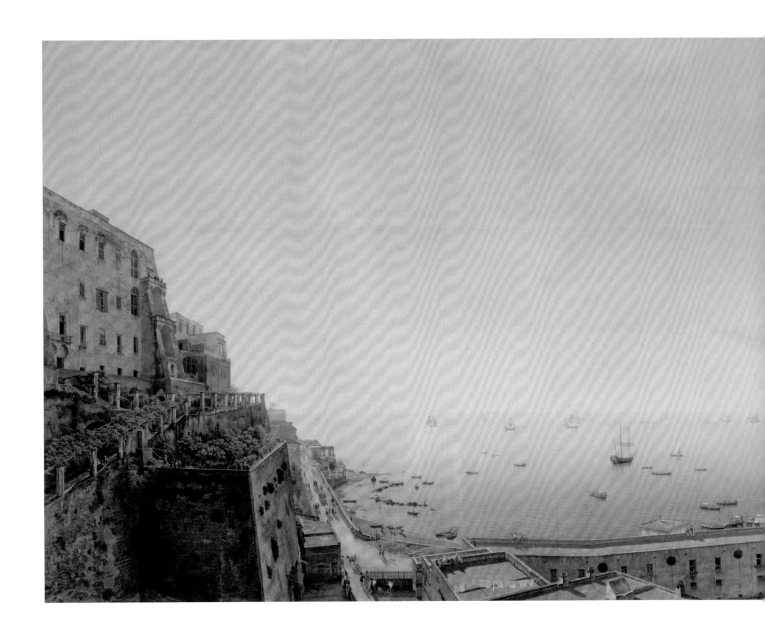

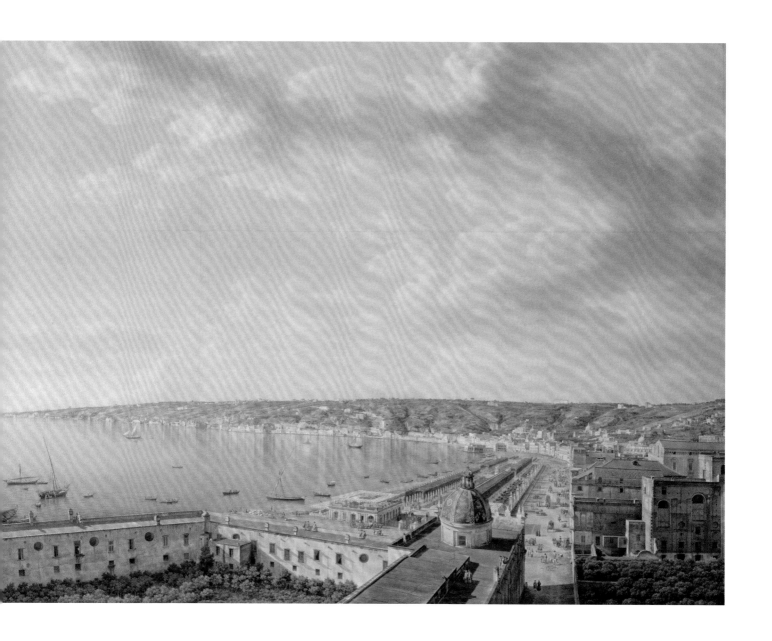

Pietro Fabris

Naples from the west, with
peasants gaming, *c.* 1760
Oil on canvas
Compton Verney

This is a view from the Posilippo
side; the city proper lies beyond
the promontory ending with
the Castel dell'Ovo.

A CLASSICAL EDUCATION: NAPLES AND THE HEART OF EUROPEAN CULTURE

the Palazzo Sessa. From her quarters, she had one of the grandest views in Naples. To the south, the Bay of Naples defined the city as a maritime town. Along the coast, merchant ships were filled with olive oil and grain that had been delivered from the hinterlands. The quayside was lined with hawkers and quacks. Prostitutes and musicians vied with mountebanks, dancers and puppet shows for attention and money. Friars preached from street pulpits as the smell from food vendors, fish markets and excrement wafted through the air. By using carriages, some privileged inhabitants tried to protect themselves from the filth and the pickpockets, but others – in particular, tourists – sought out street life. Their travel guides encouraged them to take ethnographic notes on the poorest Neapolitans, who supposedly ate *macaroni* with their hands and might erupt into dance at any moment. The impoverished *lazzaroni* were of particular interest. Rag-clad and unemployed, they numbered in the tens of thousands. Many travellers imagined that the climate made them languorous. Avoiding work, sleeping in the streets, these were people in a 'state of nature', with their own strict moral codes and honour systems.[10] These tourists commissioned artists to paint street scenes featuring the *lazzaroni*, imagining the Neapolitan urban landscape as a parallel to the rustic picturesque.[11] Among these patrons was Sir William Hamilton, who commissioned painters such as David Allan and Pietro Fabris to present an idealized version of the life of the commoners for the Palazzo Sessa.

Following the beach to the east, a smoking Vesuvius dominated the skyline. At its foot were the ancient buried towns of Herculaneum, Stabiae and Pompeii, which had been excavated by successive kings since 1738. The treasures that these digs produced filled the royal collections at the Portici palace and generated a vast market for antiquities and reproductions. The monarchs kept a close eye on these treasure troves. Not only did they closely regulate any sales but also attempted to prevent artists from drawing the antiquities. Only the Regale Accademia Ercolanese was legally permitted to produce images of these ancient finds, published in a series of volumes known as the *Antichità di Ercolano* (1757–92). Unsurprisingly, however, artists smuggled out pictures and the well-connected smuggled out antiquities.[12]

Hamilton had a double fascination with this area of Naples. His interest in natural history prompted him to study the area's geology, while his passion for the ancient world led him to collect and write about its antiquities. Hamilton's reports to the Royal Society in London on the eruptions of Vesuvius, and related local phenomena, were central to the development of volcanology.[13] He even kept a small house at the foot of the volcano, the Villa Angelica, where he could keep an eye on its constant activity and from which he also led tourists up to view the caldera at close range. Emma, too, became well versed in the natural history of Vesuvius and made numerous visits with friends and acquaintances. She was particularly 'enraptured' by its magnificence against a starlit night sky:

A CLASSICAL EDUCATION: NAPLES AND THE HEART OF EUROPEAN CULTURE

Pierre-Jacques Volaire
An eruption of Vesuvius
by moonlight, 1774
Oil on canvas
Compton Verney

The artist was well known
to Sir William Hamilton,
who had purchased one
of his works in 1769.

Pietro Fabris

The Temple of Hera at
Paestum, late eighteenth
century
Oil on canvas
Compton Verney

Sir William Hamilton visited
these ruins on a number
of occasions, and objects
from Paestum featured
in his collection.

A CLASSICAL EDUCATION: NAPLES AND THE HEART OF EUROPEAN CULTURE

I could have staid all night there, and I have never been in charity with the moon since, for it looked so pale and sickly. And the red-hot lava served to light up the moon, for the light of the moon was nothing to the lava.[14]

The proximity of the Villa Angelica to the excavations at Herculaneum also placed Hamilton in an ideal location for acquiring antiquities. He was an avid collector, particularly of ancient Greek vases, which at the time were thought to be Etruscan. They lined the walls of his homes, and the publication and sale of a large portion of his collection to the British Museum made him an international celebrity among connoisseurs.[15] These dilettanti imagined that his vases were among the works of antiquity that captured the elusive point at which art both expressed nature and elevated it to perfection. Such was the case with the Portland Vase – a unique piece of Roman cameo glass – which Hamilton had acquired and then sold to the Duchess of Portland in 1784. Whereas the ancients had often been able to express such perfection in art, many collectors believed that the moderns had rarely achieved it. Studying the classical world, reproducing ancient works in print and creating museums might, they thought, help the moderns reach, or even surpass, the artistic heights of antiquity. One of the organizations most famous for this endeavour was the Society of Dilettanti.

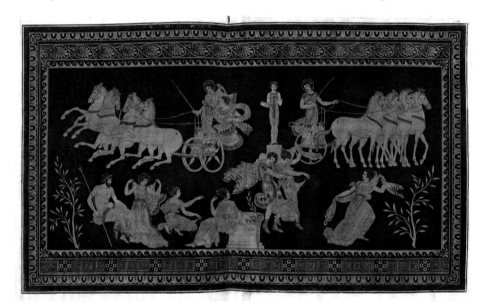

Pierre d'Hancarville
Plate from *Antiquités Etrusques, Grecques et Romaines, tirées du Cabinet de M. William Hamilton*, four volumes dated 1766–67 but printed later
British Library
BLL01001761863

Put. June 20 1799 by S W Fores N° 50 Piccadilly.

Befws of Caracatures lent out for the Evening

Rowlandson. 1799

CONNOISSEURS.

A convivial dining club of wealthy collectors and connoisseurs, well known for its patronage of the arts as well as its sponsorship of archaeological expeditions to the lands of classical Greece, the Dilettanti elected Hamilton a member in 1777.[16] This moment, commemorated in a group portrait by Joshua Reynolds, captured the centrality of Hamilton's work in the scholarly and imaginative universe of eighteenth-century classicism. Hamilton's collection went far beyond vases, however. If Emma wished, she could have visited his secret treasure vault which, according to Goethe, 'was crammed with works of art and junk, all in the greatest confusion. Oddments from every period, busts, torsos, vases, bronzes, decorative implements of all kinds made of Sicilian agate, carvings, paintings and chance bargains of every sort.' In one crate he found two candelabra, which 'somehow strayed here from the cellars of Pompeii'.[17] It seems that Hamilton was not immune to the temptations of the illicit antiquities trade.

To the west, beyond the Palazzo Sessa's windows, were the Campi Phlegræi or Phlegræan Fields, a site of two dozen calderas that spoke to the long history of tectonic instability in Naples. The geology of this area fascinated natural historians and William Hamilton published a lavishly illustrated book on it in 1776.[18] On the southern edge of the Campi Phlegræi, Hamilton kept a small villa on the beach at Posillipo, which was thought to have been the home of Virgil. This building of just a few rooms extended into the sea and provided unparalleled views to the east, where Vesuvius puffed and rumbled. It had been a favourite destination of Hamilton and his first wife, Catherine Barlow, who had died in August 1782. Hamilton had experienced her passing as a 'heavy

A CLASSICAL EDUCATION: NAPLES AND THE HEART OF EUROPEAN CULTURE

Left and opposite
Sir William Hamilton
*Campi Phlegræi:
Observations on the
Volcanos of the Two
Sicilies*, 1776
Jean Johnson Kislak
Collection
1990.024.00.0001a and d

Hamilton's magnificent work
of geology and volcanology
was copiously illustrated by
Pietro Fabris. These plates
show eruptions of Mount
Vesuvius, one including the
lighthouse on the mole
at Naples.

loss': 'In spite of all my Philosophy I am quite unhinged by the cruel separation from an amiably true friend with whom I have lived the last 26 years of my life.'[19] This place was no doubt suffused with Hamilton's memories of Catherine, a woman of delicate health, to whom it had provided escape from the courtly life of the envoy. Soon, however, Emma made it their summer home, helping Hamilton to forget his loneliness and the pain of his separation from Catherine. Within a few years, he renamed this little structure the Villa Emma.

Emma and William had a fourth residence, which lay to the north of the Palazzo Sessa, in Caserta. Hamilton called it his *capannina*, or 'little hut', but in fact it was quite a large residence. The couple wintered there, primarily because it was just a few miles from King Ferdinand's winter palace. Since Hamilton was obliged to spend many hours attending on the king – often as one of his hunting companions – Emma passed much of her time taking lessons, and was also entertained by visits from artists and tourists. As she wrote about her typical week:

> Our house at Caserta is all new fitted-up for me – a new room for my master, a musick-room for me. I have my French master; I have the Queen's dancing-master 3 times a-week; I have 3 lessons in singing a day – morning at eight o'clock, before diner, and the evening; and people makes enterest to come and hear me. My master goes to England with ous. O, then I give up one hour in the day to reading the Italian. There is a person comes a purpose; and for all this their is now five painters and 2 modlers at work on me for Sir William, and their is a picture

going of me to the Empress of Russia. But Sir W^m as the phaeton at the door, after I have had my first singing lesson and dancing lesson, and he drives me out for 2 hours. And you will say that's right, for, as I study a deal, it is right I should have exercise.[20]

Emma knew that she needed to school herself in the fundamentals of an elite education. This was central to her self-fashioning if she were to succeed in Naples; and, being particularly keen to shape Emma's tastes and sensibilities, Hamilton was eager to oblige.

The style of education that she pursued was particularly well suited to her environment. On the streets of London, and in the bawdy house of Mrs Kelly, she had developed street 'savvy' and the skills of flattery, flirtation and conversation. As Greville's mistress, she had learned domestic accounting, a skill important to middling domestic life and one which he had thought would help control her penchant for overspending. Here in Naples, in a house through which an international assortment of aristocrats, artists and scholars flowed, she needed to know the skills of a hostess and diplomat: how to entertain and how to engage in polite, and sometimes learned, conversations in multiple languages.

Emma's training in Naples was typical for society women of this period. It included a proficiency in romance languages – especially French – drawing, dancing and singing. She was quickly fluent in Italian. She was taught singing by Signor Galluci, who lived with them at the *capannina*, and also took history lessons, which were not typically central to upper-class female education, if eighteenth-century conduct books are to be believed. However, considering Hamilton's own penchant for historical learning, it is not surprising that Emma would focus on this area as well.

She also picked up on the unspoken codes that policed the proper boundaries of elite learning. There was a base level of knowledge below which one came across as an ignoramus – and there were certainly plenty of those to be found among Europe's aristocrats – but, since she was just beginning at the age when they were finishing their education, she focused on becoming a quick study. Emma took great pride in her learning, especially, it seems, when it set her apart from those born into privilege. In one instance, she directly poked fun at a prince for his lack of geographical knowledge. There was, however, such a thing as being too learned: one did not want to come across as knowing too much or as overspecialized. One had to project a certain diffidence to learning; to be educated but not pedantic. Writing of her botanical studies with Hamilton, she noted that they were not doing it 'to make ourselves pedanticall prigs and shew our learning like some of our travelling neighbours, but for our own pleasure'.[21] The subtext to her observation was that, like nearly everything in the elite world of the eighteenth century, knowledge was performative and operated according to a set of social codes.

Although Hamilton's residence had always been a centre of social life, particularly for visitors from Britain and Ireland, Emma's arrival infused it

Pietro Trapassi
Opere del Signor Abate Pietro Metastasio, 1784
Jean Johnson Kislak Collection
1988.013.00.0001

Metastasio (the pen name of Pietro Trapassi) was a celebrated Italian poet and dramatist. The signature 'Horatia N[elson] Ward' at top right shows this was a copy owned by Emma and inherited by her daughter.

Pietro Fabris
A concert party at the apartments of Lord Fortrose in Naples, 1771
Oil on canvas
Scottish National Gallery
PG 2611

Fortrose stands at the centre of the composition with Sir William Hamilton to his left. The keyboard players are Wolfgang Amadeus Mozart and his father. The cultural world depicted here – in which music, painting and classical antiquity merged seamlessly together – had many parallels in Hamilton's Palazzo Sessa.

with new vitality. She was a keen hostess, and in the early 1790s wrote that 'Every night our house is open to small partys of fifty and sixty men & women.' However, there was a difference between being a mistress and a wife, and she was treated accordingly. Often shunned by women of influence and fully cognizant of her precarious social position, Emma pushed Hamilton for marriage. Unsurprisingly, he was reluctant. In May 1789, he wrote to Greville:

> I endeavour to lose no time in forming her, & certainly she would be welcome to share with me, *on our present footing*, all I have during my life, but I fear her views are beyond what I can bring myself to execute; & that when her hopes on that point are over, that she will make herself & me unhappy.[22]

He cited a number of reservations including their age difference (thirty-five years) and his public reputation. Moreover, for his part, he had nothing to gain. They lived together under the same roof and, he wrote, 'no Princess could do

Unknown artist, Neapolitan school
Miniature, c. 1789
Watercolour on ivory
Private collection

The miniature is inscribed on the reverse, 'Dutchess [sic] of Hamilton Painted in Italy. Presented to Sir George Rose by E.H. [Emma Hamilton]'. The Duchess of Hamilton (who by this time was also the Duchess of Argyll) was not born an aristocrat. Christened Elizabeth Gunning, she was a famous beauty and made a dramatic social ascent through marriage. She became a firm friend of Emma in Naples and may have encouraged her to pursue the goal of marrying Sir William.

the honours of her Palace with more care & dignity than she does those of my house'. There was little social pressure for marriage either. On the one hand, living together in Naples caused 'no Scandal';[23] on the other, marriage would cause 'eternal tracasseries' if she were to be ranked above the English visitors as 'a Minister's Wife'.[24]

Emma, however, circulated rumours that they had been privately married, which, in fact, many people thought they were. Between spring 1790 and early 1791, she was able to convince Hamilton that they should wed. It is unclear what prompted Hamilton's change of mind on the matter but they were planning a trip to England and as things stood were sure to face scandal. Once there, a number of individuals (including the queen and Lady Spencer) actively avoided any meetings with Emma, and the Archbishop of Canterbury denied Hamilton's request for a private ceremony.[25] However, the king gave his consent, and they were married in a small ceremony at Marylebone on 6 September 1791. While not everybody was pleased that Hamilton had married a woman of Emma's background, the couple nevertheless found support from family and friends. Frederick Hervey, fourth Earl of Bristol, for example, congratulated Hamilton for 'braving the world & securing your own happiness & elegant enjoyments in defiance of them'.[26]

Still, Emma struggled to impress the British aristocracy. As Lady Elizabeth Vassall Fox Holland complained of the Earl of Bristol:

> He is a great admirer of Lady Hamilton and conjured Sʳ W. to allow him to call her Emma. That he should admire her beauty and her wonderful attitudes is not singular, but that he should like her society certainly is, as it is impossible to go beyond her in vulgarity and coarseness.[27]

Mary Mee Temple, Lady Palmerston, was more generous:

> Lady H. is to me very surprising, for considering the situation she was in, she behaves wonderfully well. Now and then to be sure a little vulgarness pops out, but I think it's more Sir William's fault, who loves a good joke and leads her to enter into his stories, which are not of the best kind.[28]

Hamilton, always eager to protect Emma from the condescension of aristocratic privilege, wrote letters subtly encouraging his peers to recognize Emma as one of their own. In many of these, he emphasized her progress in deportment, learning and manners, unintentionally revealing his own condescension towards her.

Although their daily parties were quite different from the salons of Paris and London, as the impresario of the festivities Emma had an analogous role to the *salonnières*. She had to maintain a festive and convivial atmosphere, while providing entertainment that appealed to the tastes of the assembly. Being of a theatrical bent herself, it is not surprising that she used these opportunities to invite performers and singers to entertain

No. XXXII.

No. XXXIII.

The Venus de Medicis.

The Consular Artist.

Published 1.ᵈ Dec.ʳ 1790 by A.Hamilton Jun.ʳ Fleet Street.

A. Hamilton
The Venus de Medicis and *The Consular Artist* from *The Town and Country Magazine*, 1790
Engraving
National Maritime Museum
PAI5189

This representation of Emma and Sir William before their marriage was one of the magazine's '*tête-à-tête*' series of paired portraits. Each provided a barely veiled reference to a gossip-worthy or notorious relationship of the day.

her guests. However, as so many letters and diaries make clear, it was Emma who often became the centre of attention as she sang, danced and performed her Attitudes. It did not take much to coax her into doing so. Having spent much of her life catering to the needs and expectations of her employers, and serving the egos and libidos of gentlemen and aristocrats, she knew the power that she could wield. She also clearly relished the attention. This was a space in which the audience became pliant to her desires.

Both she and Hamilton took great pride in her singing, which by most accounts was quite good. She was often showered with compliments, especially in the first few years when she lived in Naples. A gracious word by the accomplished soprano Brigida Banti led to an outpouring of pride in a letter to Greville:

> But last night I did do a thing very extraordinary. We gave yesterday a diplomatic diner. So after diner I gave them a Concert. So I sent the coach and my compliments to the [Brigida] Banti, who is first whoman at St. Carlo's [the city opera house], and desired her to come and sing at my concert. So she came, and their was near sixty people. So, after the first quartett, I was to sing the first song. At first I was a little frightened, before I begun; for she is a famous singer, and she placed herself close to me. But when I begun all fear whent awhay, and I sung so well that she cried out, 'Just God, what a voice! I would give a great deal for your voice!' In short, I met with such aplause, that it allmost turned my head. Banti sung after me, and I asure you everybody said I sung in a finer stile than her. Poor Sir William was so enraptured with me![29]

She continued by explaining that she had received an offer to be the 'first whoman in the Italian Opera' at £6,000 over three years. She boasted that her voice was:

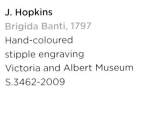

Philippe Benoist
The Teatro San Carlo in Naples,
mid-nineteenth century
Hand-coloured lithograph
Victoria and Albert Museum
S.3887-2009

This image dates from after the
fire that damaged part of the
opera house in 1816.

the finest *soprana* you ever heard, so that Sir William shuts his eyes and thinks one of the *Castratos* is singing; and, what is most extraordinary that my shake, or tril, what you call it, is so very good in every note, my master says that, if he did not feil and see and no that I am a substance, he would think I was an angel.[30]

In addition to Signore Galucci, she trained with the castrato Giuseppe Aprile, and sang a range of pieces by contemporary composers, some of whom she knew.[31] Her collection of manuscript scores reveals that a number of these composers – who included Giovanni Paisiello, Giuseppe Sarti, Pietro Carlo Guglielmi, Vicente Martín y Soler and Giuseppe Nicolini, among others – even created music for her.[32] Not all visitors were so complimentary, however. The attempt to close ranks to exclude Emma from elite circles found voice in gossip about her singing.

Even if her voice could be uneven at times, Emma could command a room with her Attitudes and dancing. On these, even her most vocal critics could not carp. One of her cruellest observers, Sir Gilbert Elliot, later first Earl of Minto, admitted to being entranced by Emma's performance in late December 1796:

> We had the *attitudes* a night or two ago by candlelight; they come up to my expectations fully, which is saying everything. They set Lady Hamilton in a very different light from any I had seen her in before; nothing about her, neither her conversation, her manners, nor figure announce the very refined taste which she discovers in this performance, besides the extraordinary talent that is necessary for the execution.[33]

Emma's Attitudes took the form of a fluid and soundless performance in which she created a series of *tableaux vivants*, mimicking poses from ancient sculpture or Old Master paintings. Usually dressed *à la grecque* in sheer fabric that revealed the contours of her body, the performance was both an erotic and a learned exercise.[34] The complex origins of the Attitudes as a piece of performance art are explored in the following chapter. It is important to stress here, though, that they were also a unique intervention in the world of connoisseurship and classicism, fitting into the wider intellectual discussions about antiquity, beauty and nature that were taking place in late eighteenth-century Naples. While excavations in Naples revealed much about the material culture and lives of the ancient Romans, Emma's Attitudes brought that world to life. On occasion, she even used antiquities such as vases as props.[35] To be so effective in her technique, Emma studied the numerous publications that reproduced the most popular sculptures and paintings of the age.

Her Attitudes were also part of a broader set of performances, in which Emma both reflected and informed contemporary intellectual discussions, while simultaneously exploiting the ambiguities of her own social position. One of these was the tarantella, a peasant dance that had piqued the historical curiosity of the Neapolitan literati for decades.[36] The dance was done to the rhythm of a tambourine and performed primarily by women. Henry Swinburne wrote that

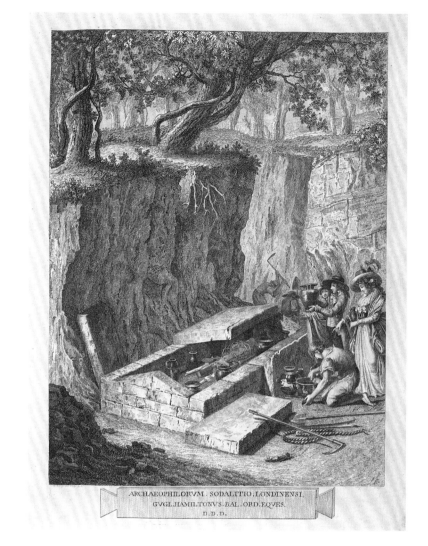

ARCHAEOPHILORVM . SODALITIO . LONDINENSI.
GVGL . HAMILTONVS . BAL . ORD . EQVES.
D . D . D .

it consisted 'of turns on the heel, much footing and snapping of the fingers'. It was, in his opinion, 'a low dance'[37] but, according to the Comte d'Espinchal, nevertheless a '*danse très libre et très voluptueuse*' (a very free and voluptuous dance), especially when performed by Emma Hamilton.[38]

Emma was well aware of her audiences' interests in the ancient origins of the tarantella. A popular belief among the Neapolitan intelligentsia and repeated by Swinburne suggested that it 'was in use among their ancestors, as appears by the pictures of Herculaneum'.[39] Pierre François Hugues d'Hancarville, the friend and collaborator of Hamilton, claimed that its origins were Greek and passed to the Romans through southern Italy.[40] Linked to the rites of Dionysus, they imagined that images of the dance could be found on countless ancient sarcophagi, vases and frescoes.[41] Some claimed that the tarantella had survived the rise of Christianity and into the modern age through a fabricated tradition that pretended the dance warded off the effects of a tarantula bite.[42] The dance, then still practised throughout the countryside and on

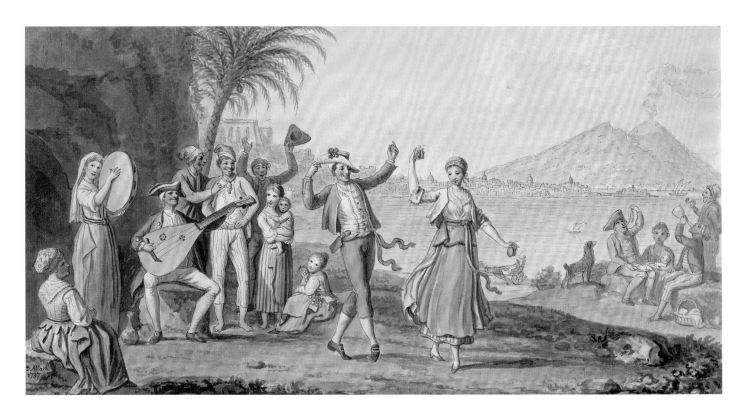

the city streets of Naples was, in effect, seen as a direct descendant of the ancient Dionysian mysteries.

The circle in which Emma moved was fascinated by ancient mystery cults and the possibility of tracing their survival into modern popular practices in Naples. D'Hancarville had made it his stock-in-trade. In 1786, Hamilton had worked with his friends in the Dilettanti, Richard Payne Knight and Joseph Banks, to publish on the survival of Priapic practices in Isernia.[43] Their conclusion was that the modern rites represented the survival of an ancient 'natural religion' uncorrupted by the artifice of society and thus closer to the state of nature. In the case of the tarantella, Neapolitan intellectuals seemed to have identified yet another fragment of ancient religion.

The ability to participate in these discussions no doubt held some appeal for Emma, to the degree that she wrote to Joseph Banks about her performances with an Italian woman named Mariuccia.[44] But, for her, these performances and discussions were more than intellectual; they were symbolic. By participating in the popular culture of southern Italy, she was able to suggest links between her humble origins and those of the Neapolitan poor, and by extension, a nobler and more 'natural' ancient civilization. In this sense, her lack of sophistication and manners was not a deficiency but a positive quality, leading her to claim that 'I shall never change but always be simple & natural'.[45] Emma had learned the language of Hamilton's circles and was able to use it to her benefit. She was not a product of schools and society but rather, as she had earlier written in a letter to Greville, of a childhood lived in 'wild' and 'thoughtless' freedom.[46]

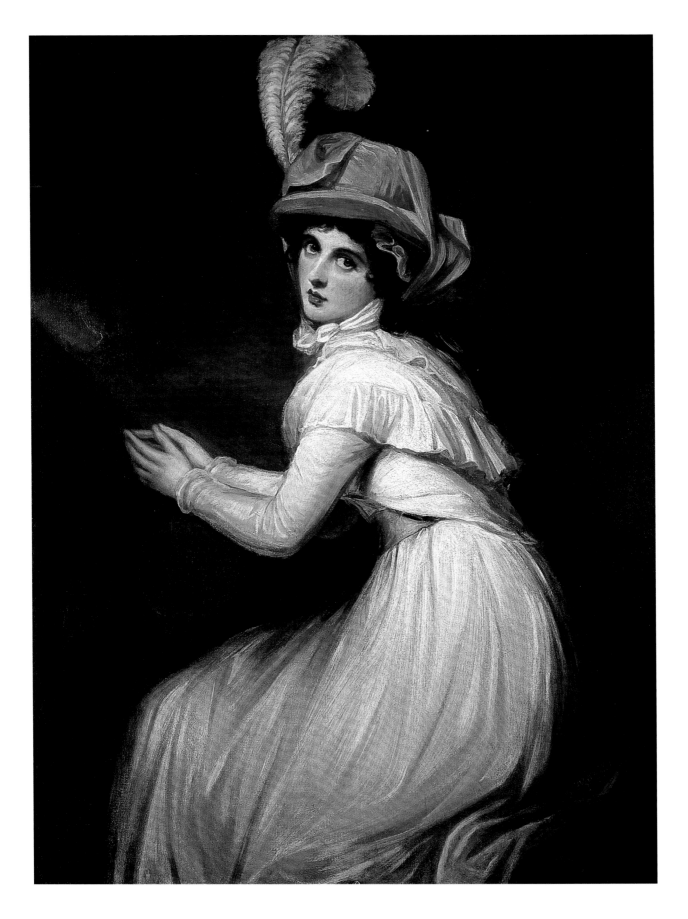

A CLASSICAL EDUCATION: NAPLES AND THE HEART OF EUROPEAN CULTURE

In effect, her performances helped craft a narrative about her origins and place in society, a sort of Rousseauian classicism that would appeal to the elite taste-makers of her age. Her performances were, in turn, bolstered by a programme of portraiture that represented her as simple, pure and natural – quite often as the ancient bacchante that she brought to life through the tarantella. Her capacity to respond to the cultural context of Naples and to craft a reputation that fascinated publics as far away as Britain reveals a woman of extraordinary ability. Even the critical Sir Gilbert Elliot admitted that he found Emma 'all Nature, and yet all Art', an observation of no small praise for the period.[47]

Although Emma arrived in Naples as the unwitting pawn in a scheme devised by her lover and his uncle, she quickly adapted, hoping to turn her betrayal to her advantage. She became the mistress, then wife, of Sir William Hamilton and immersed herself in the rich cultural world of the city. She fêted and was fêted by artists and aristocrats, acquired fluency in Italian and French, and took lessons each day so that she could deport herself in a manner characteristic of a lady. Despite having limited options and wealth, she was nevertheless intellectually nimble and extremely charismatic. Emma's schooling on the streets of London had taught her to survive in a world of haves and have-nots, and how to defend herself among rapacious men. Her education in Hamilton's household in Naples gave her the additional social and cultural literacy necessary for surviving in a world of backbiting aristocrats, enabling her to rise up the social ladder, converse with artists and the intelligentsia and even become a significant political actor. However, it was ultimately insufficient to shield her from the prejudice of British society when her husband, Sir William, and then her lover, Admiral Horatio Nelson, died. In a world of aristocratic privilege and powerful men, her common birth and gender ultimately circumscribed her options.

Above
Gold and micro-mosaic necklace
that belonged to Emma,
late eighteenth century
National Maritime Museum
JEW0370

The central panel is thought to depict
the Castel Sant'Angelo in Rome.

Opposite
George Romney
Emma as the Ambassadress, 1791
Oil on canvas
Blanton Museum of Art
1991.108

Completed shortly after her marriage to
Sir William Hamilton, this was Romney's
final portrait of Emma. It both reflects and
communicates her newfound respectability
and status as the wife of an envoy.

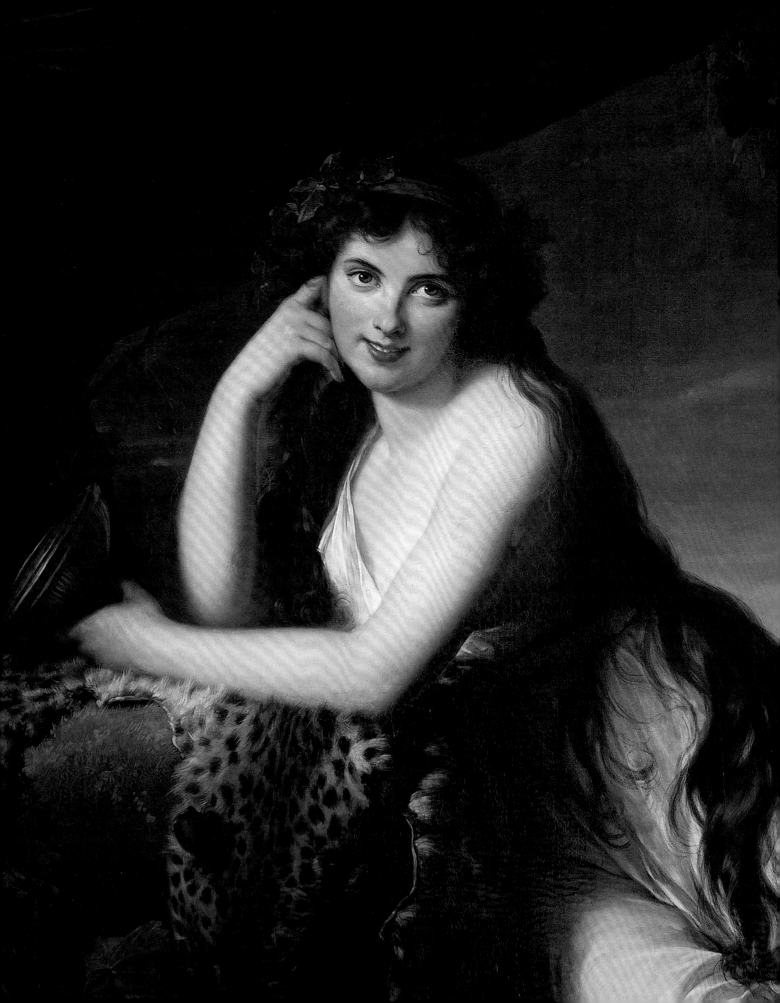

Gillian Russell

International Celebrity
An Artist on
Her Own Terms?

4

In 1828, the fencing master and intimate of London high society, Henry Angelo, gave an account in his gossipy memoirs of his first encounter in the 1780s with Emma, then the unknown Emy Lyon. Turning the corner of New Compton Street, he was confronted with the 'figure of a young woman, meanly attired in the attitude of dejection, leaning against the post'.[1] It was only some years afterwards that he realized this 'forlorn incognita' was the woman who became the celebrated Lady Hamilton, whose fame as consort of Sir William Hamilton and later mistress of Nelson was to dazzle all Europe.[2] Angelo's memory of her in Covent Garden as displaying an attitude, or pose, was conditioned, though he does not explicitly allude to this, by the reputation she had acquired across Europe in the 1790s for her Attitudes. Under the supervision of Sir William, and deploying the skills in courting the gaze through fixing and arranging the body that she learnt as a model for Romney, Emma Hamilton developed the Attitudes as a sophisticated form of performance art that anticipates, by two centuries, the work of contemporary artists such as Marina Abramović or Cindy Sherman. Much more than a kind of game of charades, the Attitudes were important in Emma's evolution from a London courtesan to an 'ambassadress' and, ultimately, political actor in the court of Naples. They were also a formative influence on the imagination of poets and artists, making Emma a key figure in the fusion of neo-classicism with sensibility that was to characterize the European-wide cultural movement later known as romanticism. The Attitudes were inextricably associated with Emma's Italian years from 1786 to 1800. However, in order to understand them, we must join the immediate context of Naples to a host of influences that shaped her earlier years in London.

Elisabeth Louise Vigée Le Brun
Emma as a reclining bacchante
(detail), *c.* 1790
Oil on canvas
Private collection

George Townly Stubbs
(publisher)
Emma as the Muse of Dance,
and an image showing
a nymph with cymbals,
1798; 1796
Stipple engravings
National Maritime Museum
PAJ3426; PAG6649

It is important to note, however, that the Attitudes were primarily a form of domestic entertainment, staged for the benefit of Sir William Hamilton's guests, and part of the role of hostess that wives and daughters, as well as mistresses, were expected to perform. Throughout the eighteenth century, but especially after 1760, many elite women exploited this role, acting, for example, as impresarios in their own households of masquerades, assemblies and private theatricals. These 'private' entertainments were publicized in the newspapers and overlapped with other commercial forms of public entertainment, such as pleasure gardens and theatres, in which women of fashion were also conspicuous. In spaces such as the Pantheon assembly rooms in Oxford Street or the pleasure gardens of Vauxhall, elite women mixed with 'demi-reps', such as actresses and artist's models with compromised reputations, who were often mistresses of gentlemen.[3] Fashionable dress meant that even a blacksmith's daughter such as Emma could parade in Kensington Gardens with her sister '*élégantes*'.[4] Emma Hamilton's domain throughout her career was this feminized sphere of fashion, in which striking an 'attitude' was an essential part of social performance. The 'theatres' for this display could range from the streets of Covent Garden or the drawing rooms of Naples to potentially the whole of Europe via the emergent mass media. Emma's success lay in realizing the chances of dizzying social mobility that the fashionable world offered her, making the Attitudes an expression of not only her own creativity but also of the possibility of change in Enlightenment culture as a whole.

Samuel Johnson's *Dictionary of the English Language* (1755) defined 'attitude' as 'the posture or action in which a statue or painted figure is placed'.[5] 'Attitude' thus entailed the deployment of the whole body, not merely the

face or head, and was the main way by which a painter or sculptor created an imitation of action or life in his or her subject. The idea of 'attitude' as entailing a 'placing' of the statue or figure also suggests a spatial dimension to this process. The putting of a figure in its place enabled the objectification of and even distancing from what had been created for purposes of satisfaction, pleasure and also artistic authority. 'Attitude' is thus fundamentally concerned with relations of power between creator and created. The liveliness or attitude of a posture or action gestured towards what lay beyond the frame of a painting or the immobility of marble, and therefore towards what the artist could not control. The classical myth that most powerfully expressed the relationship between the artist and the plastic or malleable arts in gendered terms was

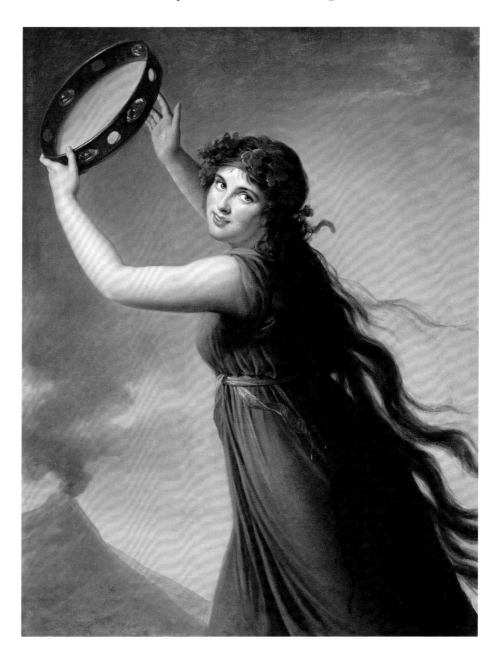

that of Pygmalion and Galatea, as told in book ten of Ovid's *Metamorphoses*. According to Ovid, Pygmalion had demonstrated his fidelity to Aphrodite, the goddess of love, by rejecting the Propoetides: fallen women or prostitutes who, having challenged Aphrodite's authority, were transformed into stone. Pygmalion sculpted his own ideal woman so perfectly that he fell in love with her and, as a reward, Aphrodite granted his wish that the statue come to life. The story of Pygmalion and his compliant living statue, Galatea, the antithesis of the Propoetides, was revived in the late eighteenth century in the form of a drama by Jean-Jacques Rousseau (first performed in 1770 and published in 1775). *Pygmalion* was an experimental work that sought to integrate music and spoken-word drama in order to explore speech as music and music as speech. Rousseau termed this new form of drama *scène lyrique* or *mélodrame*. His experiment was formative in the development of later melodrama: as Monique Rooney has recently highlighted, melodrama is a mutable and enduring modern art form, fundamentally concerned not only with the boundaries between media, but also with what it means when we bring forms such as Galatea to life.[6]

The Pygmalion myth, as interpreted by Rousseau, resonated with Enlightenment culture in a number of key ways: it foregrounded the relationship between the artist-creator and his creation; it dramatized the capacity of art to imitate 'real' life; and by linking these themes to the media through which they are expressed – such as stone, the performing body, and the speaking or singing voice – it suggested how such media were malleable and permeable. Song could merge with speech (and vice versa) whereas stone might become flesh. Rousseau's *Pygmalion* coincided with the rise of new scholarly interest in classical sculpture, the subject of influential treatises by Johann Joachim Winckelmann (1764) and Gottfried Lessing (1766). The acquisitive zeal of antiquarians such as Sir William Hamilton and the Europe-wide traffic in antiquities, particularly after the French Revolution, meant that Greek and Roman sculpture was better known and more accessible than ever before. In 1778, the German philosopher, literary theorist and poet Johann Gottfried Herder published an essay entitled *Plastik* or *Sculpture*, with the subtitle *Some Observations on Shape and Form from Pygmalion's Creative Dream*. Herder argued that sculpture was superior to painting in its capacity to represent a figure that had three-dimensional solidity. A statue could be observed from afar, walked around and touched, while a figure in a painting only appealed to the surface of the eye: 'Sculpture creates in *depth*, it creates *one* living thing, an animate *work*, which *stands there* and which endures...A sculpture before which I kneel can embrace me, it can become my friend and companion: it is *present*, it is *there*.'[7] The dream which the Pygmalion–Galatea story licensed was thus not only the fantasy of the male artist's capacity to sculpt and control feminine beauty, but also the idea that the work of art could be one's friend and companion, thereby confirming one's reality in the world.

Such circumstances – the pursuit of antiquities, sculpture as an object of aesthetic theory, and Rousseau's experimental *mélodrame* – meant that Sir William Hamilton's playing of Pygmalion to his own Galatea in the form of Emma Hart aroused considerable interest within and beyond Hamilton's circle. Emma herself was the first to describe her Attitudes in a letter to Charles Greville of August 1787:

> Last night their was two preists came to our house, and Sir William made me put the shawl over my head, and look up, and the preist burst into tears and kist my feet and said, 'God had sent me a purpose.' O, à propo. Now as I have such a use of shawls, and mine is wore out, Sir William is miserable, for I stand in attitudes with them on me. As you know Mr. Mack Pherson, ask him to give you one for me…O pray, send me 4 or 5 prints of that little Gipsey pictur with the hat on. Sir William wants one, and 2 other people I have promised.[8]

It is possible that Emma's Attitudes began with an imitation of the Virgin Mary, a performance that would have carried a powerful, even blasphemous, frisson in Catholic Naples. Goethe claimed that Sir William had originally devised an arrangement in which she stood in a black box like a picture frame.[9] The box was later abandoned because it was cumbersome and difficult to illuminate properly but also, possibly, because it gave her little space in which to move or create the Attitudes as a sequence of poses.

Emma was long accustomed to being 'placed' in an 'attitude' as Sir William had done, and Greville, to whom she was writing, would have seen this done many times as she modelled for George Romney. A readiness to perform for

Sir Joshua Reynolds
Frances Abington as Miss Prue in William Congreve's Love for Love, 1771
Oil on canvas
Yale Center for British Art
B1977.14.67

the entertainment of others, mainly men, was also part of her training and obligation as mistress of Sir Harry Fetherstonhaugh and then Greville.

A notable example of the cultivated demi-rep was Martha Ray, a milliner's apprentice who, as mistress of the fourth Earl of Sandwich, presided over his table and entertained his circle with her singing, knowledge of literature and skill in private theatricals. Martha Ray became still better known when, in 1779, as she was leaving the Theatre Royal, Covent Garden, she was shot and killed by the Reverend James Hackman – a young man who became obsessed with her after meeting her at the Earl's country residence.[10] Many demi-reps such as Sophia Baddeley and Mary Robinson had professional careers as actresses, dancers and singers – a theatrical world with which Emma was, of course, extremely familiar. The theatre of the 1770s and 1780s was dominated by outstanding female performers such as Frances Abington and Elizabeth Farren, who developed public reputations as fashion icons and celebrities in their own right, consorting with high-society women whose styles and hauteur they emulated and often outdid on stage. Emma Hart may have witnessed (from the gallery) or was at least aware of Sarah Siddons's triumphant return to the London stage in 1782. Emma's tall, elegant friend Jane Powell had a long and moderately successful career as the main support for Siddons in her tragic roles.

The blurring of distinctions between elite women of fashion, actresses and demi-reps such as Emma was central to the circulatory energies of fashionable sociability in the late eighteenth century, energies that were capitalized on by entrepreneurs, print and visual culture, and the nascent fashion industry. One such entrepreneur was the Scottish quack doctor and showman James Graham, famous for his Temple of Health in London, and for whom Emma was reputed to have worked as a semi-dressed model in the early 1780s (see Chapter 1). Graham's establishment was only part of a diverse and proliferating network of innovative entertainments in 1780s London, such as Philippe-Jacques de Loutherbourg's Eidophusikon, now regarded as important in the prehistory of cinema, and the play readings of the French actor Anthony A. Le Texier, both located in Soho, near Emma's old stamping ground. Patrons of the latter would pay to visit Le Texier's home, where he staged one-man performances of French plays. According to a later commentator, Le Texier 'marked his various characters by his countenance, even before he spoke, and shifted from one to the other without the slightest difficulty'.[11] (Le Texier had also played the original Pygmalion in the 1770 production of Rousseau's *mélodrame*.) As precedents for what Emma would do in Naples, the Eidophusikon and Le Texier's readings suggested the potential for a new kind of hybrid salon theatre that blurred the boundaries between private and public, bringing the viewer up close with a constantly changing performer or (in the Eidophusikon's case) scenic spectacle.

The fashion for private theatricals was also part of this trend. Lavish productions were staged at Richmond House in Westminster in 1787–88, directed by the Hon. Anne Seymour Damer, whose career as a woman of fashion

was complicated by the scandalous death by suicide of her husband in 1776, and her identification in the press as a lover of women. Extremely well connected in aristocratic Whig circles and close to Horace Walpole (her father was his cousin), Damer had a recognized non-professional career as a sculptor lasting many years, one of her subjects in 1803 being Nelson. Damer was related to Sir William Hamilton and visited him in Naples, taking inspiration from his collection of statues, and practising sculpture in a studio there in 1780. The presence of this female Pygmalion in Naples complicates gendered assumptions about women as primarily objects to be 'placed' or sculpted by the male artist-patron-protector. Damer's acting in and stage-managing of the Richmond House theatricals can be said to parallel what Emma was doing at the same time in Naples: both women were playing Pygmalion to their own star roles as Galatea.

Though Damer's social status was much higher than Emma's, the types that they exemplified – the woman of fashion and the demi-rep – were not poles apart. They sometimes socialized in the same space, if not with each other.

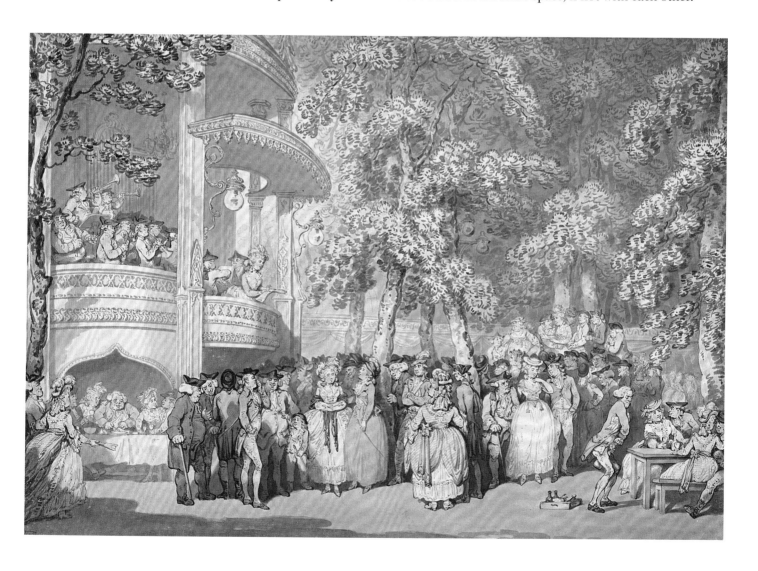

The novelty of such a possibility is represented in Thomas Rowlandson's drawing *Vauxhall Gardens* (engraved in 1785) which stages a kind of 'selfie' of the late Georgian fashionable world as a fluid interplay between multiple social spheres: the political, the literary, women of fashion (in the form of the Duchess of Devonshire) and actress demi-reps (such as Mary Robinson). Marcia Pointon has argued that 'femininity in its married or marriageable state and the licentious objects of sexual desire' represented an 'axis or continuum' for women in Georgian society: 'one mode [was] never clear-cut or independent of the other'.[12] Romney and later Elisabeth Louise Vigée Le Brun frequently depicted Emma as a bacchante, one of the female devotees of Bacchus, the Roman god of wine and agriculture. The type of the bacchante, free-spirited, loose-limbed, flowing-haired and cheerfully erotic, corresponded to Emma's 'profession' as a demi-rep hostess for Greville and later Hamilton. But, as Pointon argues, more respectable women could also be depicted in a similar bacchanalian way, as a sign of the continuum between 'proper' and 'improper' femininity. This relationship was most visible in the studios of painters such as George Romney and Sir Joshua Reynolds, where portraits of duchesses and demi-reps were displayed side by side, and also in the art galleries and printshops that retailed such images. These were the spaces in which Emma was best known in the 1780s: her request that Greville send her four or five prints of the 'little Gipsey picture with the hat on', possibly Romney's *Emma in a straw hat* of c. 1784–85 (see p. 75), suggests her awareness of the power of her image and a desire to control its circulation in Naples, like a calling card. By the mid-1780s then, Emma had become a media celebrity in the sense of being someone who was known primarily for her visual image. A report in *The World* newspaper, for example, referred to the 'dozen portraits' that Romney had done of 'Mrs. *Hart*',

> with her hat tied under her chin, with the spinning wheel – with the loose hair and the uplifted eye or her new picture now in the room. They are full of captivation – and of captivation independent of the portrait.[13]

Emma, in other words, had become a 'star' in the sense of being able to communicate through the visual image an aura of her 'real' presence, forging a sense of connection or 'touch' with the viewer. It was this appeal that she was able to exploit further in the form of the Attitudes.

Emma left London and Greville for Naples in 1786, a departure that would bring important changes to her role as courtesan-mistress. Not least, whereas in Britain her mode of speech and accent immediately marked her as 'vulgar', in Naples her class status was obscured by a foreign tongue, a masking that was part of Hamilton's Pygmalion-like transformation of her from the equivalent of the Propoetides, the petrified fallen women of the *Metamorphoses*, to a living, breathing Galatea. By 1787, when Goethe visited Naples, the elements of Emma's performance were in 'place'. Hamilton, Goethe wrote,

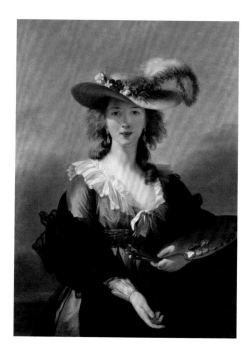

**Elisabeth Louise Vigée
Le Brun**
Self-portrait in a straw hat,
after 1782
Oil on canvas
National Gallery
NG1653

Vigée Le Brun was a
confidante of Europe's
royal families. Although her
relationship with Emma was
by no means straightforward,
she helped her to capture the
attention of a European elite.

has had a Greek costume made for her which becomes her extremely. Dressed in
this, she lets down her hair and, with a few shawls, gives so much variety to her
poses, gestures, expressions, etc., that the spectator can hardly believe his eyes.
He sees what thousands of artists would have liked to express realized before him
in movements and surprising transformations – standing, kneeling, sitting,
reclining, serious, sad, playful, ecstatic, contrite, alluring, threatening, anxious,
one pose follows another without a break.[14]

There are precedents for Emma's Attitudes in the history of eighteenth-century
dance: in 1771 Horace Walpole noted the current fashion for the dancer Anne
Heinel, who was displaying 'a set of attitudes copied from the classics; she
moves as gracefully slow as Pygmalion's statue when it was coming to life'.[15]
It is possible that, moving as he did in the same circles as Walpole, Sir William
Hamilton knew of or had even witnessed Heinel's performance. An attitude
in dance, however, was a specific pose that entailed balancing on one leg while
raising and moving the other leg in various configurations. Emma's Attitudes
do not seem to have deployed the attitudes of ballet: indeed, as Kirsten Gram
Holmström emphatically insists in her influential study on attitudes, 'there is
no mention whatever of dance-like movements as a connecting link between
the different attitudes or of any musical accompaniment'.[16] Emma was known,
however, to perform the tarantella, a dance associated with the bacchante, as
part of a whole show, including singing, of which the Attitudes seem to have
been an element.

An important dimension of Emma's performance was the deployment of
shawls. Her request to Greville to send her one as hers was 'worn out' indicates
that she used the shawl as a prop from the very beginning. Goethe noted
their role in her multiple transformations, as did Adelaide d'Osmond, later
Comtesse de Boigne, who witnessed and participated in the Attitudes in Naples
as a child in 1792. De Boigne later wrote that Emma's props consisted of 'two
or three cashmere shawls, an urn, a scent-box, a lyre, and a tambourine'. The
performance began with her throwing 'a shawl over her head which reached
the ground and covered her entirely…Then she suddenly raised the covering,
either throwing it off entirely or half raising it, and making it form part of
the drapery of the model which she represented.'[17] Writing in 1800, Melesina
Trench also noted the importance of '[s]everal Indian shawls' to the Attitudes:
'She disposes the shawls so as to form Grecian, Turkish, and other drapery, as
well as a variety of turbans. Her arrangement of the turbans is absolute sleight-
of-hand, and she does it so quickly, so easily, and so well.'[18]

Shawls, especially those from India made from cashmere, were highly
sought-after fashion accessories in late-Georgian Britain. The word 'shawl'
itself was of South Asian origin, having entered the English language in the
1660s. The importation of Indian examples after 1760 is a sign of how the
globalizing impact of imperialism and war in this period were manifested
in fashion and particularly on women's bodies. By 1800 the word shawl was

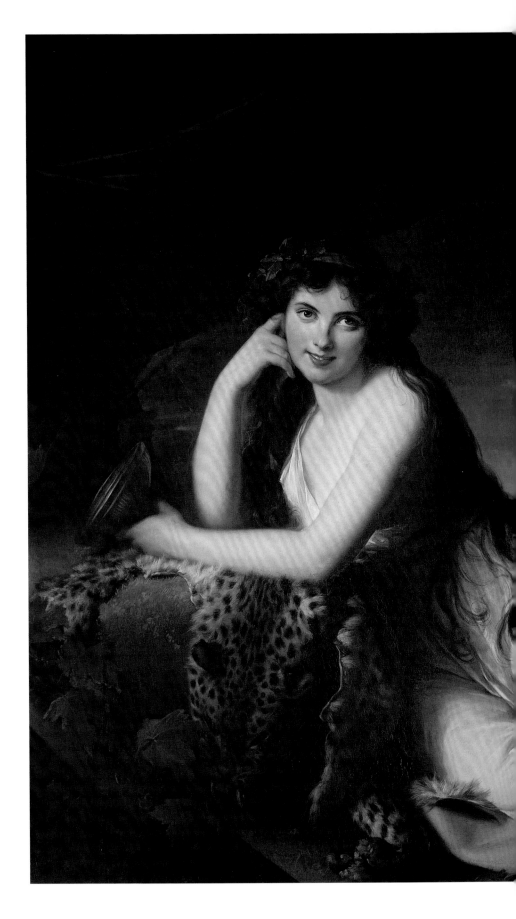

INTERNATIONAL CELEBRITY: AN ARTIST ON HER OWN TERMS?

Elisabeth Louise Vigée Le Brun
Emma as a reclining bacchante, c. 1790
Oil on canvas
Private collection

This work was completed in Naples for Sir William Hamilton, who later commissioned a miniature of it by Henry Bone. Both works of art were subsequently owned by Horatio Nelson.

INTERNATIONAL CELEBRITY: AN ARTIST ON HER OWN TERMS?

beginning to be used for all sorts of cloth coverings and by the twentieth century a 'shawlie' was a colloquial term for a lower-class woman, often Irish, wearing a woollen shawl as a head cover and in some cases using it to carry a baby, along the lines of today's slings.

The materiality of thin cashmere – malleable, easily compressible, shimmering in movement – was intrinsic to the effects of fluidity and rapid transformation that Emma achieved in the Attitudes: drapery in motion. As an exotic and luxurious fashion object, the cashmere shawl also testified to her own cross-class mobility, how far she had come from the streets of Covent Garden. The importance of the shawl to the Attitudes can be gauged from the drawings by Pietro Antonio Novelli and William Artaud. The latter's rapidly executed sketch captures the speed and dexterity of Emma's transformations and also how the shawl acted as a kind of prosthesis, extending and magnifying her body. Emma's manipulation of the shawls represented an active control of the moment of revelation – a game of 'there she is, there she isn't' in contrast to Galatea's subjection to Pygmalion's unveiling. In other words, the shawl functioned as kind of curtain or, we might say, a screen, as indeed did her long auburn hair.[19] In a context in which 'dressed' hair for both men and women was a sign of public social status (that is, the use of wigs and other hair extensions, powdering and decorations), the display of 'natural' hair challenged custom and social hierarchy. A politics of hair would come to the fore after 1789 when revolutionaries in France discarded wigs and powder and both men and women wore their hair *au naturel*. As in the case of the shawls, Emma's hair was used as a device to conceal her body. The Comtesse de Boigne recounted how Emma involved her, as a child, in one of the Attitudes by covering her with her hair and then suddenly rising up, grasping her own hair and pointing a dagger at her. 'The passionate applause of the artists who were looking on resounded with exclamations of "Brava, Medea!" Then drawing me to her and clasping me to her breast as though she were fighting to preserve me from the anger of Heaven, she evoked loud cries of "Viva, la Niobe!"'[20]

Emma switched in a few moments from being Medea, a mother who killed her children (in revenge for her husband Jason's infidelity), to Niobe, a mother whose children were killed as punishment by Apollo and Artemis. Her linking in this way of Medea and Niobe highlighted the fact that both myths concerned the loss of children (and it is perhaps relevant that De Boigne was comparable in age to Emma's daughter by Fetherstonhaugh). The Attitudes can thus be seen to anticipate one of the key genres of melodrama – that of the maternal melodrama – focusing on the mother–daughter relationship as the catalyst for intense feelings of love, longing and loss that were mythological in their resonance, but also specific to the changing roles of women in an Enlightenment world on the verge of revolution. This is possibly one reason the Attitudes were particularly intriguing to women such as De Boigne and Trench. Probably the best witnessing of the Attitudes is an imaginative one

Right
William Artaud
Emma performing her Attitudes,
1796
Sketchbook
British Museum 1973,1208.85.1-65

Swiftly produced from life,
Artaud's drawings record
Emma's rapid movement as
she represented figures such as
Medea, and a penitent Magdalene.

Below
Pietro Antonio Novelli
Emma performing her Attitudes,
late eighteenth century
Etching
Victoria and Albert Museum
S.5154-2009

The standing and reclining figures
demonstrate how subtle and
incremental alterations in costume
and expression could prescribe
a transition from, for instance,
beseeching desperation to
dissolution.

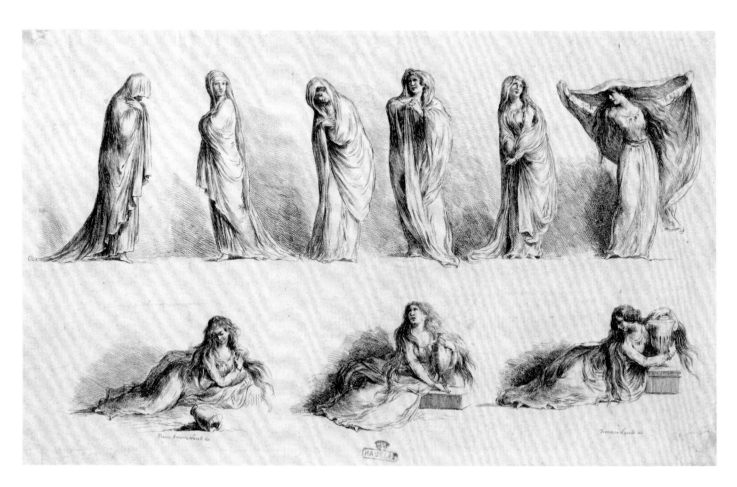

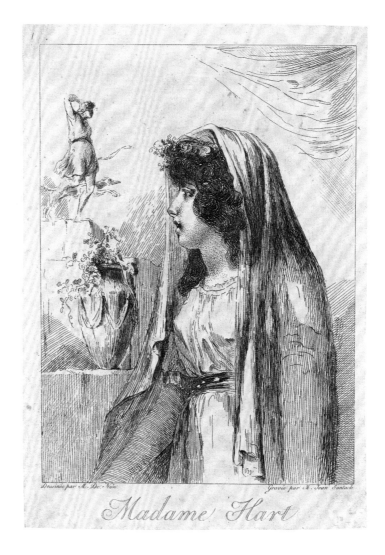

Madame Hart

from the future, by critic Susan Sontag in her historical novel about the relationship between Hamilton, Lady Hamilton and Nelson. Sontag suggests that the Attitudes were a kind of levitation that freed her from the world: 'it was not like donning a mask – one must have a very loose relation to one's body. To do this one must have a gift for euphoria'.[21]

Emma's gift was such that the fame of the Attitudes spread beyond the immediate circles of the *conversazioni*, the small-scale parties at which she entertained Sir William's guests in her role as the envoy's mistress-cum-hostess. Assuming the role of Lady Hamilton meant that Emma needed to be introduced to and acknowledged by fashionable society as wife rather than mistress. Hence, in August 1791, the Duke of Queensbury held a concert and supper at his house at Richmond, outside London, at which leading women of fashion such as the Duchess of Devonshire were present. Widely reported in the press, the event was a public-relations exercise, designed to smooth the path to Emma's acceptance as Lady Hamilton. She sang for the company but did not perform the Attitudes, which were reserved for a more intimate occasion –

a breakfast party the day after, which was not reported in the media.[22] Emma's
Attitudes were only properly acknowledged publicly in Britain well after her
marriage to Hamilton. In 1797, an English translation of Friedrich Rehberg's
Drawings Faithfully Copied from Nature at Naples (1794), with engravings by
Tommaso Piroli, was published in London by the printseller S. W. Fores under
the title *Lady Hamilton's Attitudes*. The *Morning Post* newspaper commented
that 'LADY HAMILTON'S *attitudes* are at last made *public*'.[23] Via Romney's
portraits and the printsellers' copies, Emma's image had made her a familiar
face in metropolitan London in the 1780s, but her translation into the identity
of Lady Hamilton made her a different kind of public figure. She was now
entitled to recognition as consort of the king's representative, as signified by
Romney's 1791 portrait of her as the Ambassadress. Lady Hamilton became
perhaps her most successful and sustained 'attitude', and one performed for
the rest of her life.

However, her publicly 'out' status as Lady Hamilton also made her liable
to the exaggerations and cruelty of caricature. In prints such as *Lady H*******
Attitudes by Thomas Rowlandson (*c.* 1800), her reputation as a denizen of
Graham's Temple of Health was conflated with the representation of Sir William
as a sleazy Pygmalion figure exhibiting his Galatea. As Lady Hamilton aged
and grew bulkier, the body of the Attitudes took on a different meaning. In
1800, Melesina Trench described her figure as 'colossal', while the viceroy of
Corsica, Sir Gilbert Elliot, described her 'person as nothing short of monstrous
for its enormity, and...growing every day'.[24] Later, in 1807, a satirical version of
Lady Hamilton's Attitudes, published by Hannah Humphrey from drawings
attributed to James Gillray, lampooned her mercilessly by contrasting the sylph
of the 1790s with the supposedly balloon-like figure of the 1800s.[25] Her last

significant presentation of the Attitudes in England was at William Beckford's Fonthill Abbey outside Bath in 1800, when her performance was the culmination of lavish Christmas and New Year festivities. The *Gentleman's Magazine* later reported that her chief impersonation was of Agrippina the Elder returning to Rome with the ashes of her murdered husband, Germanicus, to claim justice from the Roman people. Agrippina was regarded in the eighteenth century as an exemplary model of the Roman matron, combining fidelity to her husband with courageous public-spiritedness. The *Gentleman's Magazine* claimed that Lady Hamilton 'displayed, with truth and energy, every gesture, attitude, and expression of countenance, which could be conceived in Agrippina herself, best calculated to have moved the passions of the Romans on behalf of their favourite general'.[26] Her assumption of the identity of Agrippina was an affirmation of the public role she herself had played in assisting Nelson, the Queen of Naples, and ultimately the interests of Britain. The martial figure whose reputation she was figuratively defending was not her husband, Sir William, but her other 'husband', who – as the following chapter will explain

Thomas Rowlandson
*Lady H******* Attitudes,*
c. 1800
Etching
British Museum
1981,U.258

This voyeuristic satire of Emma stops just short of sexual slander by exploiting the accepted traditions of connoisseurship and of art students drawing from the nude.

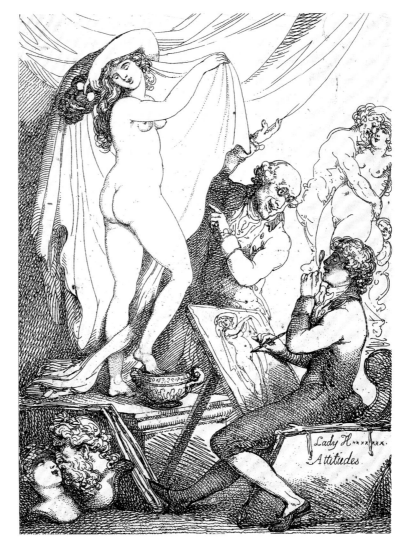

– was the naval hero Admiral Lord Nelson. Both husbands would be dead in a few years and Lady Hamilton would eventually be denied the public role of mourning for the lost hero, and her own claims for justice from the nation. Agrippina in 1800 was thus exemplary of how, after 1786, Emma had learnt to be queenly by means of the Attitudes, a training she used to full effect when she became Lady Hamilton at the court of Naples. Insofar as Agrippina also foreshadowed future public recognition that was never hers, it also signified the importance of the Attitudes as experiments in how far a woman could possibly go in Georgian society, as well as the limits of what Sir Gilbert Elliot referred to as the 'inveterate remains of her origin' that could never ultimately be effaced.[27]

The legendary status of Lady Hamilton, seen mainly in popular view through the lens of Nelson, has meant that the Attitudes have tended to

Attributed to James Gillray
A caricature of Emma, from *A New Edition Considerably Enlarged, of Attitudes Faithfully Copied from Nature: and Humbly Dedicated to all Admirers of the Grand and Sublime*, 1807
Etching
Lewis Walpole Library
lwlpr29856

The Attitude satirically depicted here shows Emma in a pose variously described as the Muse of Dance or dancing the tarantella.

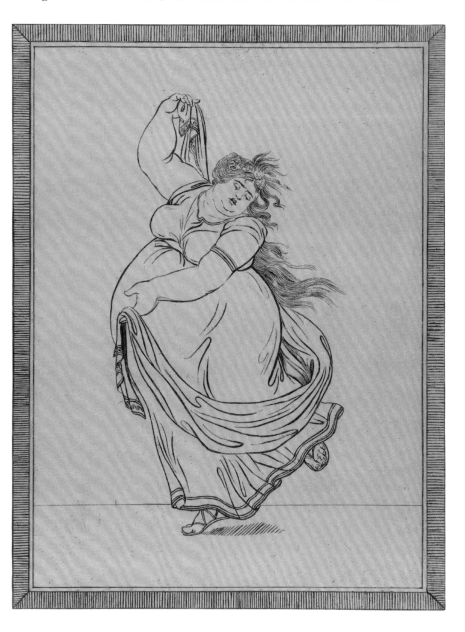

Unknown artist

The Diplomatique Lover and the Queen of Attitudes, 1791
Engraving from the
Bon Ton Magazine
British Museum
1872,1012.5626

This social satire shows Emma as a dominant figure commanding her husband's affections. The title she is given suggests that her influence owed much to her public cultural profile.

The DIPLOMATIQUE LOVER. and the QUEEN of ATTITUDES.

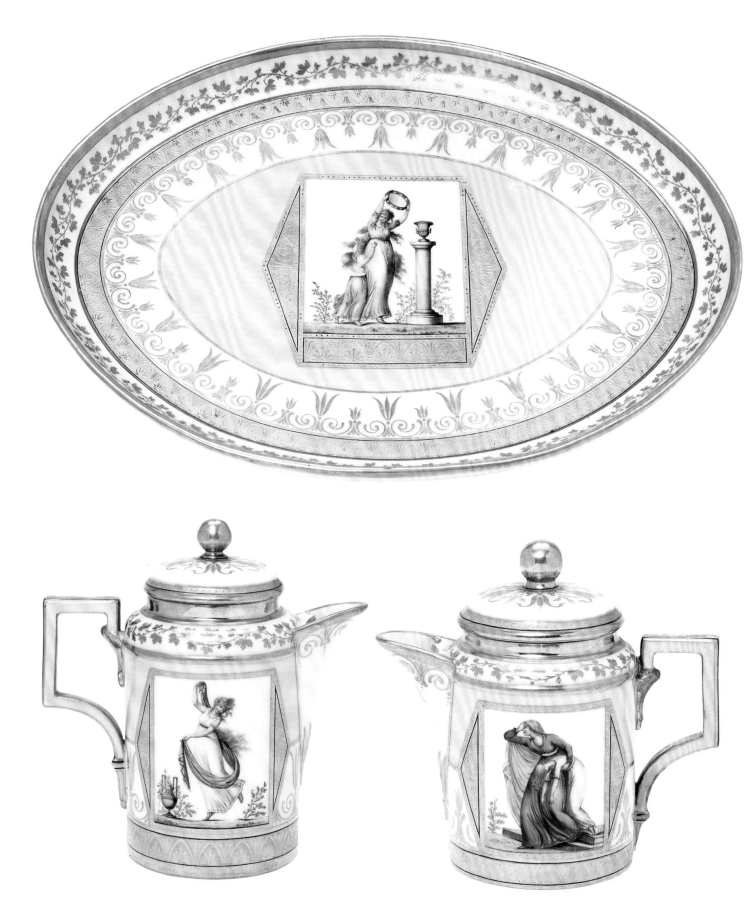

INTERNATIONAL CELEBRITY: AN ARTIST ON HER OWN TERMS?

Königliche Porzellan-Manufaktur Berlin
Porcelain service, *c.* 1795
The Clive Richards Collection

The images that appear on this lavishly produced service were taken from Friedrich Rehberg's *Drawings Faithfully Copied from Nature at Naples* (another example can be seen on p. 20). Together, they demonstrate the extent of Emma's European fame and influence.

be regarded as a curious by-way in her career, though they are increasingly receiving more attention in art history and performance studies. As I have suggested here, they were part of an innovative trend in the 1780s that produced synergies between the pictorial and the plastic arts and a new kind of theatre, melodrama, that sought for new ways of expression, to make silence speak and apparently static or lifeless bodies move. As the drawings of Novelli and Artaud suggest, the Attitudes anticipate the grammar of cinema in the form of the montage-like relationship between each identity Emma assumed, such as the transition from Medea to Niobe. Moreover, the intimacy of the theatre of the Attitudes, its exploitation of a sense of a private, individual relationship with Emma as star performer, foreshadows the conditions of viewing in cinema: the contemplation in the dark of a moving image of a person that is both distant and knowable at the same time. In this respect, Emma was the foremother of the silent film stars Lillian Gish, Louise Brooks, and even Greta Garbo. No other female performer in the eighteenth century achieved this kind of effect: to paraphrase Herder on sculpture, she was present, she stood there, she endured.

DRAWINGS

Faithfully copied from Nature
AT NAPLES
and with permission dedicated

To the Right Honourable
SIR WILLIAM HAMILTON.
His Britannic Majesty's Envoy Extraordinary and Plenipotentiary
at the Court of Naples.

By his most humble Servant
FREDERICK REHBERG
Historical Painter in his Prussian Majesty's Service at Rome
MDCCXCIV.
Engrav'd by Thomas Piroli.

Picturing Performance: Emma, Friedrich Rehberg and the Attitudes

George Romney's studio gave Emma an early and thorough training in capturing and holding an 'attitude'. Inhabiting the personas that Romney drew from ancient mythology, Old Master paintings and Shakespearian drama provided her with a store of intellectual reference and performative experience. Within little more than a year of her arrival in Naples in 1786, and with the enthusiastic encouragement of Sir William Hamilton, this talent had taken a new form. Before long, the model would become the artist, and her body and costume would be the artwork. In the process, the controlling presence of male cultural authority was subtly challenged. Hamilton, the noted connoisseur, was left literally on the margins while Emma prescribed poses with a fluidity and conviction that spoke of independent inspiration rather than mere coaching. Wearing simple Grecian costume, and using a few props, she made a sequence of dramatic poses and the transitions between them seem effortless and magical. This was not a performance of dance, and it was often apparently simple movements – letting down her hair, rapidly positioning a shawl or adjusting her expression – that Emma used to conjure a different persona.

Audiences at Hamilton's Palazzo Sessa were captivated by Emma's translation of familiar cultural forms into alluring novelty. Her Attitudes became a sensation, and an essential component of any Grand Tourist's itinerary. One of many artists drawn to Emma and her theatrical skills was the Hanoverian painter Friedrich Rehberg, who travelled to Naples in 1791. He adopted a sparse style shorn of contextual detail; his crisp delineation capturing moments from the Attitudes and pinning them to the page. In some respects, his studies of Emma reflect Rehberg's interest in the scholarly classicism of Johann Joachim Winckelmann. The purity of the resulting forms – simple dark lines on white paper – would have met with the latter's approval. However, in some cases, their failure to articulate a sense of movement suggests static statuary rather than kinetic art. Rehberg's drawings were engraved by Tommaso Piroli and published in Rome in 1794 (an image of their title page can be seen opposite). The volume – *Drawings Faithfully Copied from Nature at Naples* – helped to spread Emma's fame across Europe from pictorial art to female fashion. The twelve Attitudes originally chosen by Rehberg (which comprised only a small part of Emma's repertoire) included: figures from Greek mythology such as a Sibyl (I), the Muse of Dance (VI) and Niobe (XII); characters from classical history such as Sophonisba (IV); and a biblical figure, Mary Magdalene (II).

I

PICTURING PERFORMANCE: EMMA, FRIEDRICH REHBERG AND THE ATTITUDES

II

163

III

PICTURING PERFORMANCE: EMMA, FRIEDRICH REHBERG AND THE ATTITUDES

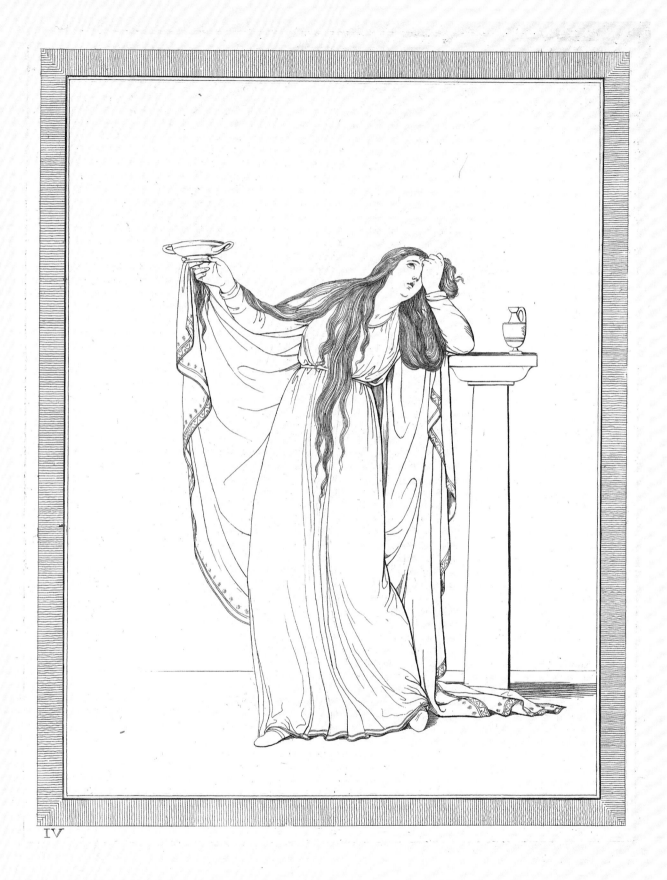

IV

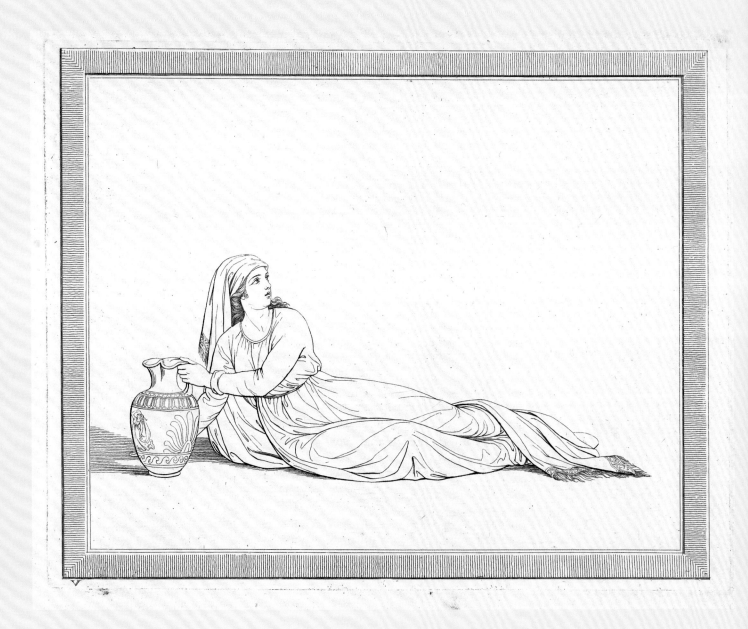

PICTURING PERFORMANCE: EMMA, FRIEDRICH REHBERG AND THE ATTITUDES

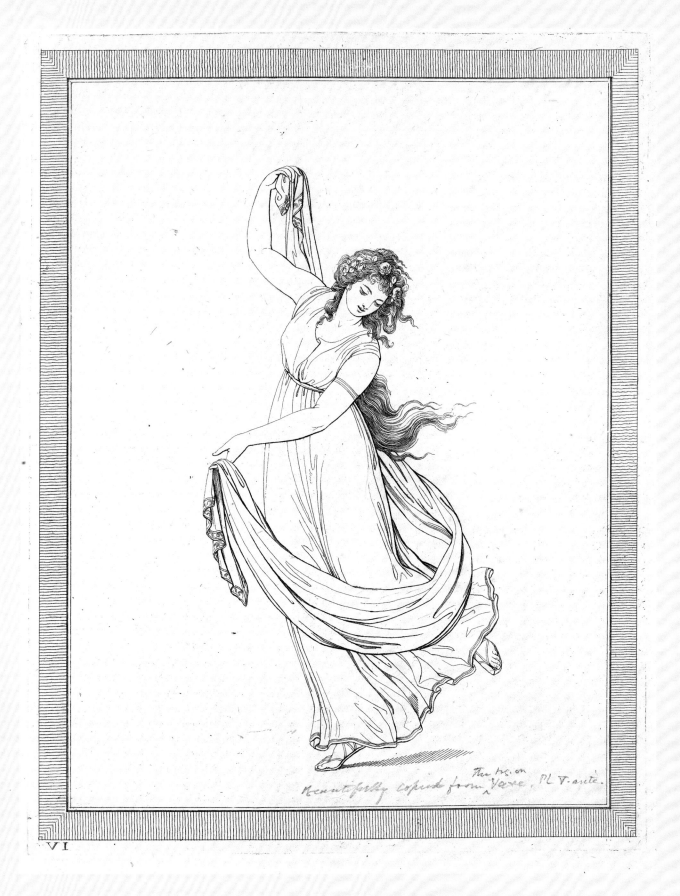

Beautifully copied from Vase, Pl. V. ante.

VI

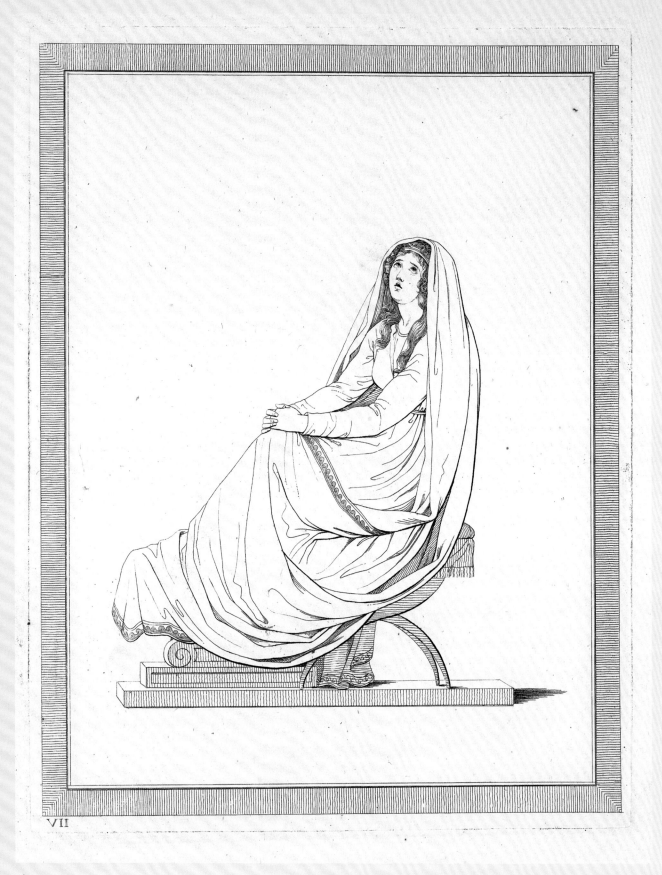

VII

VIII

IX

XI

XII

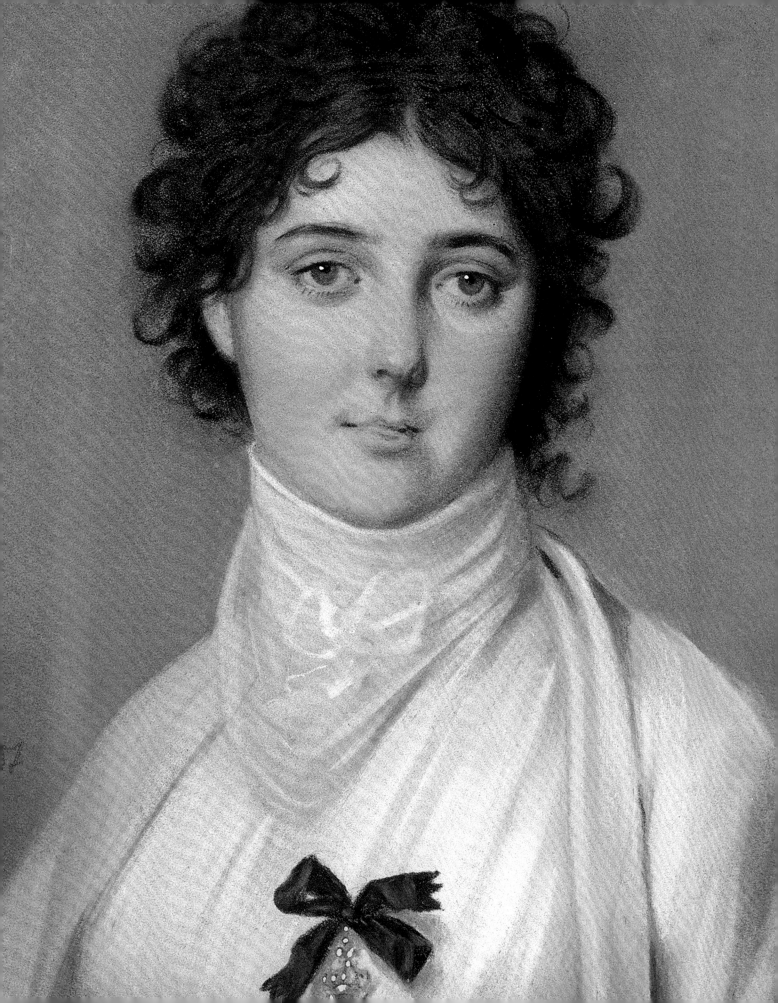

Margarette Lincoln

Emma and Nelson
Icon and Mistress of the Nation's Hero

5

Emma's marriage to Sir William Hamilton in 1791 added social prestige to the considerable cultural acclaim that she had already accumulated. As the wife of the British envoy she occupied a position of distinction within the Neapolitan court, and rapidly cemented a close friendship with Maria Carolina, Queen of Naples and Sicily. However, the elevated stage upon which she now stepped – one so distant from her humble origins – was beset by looming anxieties. The French Revolutionary War engulfed Europe from the spring of 1792, when France declared war on Austria. Louis XVI was executed in January 1793, precipitating Britain's entry into the conflict at the start of February, and his queen, Maria Carolina's beloved younger sister Marie Antoinette, followed him to the guillotine in October. In 1796, Napoleon's army crossed the Alps and headed into northern Italy, sweeping all before it. Further to the south lay Naples, where Maria Carolina and her husband King Ferdinand IV increasingly feared for their own throne.

Once Britain had entered the war against France, Emma exploited her new status to further the Royal Navy's interests in the Mediterranean, a course that happily matched her wish to reinforce her influence with Maria Carolina (who, in turn, saw her as a useful instrument in advancing her own agendas). Emma met Nelson for the first time in 1793, when he was briefly sent to Naples to secure troop reinforcements from King Ferdinand to help defend Toulon. She and Sir William – amiable, cultured and centre-stage in the Neapolitan court – easily struck up a rapport with him. In 1798, now a rear-admiral, Nelson was charged with hunting down a huge French expeditionary force in the Mediterranean. Sir William did his best to send him intelligence and both he and Emma anxiously followed his progress. When Nelson secured his

Johann Heinrich Schmidt
Emma, Lady Hamilton
(detail), 1800
Pastel on paper
National Maritime Museum
PAJ3940

Dominic Serres

Arrival of their Sicilian
Majesties at Naples,
12 October 1785, 1787
Oil on canvas
National Maritime Museum
BHC0458

This painting shows the
splendour in which the
Neapolitan royal family
periodically toured their
dominions. This was the
world of political theatre and
spectacle to which Emma now
enjoyed unfettered access.

remarkable victory at the Battle of the Nile on 1 August, Naples was the first to hear. Emma herself took the news to Maria Carolina, which brought huge relief to the whole court.

As soon as Nelson's flagship, *Vanguard*, sailed into Naples bay some seven weeks after the battle, Sir William and Emma were rowed out to meet it. Nelson described the encounter in a letter to his wife, Fanny. The couple came on board to greet him and Emma cried out, 'Oh God! Is it possible!' then, half swooning, fell towards him, more dead than alive. A moment of high drama, the action would have required some calculated dexterity on Emma's part since by now she was no lightweight and Nelson, tired and still recovering from a serious head wound, had just the one arm with which to catch her.

Emma at once took charge of Nelson's welcome in Naples. He was hailed as a hero and deliverer, and fêted at dances and receptions on a scale hitherto quite unknown to him. On his fortieth birthday, Sir William gave him a ball attended by 1,740 people. The contrast between this lavish entertainment and the strain he had recently been under during the three-month chase after the French

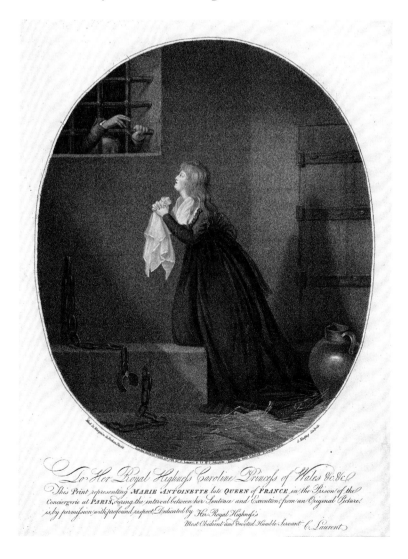

George Keating after the Marquise de Brehan
Marie Antoinette late Queen of France in the Prison of the Conciergerie at Paris, 1796
Stipple engraving
Royal Collection
RCIN 617457

EMMA AND NELSON: ICON AND MISTRESS OF THE NATION'S HERO

George Arnald
The destruction of *L'Orient*
at the Battle of the Nile,
1 August 1798, 1825–27
Oil on canvas
National Maritime Museum,
Greenwich Hospital Collection
BHC0509

Attributed to Giacomo Guardi

The arrival of *Vanguard* with
Rear-Admiral Sir Horatio
Nelson at Naples,
22 September 1798, c. 1800
Watercolour and gouache
National Maritime Museum
PAG9746

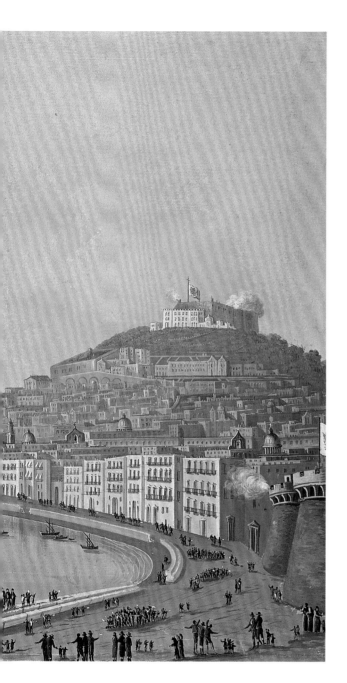

fleet could not have been greater. He was emotionally vulnerable and often unwell, still suffering from fatigue and his wound. Sir William and Emma warmly invited him to convalesce at their house, the Palazzo Sessa. Adorned with Sir William's antique vases, statues and paintings, these enchanting surroundings further helped to turn his head.

Emma may at first only have strived to gain Nelson's support for Maria Carolina's foreign policies, in which the queen was determined to avenge her sister's death. Yet Nelson found Emma's teasing flattery both new and captivating. On finding him disappointed that he would only be made a baron for his great victory, although other officers had been promoted to higher ranks for less service, she quipped: 'If I was King of England, I would make you the most noble present, Duke Nelson, Marquis Nile, Earl Aboukir, Viscount Pyramid, Baron Crocodile, and Prince Victory.'[1] The diplomat Sir Gilbert Elliot, who had many opportunities to observe Emma, once said (as Chapter 3 notes) that she was 'all Nature, and yet all Art'.[2] Sir William also encouraged her flirtatious conversations with men, provided he was present himself, and seems to have been amused by her bravado. Emma was now thirty-three and her husband sixty-eight. A realistic man of the world, he had always known that there would come a time when he was sexually no match for her. Sincerely attached to Emma, he complaisantly accepted her developing relationship with the forty-year-old Nelson, to whom he also became greatly attached, and may even have thought it a means of keeping her by his side in old age.

Nelson was a loyal monarchist but his deference to the king and queen of Naples was politically naïve. It led him to exceed Britain's immediate interests in the region and to support their belligerent project to occupy Rome and Leghorn (Livorno), the latter already under French occupation. Duly provoked, France

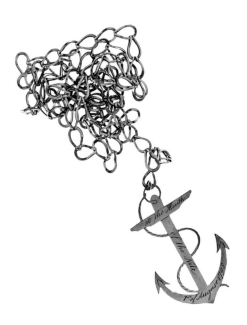

declared war against Ferdinand and marched on Rome in 1798. The Neapolitan army panicked and retreated in disarray, and Naples itself was soon threatened. Nelson used his fleet to evacuate the court, including Sir William and Emma, from Naples to Palermo, King Ferdinand's Sicilian capital. He sailed on Christmas Eve, 1798. It proved a dreadful passage: a storm blew so violently that the passengers feared for their lives and Maria Carolina's youngest son, Prince Albert, died of convulsive fits in Emma's arms. Sir William was found in his cabin, hugging loaded pistols, prepared to shoot himself, as he said, rather than die with the 'guggle, guggle, guggle' of salt water in his throat.[3] Only Emma proved equal to the emergency, a display of spirit that would have endeared her to any seaman.

Nelson was to remain at Palermo for the next five months, overseeing his commission in the Mediterranean almost exclusively from a shore base that kept him close to Emma. In England, his wife was becoming increasingly anxious about his prolonged absence and infrequent letters. On 11 April 1799,

Above
Gold pendant and chain,
c. 1798
National Maritime Museum
JEW0145

Jewelry in the form of anchors was widely produced to commemorate the Battle of the Nile. Fashionable accessories such as these were a means for women to make patriotic or political statements. As Emma wrote to Nelson: 'Even my shawl is in blue with gold anchors...My earrings are Nelson's anchors; in short, we are be-Nelsoned all over.'

Right
Leonardo Guzzardi
Rear-Admiral Sir Horatio Nelson,
c. 1799
Oil on canvas
Ministry of Defence Art Collection
MOD4177

Commissioned by Sir William Hamilton from an Italian artist, this candid painting suggests the burdens of injury and responsibility that Nelson carried in the period following his victory at the Nile.

Opposite
Camillo Landini
Maria Carolina, Queen of the Two Sicilies, 1787
Oil on canvas
Museo di Capodimonte

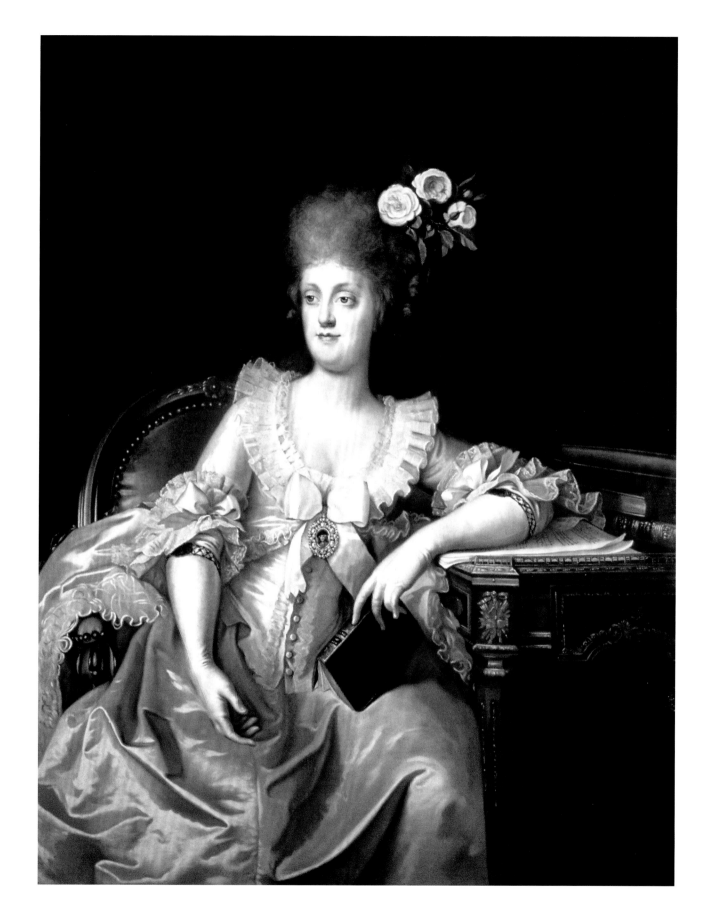

she wrote to Nelson's agent, Alexander Davison, of her disappointment: 'Lord Hood always expressed his fears that Sir W. & Lady Hamilton would use *their influence*, to keep Lord Nelson with them:– they have succeeded.'[4] Meanwhile, in the Mediterranean, some of Nelson's captains who disapproved of his involvement with the corrupt Neapolitan court tried to disentangle him from Emma. Alexander Ball was appalled at the critical paragraphs about the couple printed in London newspapers. He and Thomas Troubridge used Nelson's health as an excuse to dissuade him from the nocturnal parties and gambling sessions of the court in Palermo. They also wrote to Emma, warning her of the construction people were putting on her doubtless innocent (as they said) behaviour. This was the period when society women in London were being pilloried for holding illegal gambling parties, an activity that was deemed wholly unpatriotic in wartime. Emma promised to gamble no more but it was too late to stop the rumours about her relationship with Nelson.

In early 1799, Naples had been overrun by the French and by local republicans. By summer, forces loyal to Ferdinand had managed to contain the revolutionaries. At this point, Nelson was pressurized into securing the royalist position in Naples, despite increasing Admiralty disapproval of his views on its importance to Britain. Emma was determinedly on the side of the king and queen, and it seems that Nelson was acting under their combined influence when he proved utterly ruthless in his dealings with republicans who surrendered. He endorsed the summary hanging of their leader, Admiral Caracciolo, and was unmoved by the execution of a hundred and twenty others in Naples, with the exile or imprisonment of thousands more. Even if his actions were not strictly illegal, his complicity in the cruel revenge of the Neapolitan royalists was a blot on his reputation and many in London openly credited Emma with having encouraged the barbarity. This was not socially acceptable female behaviour, and elite women at home withdrew their earlier admiration for her. Evidently too, Sir William, the nation's minister on the spot, had neglected to provide Nelson with judicious counsel. The shameful episode probably also made it easier for British officials to ignore later pleas that Emma

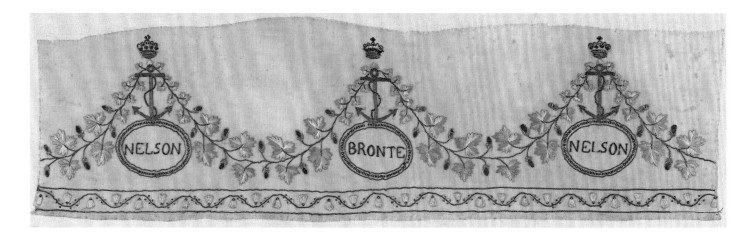

Edgar Albert Benford
Modern full-hull model of
Foudroyant, an eighty-gun
ship of the line, 1798
National Maritime Museum
ZBA2414

In 1799, this vessel served
as Nelson's flagship during
his suppression of anti-
monarchist forces in Naples.
Emma and Sir William were
present on board throughout.

Conrad Heinrich Küchler
Gilt-bronze medal commemorating
the restoration of King Ferdinand IV
to his throne in Naples, 1799
National Maritime Museum,
Greenwich Hospital Collection
MEC1159

Nelson's bust appears in a cartouche
on the reverse of the medal.

should receive a pension for her services to the nation, although during her time in Naples she had undoubtedly worked to promote British interests there.

In late 1799, Lord Elgin stopped in Palermo on his way to Constantinople where he would take up the post of ambassador. He reported dispassionately that Nelson looked 'very old, has lost his upper teeth, sees ill of one eye, and has a film coming over both of them...His figure is mean, and, in general, his countenance is without animation'.[5] Lady Elgin, travelling with her husband, wrote to her mother that Emma had Nelson in thrall. In London, their affair was the gossip of drawing rooms. Nelson's behaviour had caused Fanny to be 'sadly hurt and out of humour' in April 1799, and she would later recall that, even at court, she was confronted with rumours of the affair.[6] The following spring, the ineffectual Sir William was duly superseded at Naples. Nelson was also increasingly anxious to return to England for health reasons, but was refused permission to deprive the Mediterranean fleet of an operational naval ship in which to sail home with the Hamiltons. After conveying the Queen of Naples to Leghorn, all three opted for an overland return, departing initially for Florence with a number of other British travellers on 13 July 1800. Nelson's relationship with Emma had almost certainly been consummated by January that year: she was now pregnant.

On the way back, they stayed five weeks in Vienna, partly so that the ailing Sir William could recover his strength. Nelson was much fêted in public and his party was also entertained by Lord Minto, now ambassador there. Minto's wife eagerly reported that Nelson habitually described Emma as an 'angel' and that she led him about like a keeper with a bear. To outsiders, Nelson's relationship seemed to compromise his virility rather than enhance it: the hero of the Nile seemed inexplicably and totally in Emma's power. Nelson, of course, knew that she was pregnant with his child, a sure sign of his virility, whereas his thirteen years of marriage to Fanny had been childless.

The fifteen-week journey to England gave Emma time to strengthen her hold on Nelson. Equally, the long wait for the hero's return fanned the rumours in London of his illicit relationship. Fanny's correspondence that autumn shows

she became increasingly tense and nervous as she made preparations for his arrival. Unfortunately, letters between Nelson and Fanny around the time of his homecoming led to confusion as to whether he would meet her at Roundwood, the house he had purchased just north of Ipswich, or in London. In the event, he and the Hamiltons went first to Roundwood, only to find it empty. This tested his patience and embarrassed him. When eventually he met up with his wife and elderly father, in the hall of a hotel in St James's, London, there was no easy opportunity for private conversation. Nelson may have imagined that Fanny would be as obliging about his illicit relationship as Sir William appeared to be. Given the double standards of the day such thinking might be understandable – Lord Minto's second establishment was an open secret, after all – but that was not Fanny's position. It was neither compatible with her 'middling class' views nor her personality. Soon afterwards, when Nelson's party went to the theatre, the famous admiral sandwiched between his two women, she fainted and had to be carried out of the box. Ostensibly Fanny was affected by the heat but some thought her

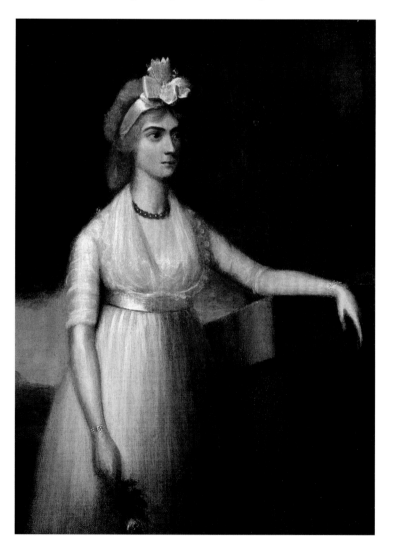

Unknown artist, British school
Frances Nelson (detail),
c. 1800
Oil on canvas
National Maritime Museum
BHC2883

Lord NELSON's *Reception at* FONTHILL.

fainting fit was due to extempore lines included in the play, *Pizarro*, about the fury of a woman scorned.

Whatever Emma's expectation, she could not be received at George III's court, any more than at her previous attempt in 1791: London was not Naples. Immediately on their return, Sir William made his bow at court without her. Nelson wrote angrily that he should not have gone without his wife but Sir William was the better judge of protocol. Sir William, aiming for a pension and a place, was anxious to maintain his courtly contacts, and Emma was a severe hindrance to his prospects. Moreover, at the levee on 12 November, George III roundly snubbed Nelson. Having asked peremptorily about his health, he turned away before Nelson could give an answer. Nelson's relationship with Emma was now the butt of satiric prints. That Christmas, he and the Hamiltons were guests of the fabulously wealthy William Beckford, a distant cousin of Sir William's in Wiltshire (Fanny was not invited). They spent one evening at Fonthill Abbey, Beckford's ostentatious Gothic Revival building, where Emma performed her Attitudes despite being heavily pregnant.

Above

James Gillray

Dido in Despair!, 1801

Hand-coloured etching

National Maritime Museum PAF3874

This print satirizes the scandalous
relationship between Emma Hamilton
and Nelson, casting them in the roles
of Dido and Aeneas. Emma's cuckolded
husband sleeps by her side, while the
warships seen through the opened window
tell of her lover's departure to sea.

Right

S. W. Fores (publisher)

*A Mansion House Treat or
Smoking Attitudes*, 1800

Hand-coloured etching

National Maritime Museum PAF3887

Emma and Nelson are pictured on the right
engaging in heavy-handed *double entendre*.

This fantastic and wonderful banquet was reported in the magazines and fired publicity surrounding the threesome.

In January 1801, Nelson and Fanny jointly signed a paper selling Roundwood, which they had never lived in together, having apparently decided that the house was not in a convenient location. Shortly after this decisive step, a rift between them seems to have taken place. Nelson's lawyer reported many years later:

> I was breakfasting with Lord and Lady Nelson…when Lord Nelson spoke of…
> 'dear Lady Hamilton'; upon which Lady Nelson rose from her chair, and exclaimed,
> with much vehemence, 'I am sick of hearing of dear Lady Hamilton, and am resolved
> that you shall give up either her or me.' Lord Nelson, with perfect calmness, said:

A COGNOCENTI contemplating ỹ Beauties of ỹ Antique.

189

'Take care Fanny, what you say. I love you sincerely, but I cannot forget my obligations to Lady Hamilton, or speak of her otherwise than with affection or admiration'. Without one soothing word or gesture, but muttering something about her mind being made up, Lady Nelson left the room, and shortly afterwards drove from the house. They never lived together afterwards.[7]

The lawyer's account, written from memory with the benefit of hindsight, is probably embellished, but Fanny might easily have felt her position to be intolerable. The domestic situation was saved for the moment by Nelson's recall to duty. In January 1801, he was appointed second-in-command of the Channel Fleet, promoted to vice-admiral of the blue and duly hoisted his flag in the *San Josef* at Plymouth. In the spring he moved his flag to the *St George* and sailed as second-in-command to the Baltic, securing a further notable victory at the Battle of Copenhagen on 2 April.

Meanwhile, in London, Emma was preparing for the birth of her child at 23 Piccadilly, where she lived with Sir William. On 29 January she had a girl, Horatia. The baby was less than a week old when Emma took a hackney cab to a pre-arranged nurse, a Mrs Gibson, keeping the baby warm and hidden in her large, fashionable muff. Later, when Horatia was christened, her birthday was given as 29 October, a date when both Nelson and Emma were out of the country. On 3 February newspapers reported that Emma went in full evening dress to a grand concert given by the Duke of Norfolk at his house in St James's Square. She needed to be seen in public at this time, in spite of any risk to her health, in order to save her reputation. Davison called on her the next day to collect a packet of letters for Nelson and reported, perhaps disingenuously, that she had 'grown thinner' but looked 'handsomer than ever'.[8]

Nelson was ecstatic on hearing news of the birth. Emma, doubtless feeling vulnerable since his joy did not allow her to put the child away, still wished to make sure of his affections. She attempted to make Nelson jealous by telling him that she and Sir William were about to entertain the Prince of Wales, a notorious womanizer. Like Lady Nelson, but in a very different way, she was not always good at the kind of letters naval wives should send their husbands: cheerful loving ones full of inconsequential domestic issues that had already been resolved were ideally what was required. It was folly to raise anxieties that a distant partner could do nothing about. On receiving Emma's news about the Prince of Wales, Nelson was beside himself with rage and jealousy. In fact, Emma became so concerned at the storm she had raised that she was forced to ask Sir William to send him a placating letter. Hamilton tactfully explained that he had used all his powers to persuade a reluctant Emma to receive this royal attention. He assured Nelson that he was properly alert to the danger but had judged it unwise to offend his prince while still hoping to secure a pension.

Once it became evident that Fanny would not be reconciled to her husband's adulterous relationship, Emma worked hard to break the Nelson marriage entirely. She spread gossip about Fanny, who had hastily left London for

Brighton. When trying to hire one of Fanny's servants as butler to the Hamilton household, she commented to him, 'I am extremely surprised at Lady Nelson's leaving London at this time of year…I cannot think the reason of it, to my knowledge Lord Nelson allows her [£]2000 a year and with that she might make a pretty appearance'. Fanny was peeved when she found out, writing, 'none of us I believe like the servants to know our incomes'.[9] Emma also courted Nelson's relations, whom she feared might take Fanny's side and persuade Nelson to remain faithful. She cruelly began to call Fanny by the nickname 'Tom Tit', reflecting the awkward way in which she walked, and later contributed to the view that Fanny was a frigid wife.[10] The truth is that Fanny did try to repair her marriage. She was economically dependent on Nelson and as a rejected

Attributed to Guy Head
Rear-Admiral Sir Horatio Nelson, c. 1800
Oil on canvas
National Maritime Museum,
Greenwich Hospital Collection
BHC2903

This theatrical and intimate portrait, showing a wounded Nelson at the Battle of the Nile, is believed to have been owned by him and was possibly intended as a love token for Emma.

Overleaf
Johann Heinrich Schmidt
Emma, Lady Hamilton, and Admiral Nelson, 1800
Pastel on paper
National Maritime Museum
PAJ3940 and PAJ3939

This pair of portraits was painted while Nelson and the Hamiltons were in Dresden during their return journey to England. Nelson subsequently hung Emma's in his cabin when at sea, including in *Victory* from 1803 to his death at Trafalgar. She is shown wearing the order of the Knights of Malta, awarded by Tsar Paul of Russia for her work in obtaining shiploads of corn for the starving Maltese in 1799. The Tsar was Grand Master of the Order of Malta.

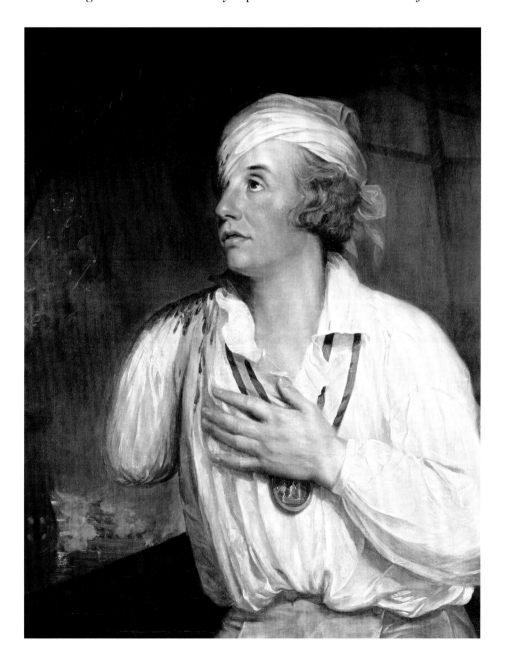

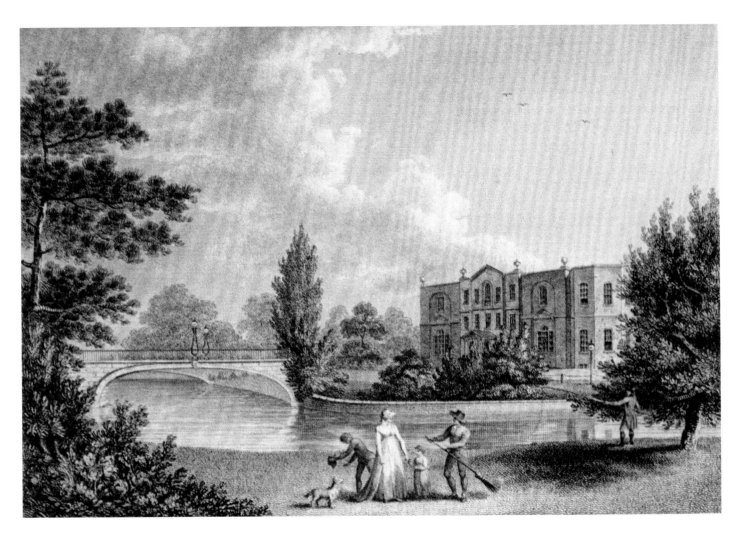

William Angus, after
Edward Hawke Locker
Merton Place in Surry,
the seat of Admiral
Lord Nelson, 1804
Etching
National Maritime Museum
PAD3982

wife her social status was irrevocably lost. Moreover, her affection for him was genuine, if undemonstrative. At this difficult time, members of his family and their joint acquaintances gave her hope that he would return to her. Yet Nelson adamantly rejected her attempts at reconciliation and, in the end, Emma seems to have encouraged Nelson to write to Fanny in terms that made it clear he never wished to see her again.

Nelson's treatment of his wife and the public display of his mistress were totally out of accord with the times. The prevailing rhetoric during these war years was of heroic soldiers and sailors serving their country overseas while remaining faithful to their wives and sweethearts. Meanwhile, with their menfolk away, equally patriotic, supportive wives were selflessly maintaining the home and bringing up the children. The problem was not that Nelson had taken a mistress but that he had openly treated his wife so badly.

Having sold Roundwood, Nelson had no home of his own. He desperately wanted a house where, he imagined, he might live with his new family. He entrusted Emma to look for a property and eventually she settled on Merton Place, seven miles from London. Naval wives were used to maintaining the

Above
Mirror, early nineteenth century
Private collection

Emma took a particular interest in purchasing mirrors for Merton Place. This example, with naval and Nelsonian motifs, may have been among them.

Right
Satinwood veneer pier table made to a Sheraton design, late eighteenth century
National Maritime Museum, Nelson-Ward Collection
AAA3193

Said to have been purchased by Nelson, this table was used to furnish Merton Place.

home in their husband's absence: some even ran large estates, but it was unusual to purchase a property sight-unseen – as Nelson did Merton – on the advice of a woman, and Sir William opined that only a sailor would do so. Emma now had ample opportunity to act out the role of naval wife and set about furnishing Merton in preparation for Nelson's homecoming. While competent naval officers' wives promoted their husbands' interests, paving the way for promotion or other office, Emma took this to extremes and decorated Merton in a way that excessively promoted Nelson's image. Even his friend Lord Minto objected:

> The whole house, staircase and all, are covered with nothing but pictures of her and him, of all sizes and sorts, and representations of his naval actions, coats of arms, pieces of plate in his honour...an excess of vanity which counteracts its own purpose. If it was Lady H's house there might be a pretence for it; to make his own a mere looking-glass to view himself all day is bad taste.[11]

In an age when the elite were distinguished by their cultured taste, Minto's disparaging comment on Emma's is a devastating swipe at her status. He also alludes to the fact that, commonly, a husband and wife would agree on interior decoration. It was one of the pleasures of setting up home together.[12] Emma, who was not Nelson's wife, was in danger of appearing to usurp that role.

Meanwhile, Horatia was still with Mrs Gibson. Nelson, like most naval fathers at sea, sent advice for his child's upbringing and took a keen interest in her progress. He repeatedly asked Emma to establish the child permanently at Merton but in this matter she did not carry out his wishes. Emma placed greater importance on preserving her reputation, not least with Nelson's relatives, and did not want to be visibly or closely connected with the child.

Nelson first came to Merton on 23 October 1801. He stayed there with the Hamiltons during the Peace of Amiens, 1802–03, though Sir William maintained his Piccadilly town house for the sake of appearances. This was

a happy period for Nelson, who had never lived in his own home before. Emma set about making a series of improvements to the property, which would later contribute to her financial ruin.

In July 1802, Nelson and the Hamiltons set off for a six-week tour of Wales and the West Country. At Worcester, they visited a china factory and ordered a set of tableware for Merton. It was to be decorated with Nelson's coat of arms. This, too, was an incongruous visit, since such purchases were usually made by husband and wife; and the china was never paid for.

Horatia was still excluded from Merton so that her existence was kept from Nelson's family, but Emma invited his relations and gave balls for the young people. Sir William, finding it increasingly hard to cope with the whirl of entertainment, complained about the numerous people at dinner and also the expense. At his age, he only wanted peace and a little fishing, and made this very clear to Emma:

> I feel that the whole attention of my wife is given to Ld. N. and his interest at Merton. I well know the purity of Ld N's friendship for Emma and me, and I know how very uncomfortable it would make his L[ordshi]p, our best friend, if a separation shou'd take place & am therefore determined to do all in my power to prevent such an extremity, which wou'd be *essentially detrimental* to all parties, but would be more sensibly felt by our dear friend than by us. I cannot expect to live many years, every moment to me is precious, & I hope I may be allowed sometimes to be my own master, & pass my time according to my own inclination, either by going [on] my fishing parties on the Thames or by going to London to attend the Museum, R[oyal] Society, the Tuesday Club, & Auctions of pictures.[13]

Since Sir William was frequently absent from Merton, Nelson's fifteen-year-old niece Charlotte was invited to stay as chaperone. Ostensibly it was an opportunity for her to be tutored by Emma in music and foreign languages. Yet whatever proprieties were observed, several of Nelson's naval acquaintances shunned Merton.

Emma was a woman who had learned to live by her wits. Her return to London from Naples must have been a disappointment. She was attached to two men, neither of whom had sufficient money to satisfy her expensive tastes. These were now driven not only by the need to keep up appearances but also to forge relationships with Nelson's family, whom she cultivated with presents. She also had a child, a secret that could ruin her. Yet because Nelson doted on Horatia, she could not give up the baby as she had done her previous daughter by Sir Harry Fetherstonhaugh, who had been brought up in Cheshire.

After Sir William's death in April 1803, Emma's position was even more difficult. Her husband had instructed his executors to discharge her debts but he left her an annuity of only £800, half the amount Nelson had provided for Fanny. Out of this, £100 annually was to go to Emma's mother, Mrs Cadogan, who effectively acted as her housekeeper. Nelson advised economy as far as Merton was concerned but Emma was incapable of prudence. Exposed to the glare of society and in danger of sliding down the social scale, she also needed expensive goods and furnishings to establish her status. When Nelson returned to active service, he urged Emma to make Merton her permanent home. Instead, she took a house in Clarges Street, Piccadilly. She invited Nelson's young relations to spend holidays with her and lavished gifts on them that she could not pay for. It remained essential that she secure their friendship

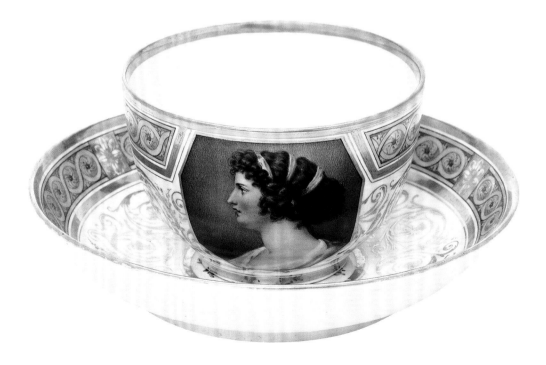

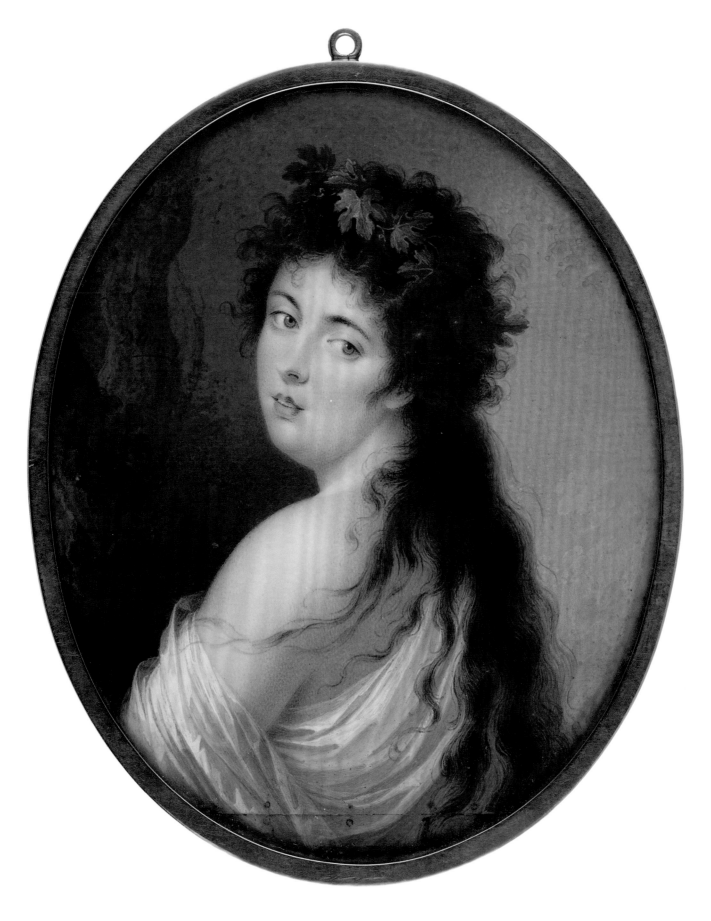

so that they continued to prefer her to Fanny, his legal wife. Very soon she had importunate creditors. Even Mrs Gibson went unpaid, although Nelson regularly sent money for Horatia's maintenance. Moreover, in 1803 Emma was once again pregnant with Nelson's child, though the baby did not survive.

Yet if the elite and aspirational elements of society refused to recognize the couple, their relationship made no difference to Nelson's reputation with the common people, and Nelson never kept his love affair secret from his fellow officers: he always took Emma's picture to sea and hung it in his cabin. They were sincerely in love but their affair was nevertheless entwined with self-serving elements that critical observers easily mistook for cynicism. After all, Emma's link with Nelson put her on the public stage and offered the drama she craved to add zest to her life. Nelson, for his part, had found the warm, uncritical adoration he needed and could revel in having captured a famous beauty, which bolstered his reputation for virility. Nevertheless, circumstances were against them: the passion that burned brightly in Naples, where the court was lax and money was no issue, was more difficult to support in London, where social conventions and creditors were rife. Emma was not even able to enjoy motherhood: Horatia did not live at Merton for any length of time until Nelson's brief period of leave before embarking in September 1805 to seek the combined French and Spanish fleet, which he finally brought to action off Cape Trafalgar, south of Cadiz, on 21 October. Such fleeting moments of shared domestic ease implanted in both their minds the notion of 'paradise Merton', as Emma described the house in her last letter to Nelson. Their companionate enjoyment of this idyll was, however, more accessible through wish-fulfilling fantasy than the more complex and troubled reality.

Hannah Greig

Decline and Fall
Social Insecurity and Financial Ruin

6

On 15 January 1815, Emma Hamilton died. In marked contrast to her youthful career as famous muse and beauty, aspirational diplomat and fashionable celebrity, the last few months and weeks of her life were bleak and lonely. Having fled to France to escape creditors, her last days were spent in cheap lodgings in Calais. Destitute, Emma's only funds by late 1814 were £30 obtained by Horatia, the illegitimate daughter who accompanied her to France and there, aged fourteen, watched her die. The French newspapers that published the first news of the event described her simply as the 'celebrated Emma'.[1] In her final days, though, there was little that suggested celebrity. There were no jewels, no glamorous clothes, no social invitations, no singing, no Attitudes and no famous friends for company in Calais. In many ways, Horatia was the only remaining vestige of her former life. Emma's physical death came after a social demise that was just as cruel and which had begun ten years earlier. This final chapter explores the dramatic and ultimately devastating decline in Emma's identity and fortunes.

At first glance, when Nelson set sail in pursuit of the French fleet in September 1805, Emma appeared enviably placed. The death of Sir William Hamilton in April 1803 had left her a titled widow, a position that brought with it a combination of independence and status denied even to aristocratic women at other stages of life. From her accommodation in Clarges Street, she dusted herself out of mourning and ventured forth into London's busy social scene, under the guise of introducing Charlotte Nelson (Nelson's niece) into the world. 'We are respected and could be out all day', she wrote with ill-concealed delight to a friend.[2]

Emma appeared to have no shortage of invitations. Newspaper columns dedicated to fashionable society noted the regular presence of the dowager Lady Hamilton at the opera, theatre and at private concerts and assemblies in the seasons of 1803, 1804 and 1805. She was, for example, to be found among the 'select assemblage' of 'fashionables' who crowded, rode and walked in Hyde Park at the weekends; and she was identified (along with the Duchess of Bedford, Marchioness of Hertford and Lady Anne Smith) as a leader of fashion and a trendsetter to watch.[3] Such was the expectation that Emma would feature as a part of London's fashionable scene, that the *Morning Post* felt it necessary to explain her absence when she was confined to her house with a cold.[4] Wherever she went she made a stir. In June 1805, only a few months before Nelson returned to sea, she appeared at a masquerade hosted by the Countess of Barrymore. Whereas the other women took the chance to drape themselves with a gaudy display of diamonds, Emma – perhaps with a tongue-in-cheek nod to her past – dressed as a gypsy, co-ordinating with Charlotte Nelson, who went as a Neapolitan peasant. Given Emma's talent for performance, such costumes were no doubt intended to draw attention. The strategy seems to have worked, for it was Miss Nelson the press singled out from the crowd of debutantes as a rising star of society: 'amongst the many beauties we observed, none shone more conspicuously than the lovely and accomplished Miss Nelson'.[5]

A London profile was not the only string to Emma's bow. In 'paradise Merton' she had the promise of domestic comfort with Nelson, a place to call their own. Emma nested enthusiastically as soon as Merton was purchased, taking Nelson at his word when he declared 'it is as much yours as if you had bought it'.[6] Her sights set on the role of lady bountiful, she planned extensive renovations, including fitting out new kitchens, creating a double frontage with an enlarged entrance hall and new reception rooms. The grounds of the formerly ramshackle residence were also altered. Emma hired labourers, gardeners and builders – all in Nelson's name – to realize her plans. She planted kitchen gardens, introduced pigs and laying hens, and managed fish stocks (a tributary of the nearby river Wandle stood close to the house and was christened the 'Nile' in commemoration of Nelson's victory). With Emma at the helm, Merton was not, of course, envisaged solely as a quiet retreat. Rather, it was a place where Emma hoped to entertain society and firmly hitch her star to Nelson's.

There was, however, something unsettling about such exuberant gestures, and the foundations on which Emma was building her next dream were more fragile than they might at first have appeared. To begin with, it was quickly

Unknown artist
Needlework
picture in silk, early
nineteenth century
National Maritime Museum
TXT0057

This image was embroidered
after an illustration from Sterne's
A Sentimental Journey, and has also
been related to Emma and Nelson.

Mr BRAHAM in the character of ORLANDO.
to Mr THOˢ DIBDIN {the Author of the CABINET &c} this PRINT
is inscrib'd by his FRIEND........ ROBᵗ DIGHTON.
Drawn, Etch'd, & Pubᵈ by Dighton, Charˢ Croſs, march, 22ᵈ, 1802.

evident that Emma's widow's income of £800 a year was unlikely to meet her costly lifestyle. To be sure, such an income represented vast wealth to many. A housemaid's salary might be only £3 a year, a curate's £40, and a gentleman was said to be able to live comfortably in the country on £400 annual income from his land. In fashionable London, however, £800 was pocket change. At the same time, Merton was a thirsty investment, needing vast cash injections to create the 'paradise' stage set that Emma desired. Nelson provided her with a monthly allowance of £100 to cover Merton's running costs, but this was a pittance in comparison to the bills she was creating. Also, since Emma did not own Merton, she was not herself accountable for the costs that she was incurring, but her fast spending in all areas of her life revealed a complex relationship with cash. Soon after Hamilton died, Emma and her friends began to petition the government for her to receive a pension in recognition of the role she played as Hamilton's spouse in Naples. Such an award would, they all hoped, provide her with an increasingly necessary supplementary income.

Despite her claims of being 'respected' and in demand, Emma's footing in London society at the turn of the century, and her participation in fashionable circles, was not without its drawbacks and limitations. She could undoubtedly boast many an enviable invitation. Her presence at society gatherings, however, was often sought as much as an entertainer as a guest, and she was required to turn out her party pieces – staging her Attitudes and singing duets with professional performers – time and time again.[7] In consequence, her status at such events was uncertain. Was she a guest among equals, or an unpaid part of the cast of hired professionals booked to showcase the cultural capital and fashion leadership of the host? The quiet sneering about Emma's lack of polish, found in contemporary letters, reveals that she was always dogged by her dubious past and her lack of bloodline breeding.[8] Even the newspaper reports that helped promote her celebrity were not without the occasional spike. Queen Charlotte's refusal to allow Emma to be presented at her drawing

Letter from Nelson to
Emma, *c.* 5 February 1801
Jean Johnson Kislak Collection
1989.037.00.0002

Excited at his impending
fatherhood and concerned to
keep their child a secret, Nelson
writes here: 'Its name will be
Horatia Daughter of Johem &
Morata Etnorb. If you read the
surname backwards and take
the letters of the other names,
it will make...Lady H and myself'.

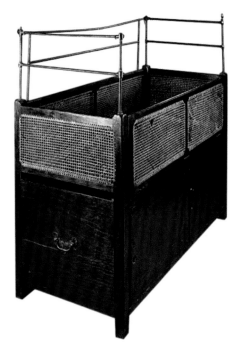

Mahogany and caned
cot, *c.* 1800
Jean Johnson Kislak
Collection
2006.017.00.0002

After belonging to Horatia,
this crib later passed to the
family of Nelson's sister,
Catherine Matcham.

room was an especially clear marker of her uneasy social position, and the newspapers underscored the significance of Emma's exclusion from court, reporting her absence from the drawing room week after week.

Marriage to Sir William Hamilton had offered Emma significant protection, even while society quietly gossiped about the status of her relationship with Nelson, not least since all three were clearly devoted to each other. Once Hamilton died, the problematic nature of her position as a mistress was harder to ignore. Without the shield of marriage and the company of her husband, her closeness to Nelson and their quasi-domesticity at Merton looked rather too dirty for the unspoken codes of fashionable society life. The shades of scandal that surrounded Emma were made shadier still by her ill-explained guardianship of Horatia. The public story of their relationship was that Emma was simply acting as a matronly influence on this unfortunate charge, in line with the fiction the lovers had constructed that she was his adopted child, daughter of a sailor called Thompson. It seems unlikely, however, that many observers missed the more probable truth. Emma was only one in a long line of society mistresses to have borne an illegitimate child, but hiding the evidence, so that such scandal might be resolutely ignored, was deemed essential in fashionable circles. Even the powerful and vivacious Georgiana, Duchess of Devonshire, was forced to abide by such principles and disguise the birth of a daughter by her lover Charles Grey, giving her up and never once acknowledging her. Others, like Lady Sarah Bunbury, kept their bastard child close but in so doing were forced into exile, excommunicated by fashionable society and removed

Silver muffin dish; silver-gilt sugar basin and cream jug, late eighteenth to early nineteenth century
National Maritime Museum
PLT0160; Nelson-Ward Collection
PLT0162; PLT0163

These objects were given to Horatia by Emma on the occasions of her birthdays in 1807 and 1811. The inscriptions give a false early date for Horatia's birth, used by Emma and Nelson to allay suspicions of their parenthood. For the same reason, that on the cream jug simply reads, 'From Emma Lady Hamilton To Her Dear Horatia'.

from the public gaze. Emma's public association with Horatia sat uneasily between these two acceptable positions. Horatia was not quite given up but neither had Emma retired with her from view. As a result, Emma and Nelson's approach to Horatia transgressed some of elite society's most fiercely defended rules.

Although in her own letters and comments Emma presented herself as an honoured guest and a sought-after leader of fashion, she cannot have been wholly unaware that a whiff of scandal followed in her wake. Many of Nelson's naval colleagues, for instance, flatly refused to visit Merton. Mrs Fitzherbert, the Prince of Wales's clandestine wife, was no fan, believing Emma to have 'overpowered' and 'taken possession of Nelson' by force (a rich critique from a woman who was herself a living scandal).[9] Emma's closest acquaintances were hardly the soberest of gentlemen or genteelest of matrons. Several – like Madame Bianchi, Elizabeth Billington and John Braham (see p. 204) – were flamboyant performers from the theatre and opera, the same Covent Garden scene where Emma had made her first forays into fashionable London.

After Henry Bone
Horatia Nelson, *c.* 1806
Oil on canvas
National Maritime Museum,
Nelson-Ward Collection
BHC2884

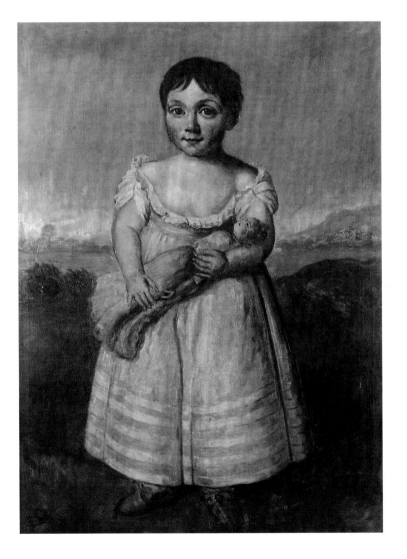

DECLINE AND FALL: SOCIAL INSECURITY AND FINANCIAL RUIN

Among her aristocratic connections, the Duke of Devonshire's second wife, Lady Elizabeth Foster, was a key figure. Yet, as the former long-term lover of the duke, who had lived alongside her predecessor, Georgiana, in an uneasy *ménage à trois*, she hardly boasted an unblemished reputation. Being welcomed into the Devonshire House circle, as it was known, might have seemed like a ticket into the highest echelons of London society. There was, however, an unmistakably racy edge to a coterie notorious for fast living, high-stakes gambling and illicit affairs.

None embraced the licentious elements of fashionable life more than the Prince of Wales and the royal dukes, and they were among the most glittering members of Emma's titled social network. The royal brothers certainly made their boisterous presence felt, enjoying lavish dinners hosted by Emma at Merton, stopping in at Clarges Street, and featuring on many of the same guest lists for balls and entertainments that made the London news. Yet, given their reputation for dissipation, such names were hardly reliable barometers of broader social acceptance. As Emma was to find, to her great cost, while the

Letter from the Duke of
Sussex to Emma,
27 [month indistinct] 1807
Jean Johnson Kislak
Collection
1998.004.00.0001

The duke, sixth son of
George III, writes to convey
his regret that he could not
visit Emma at Christmas,
and asks to be remembered
to Horatia.

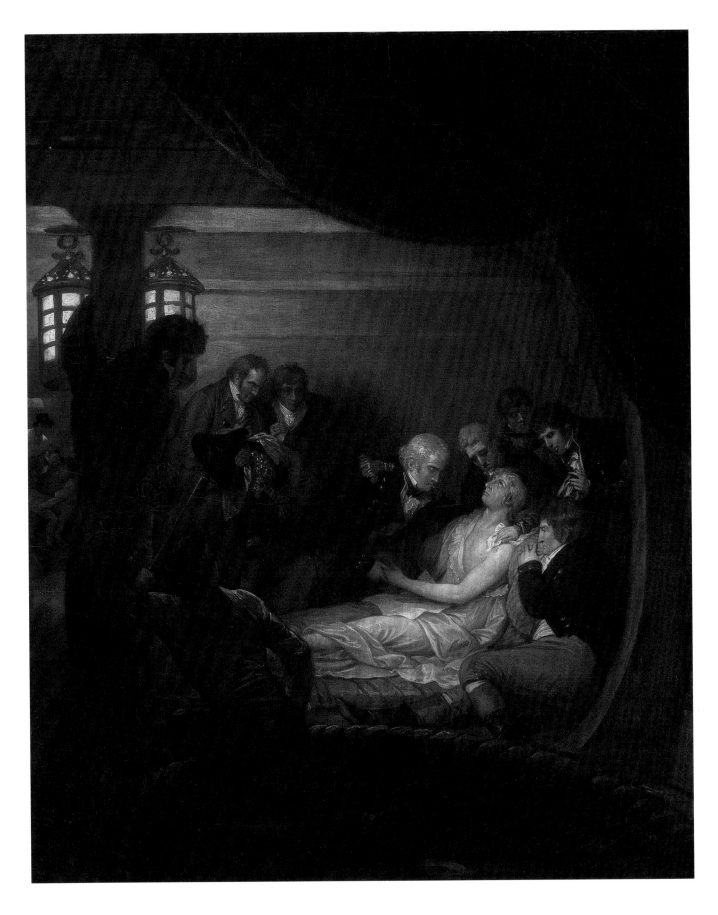

DECLINE AND FALL: SOCIAL INSECURITY AND FINANCIAL RUIN

company looked thrilling and exciting when her star was on the up, it quickly lost its sheen when she found herself on the way back down. Ultimately, her flimsy social credit was not an asset that could be cashed in once her fortunes changed – and change they did.

The tenuousness of Emma's resources and social position was laid bare on 21 October 1805 when Nelson was fatally wounded at the Battle of Trafalgar. A few weeks earlier, Emma had written one of her last letters to him. 'Oh Nelson…how do I idolize you', she cooed. 'May God send you victory, and home to your Emma, Horatia and Paradise Merton.'[10] Nelson never read those words: the letter was returned unopened from the battle. Emma was informed of Nelson's death as soon as news reached London in early November 1805. A representative of the Admiralty, Captain Whitby, presented himself at Emma's door but was too overcome with emotion to deliver the fateful news. That was communication enough for Emma. '[The] tears in his eyes and a deathly paleness over his face made me comprehend him', she recalled to Lady Elizabeth Foster. 'I believe I gave a scream and fell back, and for ten hours after I could neither speak nor shed a tear – days have passed on and I know not how they end or begin – nor how I am to bear my future existence.'[11] Paralyzed by shock and grief, she took to her bed, surrounding herself with relics of their relationship.

Tellingly, Emma had little public outlet for her sorrow. After all, in what capacity was she bereaved? She was not Nelson's wife. She was certainly his mistress but there could be no public declaration of such a role. The whole nation mourned Nelson and an elaborate state funeral was held early in the new year. On 9 January 1806, the public lined the streets and 7,000 guests witnessed the service at St Paul's Cathedral, after which Nelson's coffin was lowered into the grand and sombre tomb that remains the centrepiece of the crypt below. Emma, however, was not among those present. She remained at home in Clarges Street, hosting acquaintances attending the commemoration to which she had received no invitation.

The next few months and years brought a relentless decline into poverty with very little reprieve. In his will, Nelson left Emma their 'paradise Merton', an income of £500 a year from his ducal estate at Bronte, in Sicily, a lump-sum payment of £2,000 and an annuity to spend on Horatia's education. On the eve

Figurehead from Nelson's funeral car, 1805
National Maritime Museum, Greenwich Hospital Collection
FHD0093

The funeral car bore Nelson's coffin from the Admiralty in Whitehall to St Paul's Cathedral on 9 January 1806. The figurehead represents Fame or Victory.

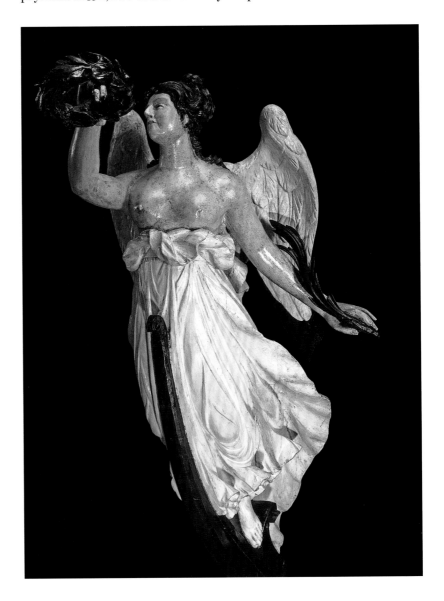

DECLINE AND FALL: SOCIAL INSECURITY AND FINANCIAL RUIN

has not been in my
power I leave Emma
Lady Hamilton therefore
a Legacy to my King and
Country that they will
give her an ample
provision to maintain
her Rank in Life, I
also leave to the benefi
-cence of my Country
my adopted daughter
Horatia Nelson Thomps
son and I desire she
will

Drawn by T.Baxter. *The Portrait is accurately taken from the much admired Bust belonging to His Lordship.* Engraved by A.R.Burt.

To Lord Collingwood the other Admirals, Captains, Officers and Men who Gallantly Fought for their Country off Trafalgar, this Print representing Britannia Crowning the Bust of our late Hero LORD NELSON is gratefully inscribed by their respectful Humble Serv.t A.R.Burt.

The Proprietor conceiving it may not be unacceptable to the Public has subjoined a Facsimile of His Lordships signature

London Published Dec.r 5.1805, by A.R.Burt, N.o 18, S.t John's Lane, Clerkenwell.

of Trafalgar, Nelson feared that this was not provision enough for his beloved
Emma. In his notebook he scribbled a hasty and ambitious statement, signed
by witnesses as a codicil to his will. 'The services of Emma Hamilton', he wrote,
'have been of the very greatest service to our King and Country.' After outlining
his view of Emma's contributions to diplomacy in Naples, he continued:

> Could I have rewarded these services I would not now call upon my country. But
> as that has not been in my power I leave Emma Lady Hamilton therefore a Legacy
> to my King and Country that they will give her an ample provision to maintain her
> Rank in Life, I also leave to the beneficence of my Country my adopted daughter
> Horatia Nelson Thompson and I desire She Will Use in future the name of Nelson
> only, these are the only favours I ask of my King and Country at this moment when
> I am going to fight their Battle May God Bless my King & Country, and all those
> I hold dear.[12]

While rich in sentiment such words had little value in real terms. Emma
came to cling to them, hoping against hope that the government would one
day honour the 'only favours' Nelson asked of king and country, and pursued
increasingly desperate and expensive routes to try and hold the state to account.
'Ought I not be proud? Let them refuse me all reward', she threatened, 'I will

the Death of ADMIRAL·LORD·NELSON · in the moment of Victory!

this Design for the Memorial intended by the City of London to commemorate the Glorious Death of the immortal
·Nelson, is with every sentiment of Respect, humbly submitted to the Right honbl the Lord Mayor, & the Court of Aldermen

go with this paper fixed to my breast and beg through the streets of London, and every barrow-woman shall say "Nelson bequeathed her to us".[13] Ultimately, however, the only element implemented by the admiral's executors was the cost-free change of Horatia's surname to Nelson. Emma was plunged into a perilous financial situation and an equally perilous social position.

With an income completely capped and no hope of any increase, her debts soon spiralled out of control. Merton was bleeding money. Although the executors of Nelson's estate were required to cover all costs for the first six months, it was an expensive 'paradise' to inherit. Over the next three years, Emma ran herself over £15,000 into debt, not least because she did little to adjust her lifestyle to her constrained circumstances. The sale of Merton by this stage seemed inevitable and Emma begged her well-heeled former friends to buy it in order to offer her some financial reprieve. Writing to the aged and wealthy Duke of Queensbury, she threw herself on his mercy. 'You are the only hope I have in this world to assist and protect me…For my sake, for Nelson's sake, for the good I have done my country, purchase it [Merton] take it, only

QUIZ-ZING a FILLY.

giving me the portraits of Sir William, Nelson and the Queen. All the rest shall go...I beseech you my dear Duke...see that I am lost and most miserable.'[14] The duke refused, although he was not unmoved: he would later transfer anonymous donations through his bankers, Coutts, to clear some of Emma's bills.

It is striking how few of Emma's titled and fashionable acquaintances stepped up with any meaningful assistance. None of those who had dined at her table, drunk from her cellar, and flattered her with invitations to perform her Attitudes and sing at their parties coughed up any capital support. Instead, a group of men from the City gathered together in 1808 in an effort to stem the destitution towards which she was accelerating. Led by an old friend, Abraham Goldsmid, a team of eight financiers raised a few thousand pounds between them to pay off her most urgent bills, and set themselves up as trustees of Merton and its contents. Merton proved hard to shift but in April 1809 the trustees finally 'found' a buyer. Its new owner was Asher Goldsmid, Abraham's brother, who secured it for a little over £12,000. It is impossible to ascertain the motives behind this sale. Was it a charitable move by a rich family to liquidate Emma's assets and appease creditors? Certainly the cash was swiftly disbursed to pay off debts due to the trustees and to other claimants. Or was it a more strategic speculation, with the savvy Goldsmids attempting to turn a profit from Emma's misfortune? Whatever the agenda, the financial relief offered by these dramatic interventions was essential but ultimately short-lived, as Emma appeared unable to escape her growing debts. She was in an impossible situation, living far beyond her means with the only hope for an increased income resting on a pipe-dream settlement from a government persuaded to recognize her 'national contribution'.

Emma was certainly not unusual among her contemporaries in subsisting on precarious credit. Even the most eminent aristocrats routinely carried vast debts from generation to generation, borrowing on the back of their property, reputation and promise of future inheritance to meet day-to-day living costs and the luxuries associated with their rank. Unfortunately for Emma, however, although she exercised a similarly *blasé* approach to credit (perhaps the product of her gilded years as an envoy's wife in Naples), she no longer had any real assets against which to borrow, either in terms of property once Merton had gone or, and perhaps more importantly, any social assets in the form of a titled husband, a celebrity lover or a wealthy patron.

With any change in fortune looking highly unlikely, her long list of creditors began trying to call in their bills. In a last-ditch attempt to stave off bankruptcy, Emma began to sell her only remaining valuables, relics large and small of her life with Nelson. The cash they realized was but a drop in the ocean, and the creditors continued to close in. Writs were served for her arrest for debt, the last resort available to creditors seeking financial recompense at the time. Emma fled from her London address but could not escape her fate. She was

tracked down to Mrs Billington's house in Fulham, and there arrested and subsequently imprisoned.

London was the location of a number of debtors' prisons, where those who owed money to disgruntled creditors could be held until their debts were cleared. Indeed, in the eighteenth and early nineteenth centuries, the vast majority of people in prison were incarcerated for debt.[15] Emma was taken to the King's Bench Prison in Southwark. Rather than a single building, the prison sprawled across a number of streets. Inmates were allowed, for a fee, to live on parole within a certain distance of the prison grounds in an area generally known as 'the rules of the King's Bench'. It was here that Emma found herself, in a 'spunging house' [debtors' lodging] at 12 Temple Place, a street 'within the rules'. On this occasion, her residence there was relatively brief, running only to a few months. Her release was secured by a City acquaintance, Alderman Joshua Smith, who acquired a bundle of Emma's possessions to provide her income enough to buy her way out. Among them was the uniform coat that Nelson wore on the fateful day at Trafalgar. During these indebted years, anything that Emma owned risked being pawned in her struggle for survival, eroding many material symbols of her life with Nelson.

After C. J. M. Whichelo
Interior of the King's Bench Prison, 1812
Engraving
London Metropolitan Archives
p5400738

Scribal letter to
the Crown, 1813
Jean Johnson Kislak
Collection
2005.023.00.0003

Emma used this petition
to rehearse, without success,
her claims for financial
acknowledgment of her
services when in Naples.

The Memorial of Dame Emma Hamilton, Widow
of his Excellency, the late Sir William
Hamilton, K. B. Your Majesty's most
faithful Ambassador at the Court of Naples,

Humbly Sheweth —

That her late husband, Sir
William Hamilton, in his liberal and munificent discharge
of the honourable duties of that elevated situation to which he
was exalted by the goodness of Your Most Gracious Majesty, had
so considerably encumbered his private fortune, that he was
incapable of making a sufficient provision for Your Majesty's
Memorialist to maintain, after his decease, the rank to which
he had indulgently raised her; and which it was her constant
study as much as possible to merit, by anxiously entering into
all her husband's zealous and enlarged views of diplomatic devo-
tion to the true interests of our dear Country, and the Beloved
Sovereign who had thus benignantly vouchsafed to honour
him. That it was the good fortune
of Your Majesty's Memorialist to acquire the confidential
 friendship

On her release, Emma continued to plead for official recognition from the government, composing a set of memorials outlining her contributions at Naples. Perhaps tipped off by Emma, in the hope that it might sway public opinion, the London papers recorded her ambitious plea. 'Lady Hamilton has published a narrative of the services she rendered to her country, by her influence with the Queen of Naples...the cost of which she states at £20,000. Her ladyship says she is now embarrassed and wishes for remuneration.'[16] Although Emma put a high price on her contribution, the ministers paid no heed and, with such public statements of her financial distress in ready circulation, creditors unsurprisingly stalked her for payment. Emma was once again arrested for debt and declared bankrupt; and this time almost every final possession at her London home was sold at an auction ordered by the Sheriff of Middlesex. The sale catalogue ran to eighteen pages. Everything from jewelry to spoons was up for grabs. Books, chairs, sea chests, beds and bedding, dressing tables, writing tables and even Horatia's doll's bed were all listed and put under the auctioneer's hammer. Emma, meanwhile, was taken back to prison, with only a handful of her own effects with which to furnish the rooms.[17]

For a year she remained in the limbo of 'the rules', neither free nor strictly imprisoned. She did her best to keep up appearances, sending out invitations to friends to dine. When an old acquaintance, Sir William Henry Dillon, accepted a summons to the spunging house he found he was not to dine alone, but with royalty, for the Duke of Sussex joined the company at the table. Food was abundant but cutlery was lacking. 'I could not help thinking that rather too much luxury had been produced', Dillon recalled. 'I had to carve a good sized bird but had not been supplied with the necessary implements.' Lacking a knife, he split the carcass with his fingers.[18]

With no other hope of a resolution to her plight, Emma's City acquaintances once again stepped up to the mark, buying her few remaining possessions and collecting donations in order to raise the funds to secure her release. Of course, a swift return to the King's Bench Prison was all too likely, for there was a long queue of creditors clamouring for payment. Emma had no choice but to leave the country, a decision doubtless speeded by the publication in two volumes of *The Letters of Lord Nelson to Lady Hamilton*. Emma was adamant that she played no role in releasing the correspondence, but their intimate content damaged Nelson's reputation, and still more hers. In early July 1814, her health already failing, she stepped off Tower Wharf onto a small packet boat that would take her across the Channel.

Less than six months later, Emma was dead – an unhappy ending to the darkest chapter of her life. Having moved between the roles of muse, model, wife and mistress, much of Emma's life had been characterized by an incredibly successful fashioning and re-fashioning of her identity. In the final act, however, it was as if there was no further role that she could play, with all former celebrity gone, all former reputation blasted and all former protectors dead or absent.

To understand Emma's social demise we need to understand some of the rules governing the London circles she latterly attempted to master. Although she had climbed far since her girlhood, navigating the worlds of Covent Garden, the artist's studio, and international stardom, it was an unforgiving *beau monde* that eventually spat her out. What Emma, and indeed other women, found to their cost was that beneath the fast-living image of fashionable London life was a culture policed by unwritten social codes that reprimanded inappropriate behaviour. In particular, it condemned female dissipation and punished transgressors. As a mistress and the mother of illegitimate children, and with no aristocratic family tree to which she might cling for support, Emma breached many a code of fashionable life. She had only to look at the experiences of some near contemporaries to appreciate the limits of what London society would tolerate.

The place of the mistress was especially perilous. Emma's contemporary, the actress Dorothy Jordan, was the Duke of Clarence's mistress for over twenty years. During that time she lived with him and bore him more than ten illegitimate children. Yet there was no happy ending. When the Duke of Clarence (the future William IV) found himself compelled to marry in order to further the royal blood line, Dorothy was unceremoniously dumped. As her financial circumstances unravelled, the former actress returned to the stage but failed to make a living. Like Emma, she fled to France to escape her creditors and died in poverty in 1815. The Prince of Wales had reputedly paid Mary Robinson £20,000 to become his mistress, but when he ended the affair a few years later, she was forced to eke out a living as a writer. A mistress had no claim to property, no legal recourse through which to defend her position and little social credit to call on when her powerful patron moved on. While many aristocratic men enjoyed a mistress, often escorting them in public to the theatre, opera or pleasure garden, it would be wrong to presume that these unmarried women could claim any substantial protection or social security among fashionable ranks. Moreover, although sexual freedom was broadly tolerated for men, it was subject to strict sanctions among titled and fashionable women.

When Emma was living in London on Greville's resources and sitting for Romney in the early 1780s, she would no doubt have been familiar with the scandal surrounding the beautiful Countess of Derby. Born in 1752 as Lady Elizabeth Hamilton, the countess was widely admired as 'one of the finest women of the age'.[19] In 1774, she stepped in line to become Lady Derby by virtue of her marriage to the future twelfth earl (who succeeded in 1776), a match marked by a famously lavish *fête champêtre*. She thereafter emerged as a renowned leader of London's fashionable world. By the time Emma was posing in Romney's studio, Lady Derby's fame as a woman of fashion had been superseded by her notoriety as a woman of scandal. In 1778, newspapers began to report an affair with the Duke of Dorset, and in consequence she was bundled

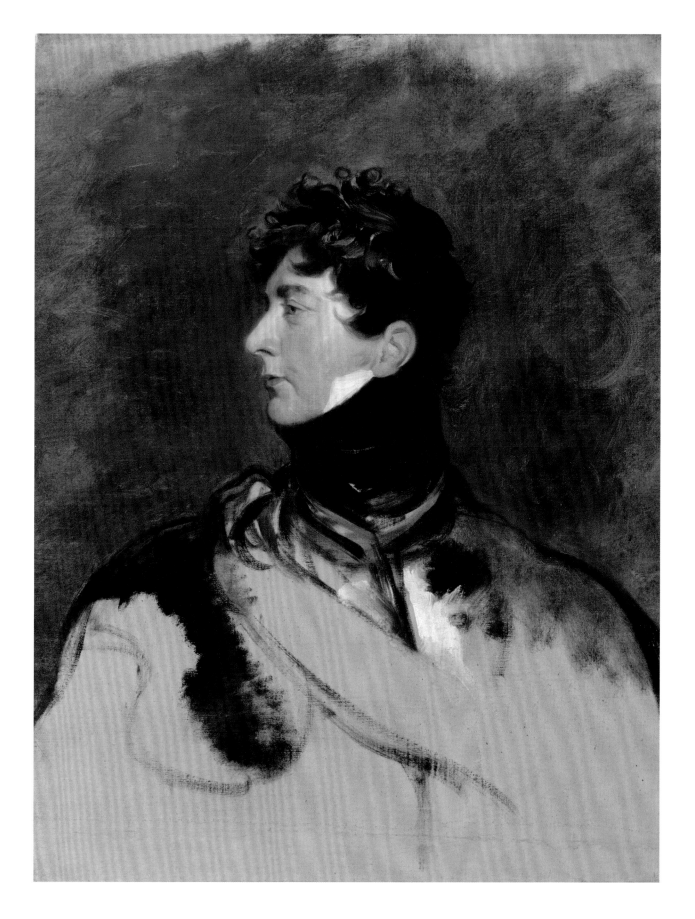

off to the country to 'keep quiet and out of the way'. However, the rumour mill continued to grind down her reputation and the gossip refused to fade. For two years her status was uncertain as she remained exiled from London society and denied access to her three children. Finally her husband announced that she was not welcome back and so her fate was sealed – as a separated, disgraced wife with no financial or social means at her disposal. She moved abroad and spent a year alone in penance, before eventually returning to England under the protection of her mother but excluded from the fashionable world.[20]

At around the same time, Emma might also have heard of the shameful past that dogged Lady Sarah Bunbury, who returned to London in 1781 with a tarnished reputation after enduring a social exile which ran for decades. Back in 1762, Lady Sarah Lennox, daughter of the Duke of Richmond, had married Thomas Charles Bunbury, a Whig MP. By 1768, the marriage had collapsed following Sarah's extra-marital affair and illegitimate pregnancy.

William Whiston Barney, after Thomas Gainsborough

Georgiana, Duchess of Devonshire, 1808
Mezzotint
Yale Center for British Art
B1970.3.363

Such behaviour could not be condoned by London's elite society and Sarah was expelled from it into solitary retreat at a cottage on her family's estate at Goodwood, Sussex. For years she effectively suffered a penitent seclusion, isolated from all but her closest family members. It was only in the 1780s that she was able to make some tentative steps back towards the London life she had once enjoyed, returning and appearing occasionally at the capital's most public resorts (such as the theatres and the pleasure gardens) but not its more exclusive arenas, such as court or the private entertainments hosted by the leaders of fashion. Writing to a friend in 1781, she acknowledged, 'I shall never again go bonneted up and hooded up in publick, and giggle and laugh at the ridiculous people we see, but I won't promise but that we shall laugh at them at home...as by which means we shall not run the risk of being abused as we have been, but enjoy our fun in our quiet way.'[21]

Perhaps closest to Emma's field of vision, given her association with the Devonshire House circle, would have been knowledge of the social disgrace suffered by London's most glamorous leader of fashion. Georgiana, Duchess of Devonshire, faced censure by the society she led following an affair with the politician Charles Grey. Pregnant with Grey's child, the duchess had committed one of the gravest social crimes in the eyes of eighteenth-century elites. Illegitimate progeny not only threatened personal reputation but also the future of titles, the security of estates and the perceived purity of the family tree. Such a transgression, as Lady Sarah Bunbury had discovered, was redressed with absolute exile. For the duchess, though, the repercussions were dramatically reduced because, in stark contrast to Lady Derby and Lady Sarah Bunbury, she retained the protection of her husband. To be sure, some form of exile, even for her, was unavoidable. The duke arranged for her to travel abroad in order to hide the pregnancy and birth from public view. For two years, the duchess fulfilled her foreign seclusion. Her absence was noted in the press but no hints were made about the cause of such retirement. Travel for health rather than for penance was the official explanation for the temporary loss of such a celebrity. Once the baby was born and her sentence was completed, the duchess returned London.

The duke formally acknowledged his wife's arrival in England with a widely reported gift of a town carriage, surely a strategic choice given that a carriage was the ultimate expression of urban sociability, connection and public status. Her mother counselled the duchess on her return, warning her to act with modesty and restraint. 'I am sure I need not warn you to observe the strictest sobriety and moderation in your dress', came the stern letter. 'Let it be simple and noble but pray do not let it be singular and how glad I should be if you could tell me you had quite done with rouge. The credit such a conduct would be to your character would far outweigh the trivial and really false idea of your looking more shewy.' 'There must be some period for taking up a different character of dress,' Countess Spencer continued, 'and when can you find

DECLINE AND FALL: SOCIAL INSECURITY AND FINANCIAL RUIN

a better [time] than now at your return after so considerable an absence.'[22] Modesty and decorum, she advised, were still required.

Even the most vivacious leaders of fashion, then, were not immune to exclusion when their conduct was deemed to have breached society's unwritten codes. Unlike Emma, however, these women had broader systems of credit, and networks that lessened the impact of their disgrace. Aristocratic title, matriarchal patronage, powerful male defenders, family heritage and access to wealth did not necessarily prevent social fall but they certainly facilitated an easier exit from it and, on occasion, a partial recovery. Emma had no such recourse, and as a result hers was the harder and more complete. Despite her glamorous acquaintances and the respectable position her marriage to Hamilton had given her, there was little in the complex codes of eighteenth-century life that gave her a way to escape the path towards destitution that opened the moment Nelson fell on *Victory's* deck. From then on, hastened by her chronic improvidence, her morally compromised status inexorably overtook the acceptable aspects of her celebrity. Her attempts to make a final reinvention foundered because there was no identity or role left for her to occupy or, at least, any that fitted with her unrealistic pretensions and the comparatively modest financial provisions left by both her husband and famous lover. Sensibly managed, their bequests would have seen her comfortably into old age, but not in the London world she aspired to inhabit and which, tiring of her intrusions, finally brushed her off. It is certainly hard even to imagine her retreating to some prosperous county town or second-order watering place and there, devoted to (unacknowledged) grandchildren by Horatia and perhaps near sympathetic Nelson relatives, building a quietly respectable new life: such a scenario was entirely outside her prior experience as much as her character.

Emma's ultimately tragic story is one of the opportunities, hazards and complexities of Georgian society, but one that also exposes its more unforgiving rules and less accommodating snobberies.

Picturing Paradise: Emma, Thomas Baxter and Life at Merton

Merton Place – purchased by Nelson on Emma's recommendation in 1801 – provided the materials for her ambitious project to secure a settled and respectable domesticity. The somewhat ramshackle, mid-Georgian house sat within a small estate that was later enlarged to provide greater privacy. Emma oversaw a host of costly improvements to the property, and enjoyed a degree of control and authority over her material environment that no other period of her life had come close to equalling. It was here that Emma spent time with her beloved Nelson, but that time was fleeting. The absence from naval duties that Nelson was afforded after the Peace of Amiens in 1802 was not to last, and he left for active service once more in May 1803. The couple were reunited in 1805 for a few precious weeks before Nelson departed from Merton on Friday 13 September 1805.

Emma's aspirations for Merton were complex. The decoration of the interior of the house cannot be established with exactitude, but she certainly used it to broadcast Nelson's naval achievements and their joint fame. The resulting assemblage attracted accusations of poor taste from elite observers, but accorded with the often meritocratic sensibilities of a couple who owed their successes to application rather than aristocratic lineage. At the same time, the 'farm' – as Merton (with its scattering of pig sties and chicken coops) was routinely if unconvincingly termed – was also designed to communicate a virtuous rusticity. Although this was one performance in which Emma was destined never to succeed, she clearly intended the honest simplicity of these surroundings to offset her unorthodox personal relationships. Moreover, the social gatherings at Merton were full of meaning and purpose for Emma. By entertaining and cultivating Nelson's relatives and their children, she sought to solidify a place among them, though its essential fragility was all too evident. As a surrogate matriarch though, she could bestow her glittering cultural cachet and, on occasion, introduce Horatia into the throng, not as a daughter but as a charge and a *protégée*.

The best visual record of this life was captured by a young artist and porcelain decorator, Thomas Baxter. It is possible that Nelson met him while purchasing dinnerware in 1801, and subsequently struck up a friendship. Regardless, Baxter visited Merton on a number of occasions between 1802 and 1805, and made a series of sketches and watercolours. Some drawings are more obviously posed; others are intimate and immediate. Taken together, they provide a unique account. The images that follow here move from exterior scenes of the house and its grounds, to social gatherings (including a study of Emma seated at a piano with Madame Bianchi), depictions of Emma's Attitudes, and a drawing of Horatia. With Emma's plans unravelled by Nelson's death, and Merton Place itself long gone, these works are the most eloquent remnant of Emma's typically uncompromising but, on this occasion, ultimately doomed ambitions.

PICTURING PARADISE: EMMA, THOMAS BAXTER AND LIFE AT MERTON

PICTURING PARADISE: EMMA, THOMAS BAXTER AND LIFE AT MERTON

PICTURING PARADISE: EMMA, THOMAS BAXTER AND LIFE AT MERTON

PICTURING PARADISE: EMMA, THOMAS BAXTER AND LIFE AT MERTON

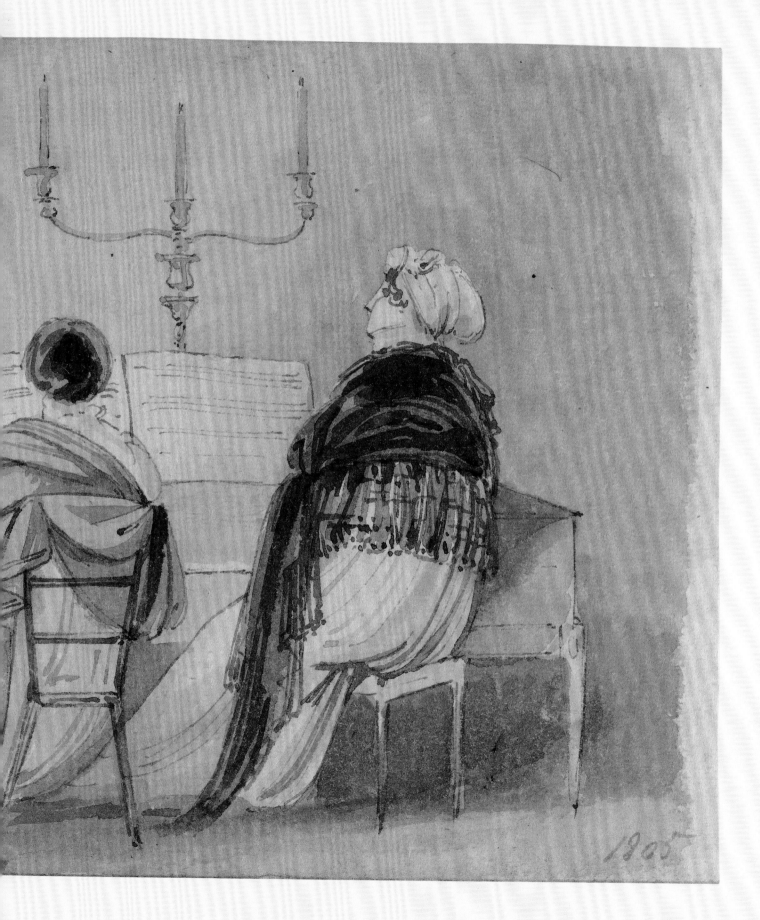

PICTURING PARADISE: EMMA, THOMAS BAXTER AND LIFE AT MERTON

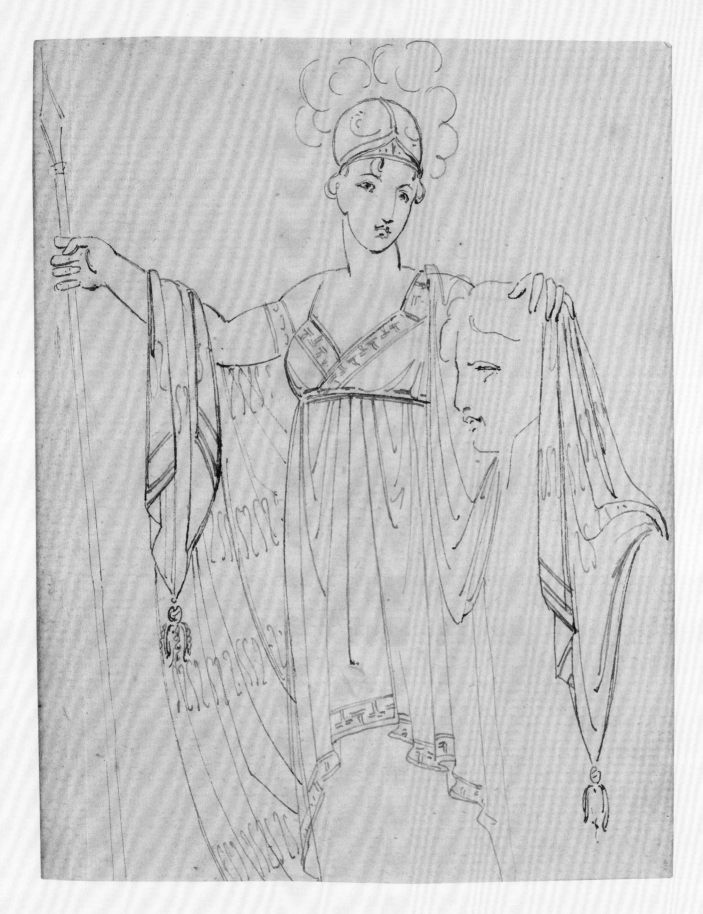

PICTURING PARADISE: EMMA, THOMAS BAXTER AND LIFE AT MERTON

PICTURING PARADISE: EMMA, THOMAS BAXTER AND LIFE AT MERTON

Horatia Nelson

Kate Williams

Epilogue
Emma Hamilton in Fiction and Film

How shall I begin, what shall I say to you 'tis impossible I can write...I am delerious with joy, and assure you I have a fervour caused by agitation and pleasure...I shou'd feil it a glory to die in such a cause. No I wou'd not like to die till I see and embrace the Victor of the Nile. Emma to Nelson, 8 September 1798[1]

Emma's passionate words have enthralled her readers ever since. Her letter to the 'Victor of the Nile' offering him an embrace was perhaps the most effective romantic invitation in history. Throughout her life, Emma was a spectacle: performing to a crowd, creating her own representations for a fascinated public. In turn, she was written about and drawn, her body and her words generating new representations and versions, spiralling out of her control. While she was alive, her own self-portrayal – and the strength of public respect for first Sir William and then Nelson – worked to counter the most negative versions of her. After her death, she was laid open to judgment as successive generations saw fit. But her early self-representations retained their impact: the Attitudes, the poses, the allure – and, most of all, the sheer power of her skilfully variable self-creation. Whatever others tried to make her into, her own power to fascinate proved stronger.

Less than twenty years after she begged Nelson to come to Naples, Emma died in penury in Calais – friendless, her health broken by imprisonment and debt. The British consul paid for her funeral, and the monies owing, including to the wine merchants. Nelson's death prompted an avalanche of pictures but Emma's was not commemorated in art, despite how often she had been painted during her lifetime. No longer beautiful, she had no place in portraiture and, deprived of power and influence, she had no appeal for caricaturists. She was instead interpreted through words. Again and again she was portrayed in both

Poster for the feature film
That Hamilton Woman
(detail), directed by
Alexander Korda, 1941
Jean Johnson Kislak
Collection
2010.104.00.0001

fiction and non-fiction and, in the twentieth century, film. It was not always a sympathetic portrayal.

Emma's death was sparsely commemorated in the press and had few mentions. *The Times* was typical: 'Death of Lady Hamilton – A letter from the Paris papers says that LADY HAMILTON died in that town the 16th instant.' The exception was the *Morning Post*, which deployed a lurid pen:

> She had experienced all these vicissitudes in early life which too generally attend those females whose beauty has betrayed them into vice, and which unhappily proves the chief means of subsistence. Few women who have attracted the attention of the world at large have led a life of more freedom.

Emma, in this obituary, is described as a woman of 'freedom' and 'vice' in an excitable tone familiar from eighteenth-century pulp novels. The piece casts her as a prostitute, claiming vice was her 'chief means of subsistence'. 'Freedom' is not considered a good quality, for it stands for sexual licence. The writer goes on to explain that it is her own fault that she died in poverty, for the 'connections' she made when she began to 'attract the attention of Painters' could have created security for her. The writer is certain on the vexed question about whether she published Nelson's letters or had them stolen – Emma is guilty and published Nelson's letters 'to the world'. Emma was, the writer concedes, privately a 'humane and generous woman', but she was of poor character: 'intoxicated with the flattery and admiration which attended her'.[2] The writing is reminiscent of the popular eighteenth-century genre of prostitute memoirs, with its emphasis on 'vice', 'freedom' and 'flattery' as the genesis of Emma's fall: she is becoming symbolic of a 'type'.

Emma had hoped to be buried in England, but she was laid to rest in the graveyard of the Church of Notre Dame since she had received frequent visits from the priest there. Her funeral was attended by 'all the English gentlemen in Calais and its vicinity' – about fifty of them. The grave first bore a wooden marker, apparently engraved with 'Emma Hamilton: England's Friend'. A headstone was later erected noting her place of death and the date, but the graveyard was subsequently cleared and the stone lost. The area is now occupied by the Parc Richelieu. In 1994, supporters erected a memorial to Emma in the park, a handsome tribute to her final days in France.

According to Horatia, she was often told that Nelson was her father but Emma only ever admitted to being her guardian, not her mother. Emma had hoped her daughter would be Nelson's legacy. She had showed her off in front of the Prince of Wales and had her painted with Nelson's miniature around her neck, but although Horatia looked very like Nelson and had Emma's early grace, she did not share her parents' hunger for drama. Instead she was practical, dutiful and, after witnessing Emma's dreadful death, determined to search for security.[3] As Horatia said, 'the time spent in Calais is indelibly stamped on my memory'.[4] She nursed her mother, and then was held for Emma's debts until

Unknown artist, British school
Horatia Nelson, c. 1815
Oil on canvas
National Maritime Museum,
Nelson-Ward Collection
BHC2886

With a miniature of Nelson
around her neck, Horatia
adopts a pose demurely
reminiscent of images of
her mother as a nymph
or a dancing bacchante.
The parallel is intensified
by the smouldering volcano
in the background. The
painting may have been
commissioned by Emma.

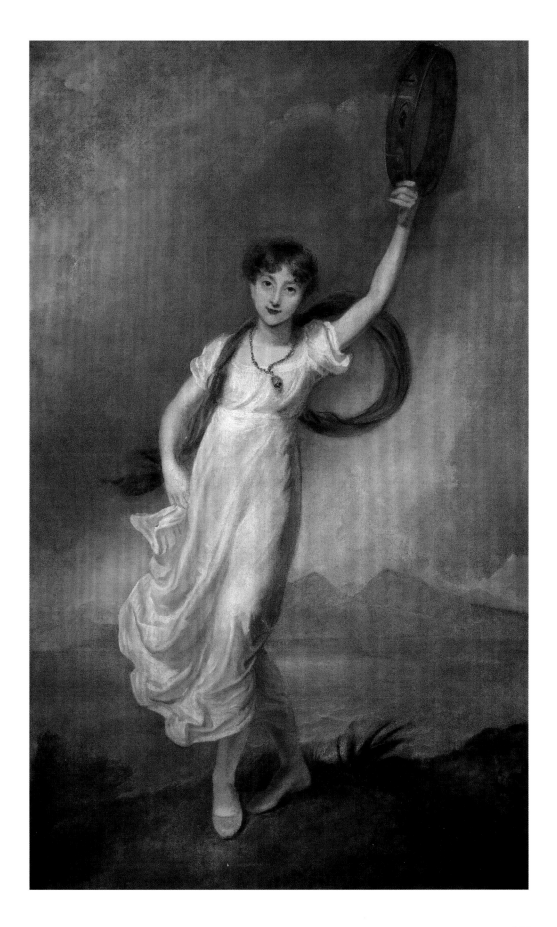

the consul paid them off. On her return to England, the teenager lived with the families of Nelson's sisters, first the Matchams, then the Boltons, helping out with the housekeeping and caring for younger children. She fell in love with Philip Ward, the young curate who lived next door to the Boltons, and married him in 1822, when she was just twenty-one.

'With all her faults,' Horatia said of Emma, 'and she had many, she had many fine qualities, which, had she been placed early in better hands would have made her a very superior woman.'[5] Whether Horatia knew the truth (and, reading her parents' correspondence, it appears clear to me that she did), it was wise for her to suggest Lady Hamilton had only been her guardian. Nelson, sacrificing himself for British naval success, was highly pleasing to Victorian mores; Emma was not. Free of Emma's taint, Horatia lived a long, respectable

EPILOGUE: EMMA HAMILTON IN FICTION AND FILM

Richmond
August 26th
1809
Given to Horatia
Nelson may she
be good virtuous &
have wisdom knowledge
& understanding to serve
God & walk in his
ways pray her
affectionate E Hamilton
amen

Moral Maxims, From The Wisdom of Jesus, The Son of Sirach, or Ecclesiasticus. Selected by a Lady, 1807
Jean Johnson Kislak Collection
2006.017.00.0003

Emma gave this book to her daughter. The inscription demonstrates her determination that Horatia should adopt habits of virtuous respectability.

life as a vicar's wife and a mother of nine children. Never wealthy, she dealt patiently with frequent requests for money from those who had known her father (and indeed those who had not). There were various efforts to encourage the government to give her a legacy – including a campaign in *Punch* – but all failed. Perhaps, had she been male, she might have had more luck – Nelson's son would have had the potential to be a powerful figure – but a girl without money was irrelevant.

After Nelson's death, his undeserving older brother William was created Earl Nelson and Viscount Merton and inherited the Sicilian dukedom of Bronte, which had been given to Nelson by the King of Naples. William's cherished son died at the age of fourteen and the British titles went to Thomas, oldest son of Nelson's sister, Susannah Bolton. The dukedom went to William's daughter, Charlotte, who had once spent so much time with Emma at Merton. She became Duchess of Bronte, the grand title Emma had longed to possess as Nelson's wife.

Few traces of Emma's life remain outside museums, galleries or private collections. Emma's home, Merton, bought by Asher Goldsmid before Emma's death, limped on, unsellable. It was finally disposed of in 1821, when the 160 acres of land were parcelled out, and the house itself was demolished in 1823. Wellington has Apsley House, No. 1 London, as a monument, but what could have been a fine one to Nelson – and also Emma – is now the site

of a block of flats named Merton Place. A plaque on the side of the block recalls its history:

> Sixty metres (200 feet) to the south east was 'Merton Place', the only house ever owned (1801–1805) by Admiral Lord Nelson and from which he set out for the Battle of Trafalgar. Lady Hamilton also lived here 1801–1808.

The area bears other ghosts of Nelson – a Hardy Road, a Nelson Road, an Emma Hamilton pub and a Nelson Hospital – but passers-by would barely notice the plaque.

After Emma left England for Calais, her remaining belongings were put into storage by her friend Alderman Joshua Smith, including plate and china, and the Nelson and Nile Worcester porcelain service. Horatia tried to recover them after she turned eighteen, asking particularly for a silver-gilt cup given to her

After John James Masquerier

Lady Hamilton, 1806
Mezzotint
National Maritime Museum
PAG6656

The original painting by Masquerier, a fashionable contemporary artist, was the final portrait of Emma completed during her lifetime.

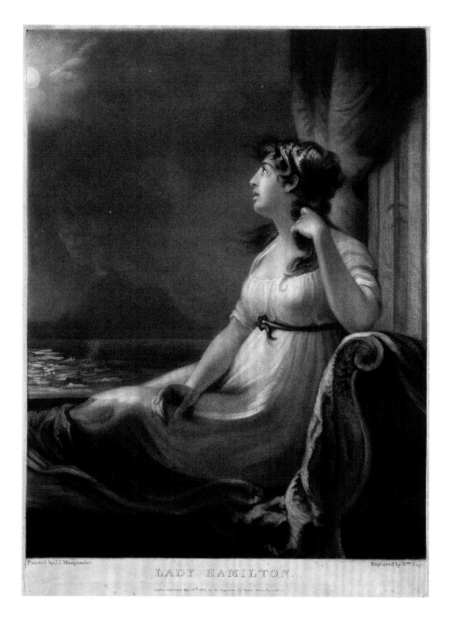

EPILOGUE: EMMA HAMILTON IN FICTION AND FILM

This was a gift from Nelson to
his daughter. Horatia had asked
for a pet dog and, unable to
provide one, Nelson sent her
the image of one instead.

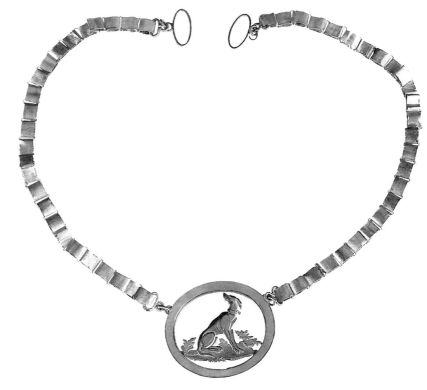

by Nelson, silver knives, as well as a plate with birthday engravings on it from Emma (see p. 207). Smith had paid the consul back for her funeral expenses and, as in effect he was one of her many creditors, presumably saw the things as his. He refused to relinquish them.

Horatia would also have found herself devoid of public mementos of her mother. When Nelson was alive, women decked themselves in Nelsonian and Battle of the Nile commemorative items: as Emma herself wrote to Nelson in 1798, 'My dress head to foot is alla Nelson'.[6] She, too, often featured on popular items such as brooches and pottery showing women resembling her waving Nelson off, or styled as Fame or Britannia. After Trafalgar, however, there was little public appetite for souvenirs featuring Emma. During her lifetime, Emma was refigured in romantic novels such as Mary Charlton's *The Wife and the Mistress* (1802) or Anna Maria Porter's *A Sailor's Friendship and a Soldier's Love* (1805) as a sweet and retiring heroine, skilled at dance and music and courted by a gentle naval hero. The adulterous relationship was oddly recreated in these, as she was described as having older godparents called Sir William or Frances.[7] After Trafalgar, a more popular view was that of Eliza Parsons's *The Convict, or Navy Lieutenant* (1807). The hero is kindly young naval officer Henry Thompson who meets a ruined girl, Ellen, and adopts her innocent little daughter out of kindness – just as Nelson pretended to have adopted Horatia. Although Parsons had connections to the navy, it is probably not a coincidence that she chose 'Thompson' as the name for her Nelsonesque hero. In reality, Nelson was so poor at conducting secret correspondence that the 'Thompson' pseudonym was sufficiently well known to be exploited in fiction. But the novel's values are clear: the child is explained and excused and is allowed access to respectable people, while Emma was excluded as unfit for polite society.

Nineteenth-century perceptions of Nelson were indebted to Robert Southey's *Life of Nelson*, published in 1813. It declared of Emma's arrival

Commitment book from King's Bench Prison, early nineteenth century
National Archives
PRIS 4/26

The entry shown here records Emma's commitment in the summer of 1813 following her arrest on a charge of debt. She uses the title of 'dame' bestowed on her with the Order of Malta.

EPILOGUE: EMMA HAMILTON IN FICTION AND FILM

Photograph of Horatia,
c. 1859
National Maritime Museum
ZBA4964

She is shown in mourning
dress following the death of
her husband, the Reverend
Philip Ward.

in Naples: 'Happy would it have been for Nelson if warm and careful friendship had been all that awaited him there.' Southey was euphemistic in his references to Emma, remarking that 'by the kindness of her nature, as well as by her attractions, she had won his heart', but he generally passed over her, rushing headlong to his conclusion about the hero:

> He could scarcely have departed us in a brighter blaze of glory. He has left us, not indeed, his mantle of inspiration, but a name and an example, which are at this hour inspiring thousands of the youth of England – a name which is our pride, and an example which will continue to be our shield and our strength.[8]

It was Emma's misfortune that the desire to make an example of glory and a saint out of Nelson coincided with a drop in public support for the figure of the mistress. As the empire expanded, its propaganda invested even more energy into sanctifying Nelson. The ideal image was that of the hero ascending into heaven, giving up his life for his country. The only thing that muddied his perfection was the romance with Emma Hamilton, the mistress for whom he had deserted his wife. Almost worse, he had publicly revealed his love, declaring Emma was responsible for victualling his ships before the Battle of the Nile and leaving her and Horatia as a 'Legacy to my King and Country'.

In the year Emma died an anonymous biography of her was published: the *Memoirs of Lady Hamilton*, probably written by Francis Oliver, former secretary to Sir William. The preface noted that readers might feel 'resentment at the disclosure of circumstances that have a tendency to weaken their admiration of men of eminence'.[9] But, the author argues, he is compelled to tell the truth and there is 'a scoundrelism about people of low birth' as the 'following memoirs' would show. During Emma's youth, she 'acquired a boldness which proved the leading of her character' and to which her 'ruin was owing', as well as her 'habits of intrigue and extravagance'. In similar style to the *Morning Post* obituary, Emma is cast as a 'helpless victim of vanity and deceit' and Dr James Graham, her possible early employer, an 'unprincipled charlatan' of 'depraved taste'. Sir William Hamilton is represented as ignorant of Emma's background on the grounds that 'a person of his talents and experience should voluntarily condescend to take the cast-off mistress of his own nephew is too revolting to the feelings of human nature'.

When Nelson arrives in Naples, Emma, 'the syren, by whom his life became afterwards ruled' was preparing her 'most powerful enchantments'. The book then jumps to the execution of Admiral Caracciolo, hanged as a traitor there after the Neapolitan rebellion rather than shot as his social status demanded (though indeed, many believed he should have been pardoned). 'Lady Hamilton was at the bottom of the whole', directing it with 'the malignity of her disposition' and 'the hardihood of her counsels'.

Emma's claim to have enabled the victualling of Nelson's ships before the Battle of the Nile is 'art and exaggeration', exemplifying how the hero 'was

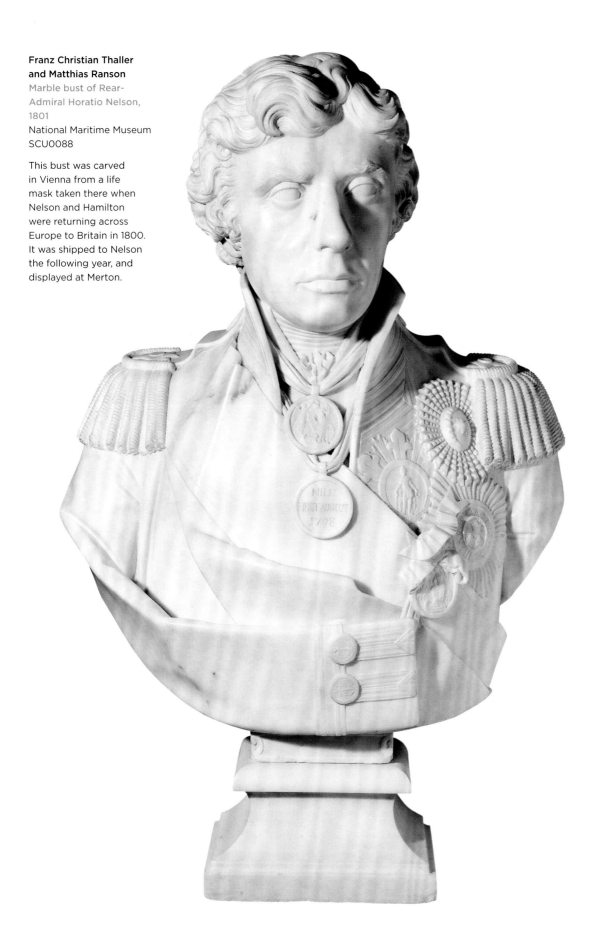

Franz Christian Thaller and Matthias Ranson

Marble bust of Rear-Admiral Horatio Nelson, 1801
National Maritime Museum SCU0088

This bust was carved in Vienna from a life mask taken there when Nelson and Hamilton were returning across Europe to Britain in 1800. It was shipped to Nelson the following year, and displayed at Merton.

deceived by female artifice'. Her argument that she encouraged him to go to fight at Trafalgar was 'an abominable insult upon all truth and modesty' since 'the honour of her hero was particularly affected by the story she had invented'.[10] The writer does suggest that Nelson's letters were stolen from Emma and notes her kindness to her mother, as well as pointing out William Nelson's ingratitude to Emma. Overall, however, the text expects its audience to see her as a scoundrel who acted to impugn Nelson's heroic memory.

By Emma's death in 1815, the eighteenth-century aristocracy's laxer attitude towards mistresses was beginning to wane. With the end of the war, society began to question its mores, and the Prince of Wales, the Duke of Clarence and the other sons of George III, once keen to dine at Emma's table, were recast in the public imagination from glamorous leaders of a licentious elite to ungrateful and expensive burdens on the privy purse – or, as the Duke of Wellington called them in 1818, the 'damndest millstones about the neck of any Government, that can be imagined'. Already there was a desire for a different, more dutiful social leadership – and if the dukes were out of favour, so was their idea of their glamorous female hangers-on. The time when women were congratulated for their beauty and daring was to be replaced by a new nineteenth-century notion of femininity, exemplified by the young Queen Victoria, ascending to the throne at the age of eighteen and always represented in prints and portraits wearing white, sometimes surrounded by the beams of heaven as an angel. Courtesans would still carry on their business, but behind closed doors. Ladies would devote themselves to the home and the ideal gentleman would be no longer the urbane man about town but the family man at the hearth – just like Prince Albert, portrayed by vivid royal propaganda as happiest at home with his wife and children. Emma was everything the Victorians reviled: sexual impropriety, adultery and even greed.

In 1835, George Ledwell Taylor suggested that the square created by clearing the area of Charing Cross should not be named in tribute to William IV, as initially planned, but to the Battle of Trafalgar. This was adopted and in 1838, the year following Victoria's accession to the throne, a committee formed of dignitaries, MPs and peers suggested a general subscription for a 'national monument' to Nelson there as 'commemoration of his glorious achievements'.[11] The inauguration of William Railton's Corinthian column on 21 October 1844 was a solemn event, with eminent men and those who had been at Trafalgar invited to share the committee's deep veneration for the memory of Lord Nelson. In the form of E. H. Baily's crowning statue, Nelson soared, proud and dignified, one hundred and seventy feet over London.

William Makepeace Thackeray's *Vanity Fair* (1847–48) was probably conceived in 1845, just after Nelson's column was finished. It is set while 'the present century was in its teens', some time around Emma's death.

Miss Crawley and the heroine Becky Sharp discuss scandal and the older woman thinks of Nelson.

> 'That was the most beautiful part of dear Lord Nelson's character,' Miss Crawley said. 'He went to the deuce for a woman. There must be good in a man who will do that. I adore all impudent matches.'

Emma is a woman who takes a man to the 'deuce' or rock-bottom, but Miss Crawley – a capricious and self-deluding figure in the book – should not be taken at face value in her admiration for Nelson. When Becky herself makes an 'impudent' match to Miss Crawley's own beloved nephew, Rawdon Crawley, she refuses to forgive them. The fascination that Nelson and Emma generated was not to be mistaken for social approval.

The character of Becky recalls aspects of Emma: she is low-class, clever, fluent in languages, flatters powerful women and is gifted as a singer and

After George Romney
Emma as Absence, 1827
Engraving
National Maritime Museum
PAG6641

actress. But she is driven by ambition: what she achieves is done through cool manipulation. Becky engages in a performance of charades very like the Attitudes:

> Clytemnestra glides swiftly into the room like an apparition – her arms are bare and white – her tawny hair floats down her shoulders – her face is deadly pale – and her eyes are lighted up with a smile so ghastly that people quake as they look at her.

She whips up a dagger and heads to the bed. The spectators are stunned, and the rakish aristocrat Lord Steyne shouts, 'She'd do it too'.[12]

Thackeray provided illustrations for *Vanity Fair* and inserted one into Chapter 67, titled 'Becky's Second Appearance in the Character of Clytemnestra'. In this, she is not dancing but hidden behind a panel, eavesdropping while her rich, stupid husband Jos is probed by his upstanding friend Captain Dobbin about the large life insurance policy he has taken out. Becky is holding what may be a bottle of poison in her hand. Jos dies three months later but Thackeray is never explicit as to the cause. Instead, it is the drawing, and the reference to Becky as Clytemnestra, that suggests murder. In *Vanity Fair*, the Attitudes are no longer a brilliant performance: they are revelatory of a terrifyingly forceful and possibly criminal character.

French society was more forgiving of Emma and Nelson and their relationship, presumably because it had little invested in creating and maintaining him as a hero. Nelson had been the scourge of the French, but his love affair with Emma Hamilton was considerably less problematic. Alexandre Dumas became interested in Nelson and Emma's story while staying in Naples between 1860 and 1864. The result was his *La San Felice*, serialized in *La Presse* from December 1863 to March 1865, about the brief period in 1799 when Naples was a republic, before the rebellion was crushed and Bourbon rule by King Ferdinand and Queen Maria Carolina restored. *La San Felice* is based on the true story of Luisa Sanfelice, an aristocrat executed as a rebel, who was widely seen as an innocent victim of royal vengeance. Emma, Nelson and Sir William are supporting actors, but Dumas was fascinated by Emma (he had a yacht of the same name) and he certainly did his research while living in Naples. He amusingly remarks on the Attitudes:

> In our own tours of Naples and Sicily, we met old gentlemen who had witnessed these magnetic exhibitions and, after fifty years' past, they had quivered like youths over the burning memories.

The Dumas novel *The Lovely Lady Hamilton*, translated into English by H. L. Williams in 1903, is a much-reduced version of *La San Felice*, designed to focus on Emma. She is introduced with gusto: 'if ever a human being arrived at the perfection of beauty, then it was Emma, Lady Hamilton'. General Acton (the Neapolitan prime minister) and Maria Carolina wish Emma to ensnare Nelson and so send her to perform the Attitudes for the admiral, pretending to be Juliet and crying 'Romeo I come' in a 'voice whose every vibration thrilled

Alexandre Dumas
The Lovely Lady Hamilton,
1903
Jean Johnson Kislak
Collection
2010.076.00.0001

the heart' (even though Juliet was not part of her repertoire). Dumas dwells on how her 'stupefying glamour, heightened by the odd apparel, had a touch of the supernatural, alarming and terrifying'. Acton and Maria Carolina leave Emma and Nelson alone, suggesting she performs her famous 'shawl dance', which leaves 'Emma frenzied with pride and Nelson mad with love'. After this dubious start as an eighteenth-century honey trap, Emma becomes rather a sympathetic figure, cast as truly attached to Nelson, loving him 'to despair', while he emphasizes her heroic effort to have his ships victualled before the Nile.

The finale of the book is the crushing of the Neapolitan rebellion and the dreadful execution of Admiral Caracciolo. Maria Carolina is the instigator, for she is convinced that if she gives the rebels a pardon, then 'royalty is forever dishonoured'. Nelson also declares that 'I have no mercy for traitors'. Emma says nothing, owing to her promise to the queen. Dumas concludes that the queen was 'satisfied' and 'Emma Lyonna accursed, and Nelson dishonoured'. We last see Emma playing the role of 'bank' in the popular card game of faro – she controls the odds, as it were. Nelson's mistreatment of the admiral is blamed on Maria Carolina. The final paragraph is a defence:

> It is hard to believe at the time, and it is next to incredible now, that the 'Mistress of the Seas' [i.e. Britain] suffered the lovely lady, to whom she was indebted for the victory of the Nile, to die in abject poverty and obscurity.

As Dumas concludes, 'Monarchies, like republics, can be ungrateful!'[13]

La San Felice was translated into English in two volumes in 1916 and 1918 by R. S. Garnett and titled *The Neapolitan Lovers*. The introduction noted that 'the author's ardent imagination had misled him' and recommended readers consult a 'book which nearly everyone possesses, Southey's *Life of Nelson*' for the truth. In the full version of the book it is the men, especially the king rather than the queen, who plot war. Emma is a weapon to captivate Nelson and the story concludes with Caracciolo's execution. The description of Emma's appearance and Attitudes is identical, excluding the odd difference in translation, to that in *The Lovely Lady Hamilton*. Nelson is possessed of a 'mad passion' for her and Dumas says it 'would be Nelson's excuse in the eyes of posterity, if posterity, which for two thousand years has condemned the lover of Cleopatra, could reverse its judgement'.[14] The conclusion notes 'Nelson was a terrible enemy of France, yet…Men like the hero of the Nile and of Trafalgar are the products of universal civilisation', but he also points out that the novel is not a 'eulogy', rather a fictional exploration of a darkest hour.

Dumas had more to tell of Emma's story. In 1865, he wrote *Souvenirs d'une favorite*. Never translated, perhaps because *La San Felice* was no great seller, *Souvenirs* is proposed as Emma's real story, written and given to a priest on her deathbed after her conversion to Catholicism (she declares Protestant priests too severe). In this version her life is rather whitewashed. She is hired young as a nurse for the children of Mr Thomas Hawarden and then spotted by 'Rowmney'

(the painter) in the countryside, who declares she must be 'the daughter of a duchess' and begs her to come to London. Dumas stretches events over more than 800 pages, sometimes slightly out of order, and Emma as narrator occasionally digresses to discuss Napoleon and French politics. She meets Sir Harry Fetherstonhaugh in dubious company but has to leave Uppark as he is in terrible debt, rather than being cast off. Graham encounters her at another dubious house, she meets Greville and is shipped off to Sir William.

This time Dumas takes Emma's story past the Neapolitan revolt. In London, the death of Sir William frees her to love Nelson, as he 'treated me like his sole and true wife'. As Hannah Greig shows in Chapter 6, in reality her situation became much more difficult after Sir William's death, for she no longer had the mask of respectability to protect her. Emma gives us a full account of the Battle of Trafalgar and skates over the funeral before declaring 'the rest of my life is nothing more than a series of errors'. As she says, when she is no longer the

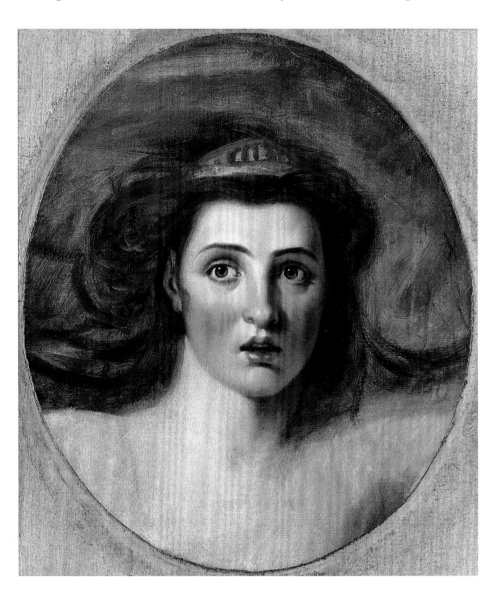

EPILOGUE: EMMA HAMILTON IN FICTION AND FILM

wife of Sir William, the mistress of Nelson or the friend of Maria Carolina, she becomes 'simply Emma Lyon, that is to say a courtesan of means who perhaps would have gained the respect that attaches to riches, if she'd held her fortune'.[15] She is buried in a grave with an inscription inviting he who has never sinned to cast the first stone.

The early twentieth century saw more historical and biographical interest in Lady Hamilton, often taking a sympathetic view of her. Walter Sichel wrote a full and excellent biography in 1905, and 1924 saw the appearance of a romanticized novel by E. Barrington (pseudonym of Eliza Louisa Moresby Beck) called *The Divine Lady: A Romance of Nelson and Emma Hamilton*. This begins with Emma singing beautifully in the countryside to children and later opines that one should brush over her early 'darkness'. Barrington concludes that there was 'gold in Emma, also, with all her evil', a 'quality which makes her memorable when women greater and better are forgotten'. The novel ends with a curious image of Nelson in the afterlife as the object of the love of his abandoned wife, Fanny, and of Emma, with both drawing him 'forever to the heart of the Beautiful made manifest in each of them'.[16] Even though it was the Roaring Twenties, the adultery still had to be excused – this time by turning it into a virtuous *tria juncta in uno* (three joined in one).

The first film, *The Romance of Lady Hamilton*, appeared in 1919, a British silent movie starring the American actress Malvina Longfellow. Released just after the end of the First World War in a Britain struggling to adjust to new social, cultural and economic realities, the film catered to an expanded demographic of wage-earning young women. *The Romance of Lady Hamilton* fudged the adultery and dramatized feminine romance and independence – an ideal message to the burgeoning 'new woman'.

Emma was an inviting role for an actress, providing much potential for love, tragedy and grand gestures. In 1929, Corinne Griffith, one of the greatest silent-film actresses, starred in *The Divine Lady*. This came out just in time for the first Oscars ceremony, where it was nominated in the Best Actress and Best Cinematography categories, and won Best Director for Frank Lloyd. Based on Barrington's novel, *The Divine Lady* is an idealized portrayal, introducing Emma and Nelson as an 'immortal romance' and Emma as 'England's greatest beauty'. Emma and her mother, Mrs Cadogan, arrive to be cook and maid to Charles Greville, who refuses to have them after he sees Emma flirt and decides she is a 'brazen hussy'. She begs him to relent: 'I know I'm vulgar but I could learn from an elegant gentleman like you.'

Emma's dubious past is blurred into an honest beginning as a servant, her heroism is much emphasized and she is often gowned in white against a dark background. She plays the harp rather than doing anything as wild as the Attitudes. Much is made of her heroism in victualling the fleet (and its scurvy-ridden men, 'dying like flies' in Nelson's words) before the Nile in a dramatic scene in which she appears on board and is shocked by his wounds. Nelson

declares, on receiving the supplies for his men, 'You have saved England – and my honour, Lady Hamilton'. Nelson and Emma, in this version, desperately resist their mutual passion – the film coyly shows waves washing onto cliffs and roses appearing on Emma's mouth as Nelson bends towards her – whereas in reality, the couple made little attempt to hide their affair. Emma's need for clamour and fame, and the blatant nature of their ongoing romance, are also whitewashed. She is never pregnant and Horatia is nowhere to be seen. The film ends with Nelson's death: he passes away dreaming of Emma and our last sight of her is as his lover, not dying in debt in France.

The depression years of the 1930s had little use for Emma and her excess.

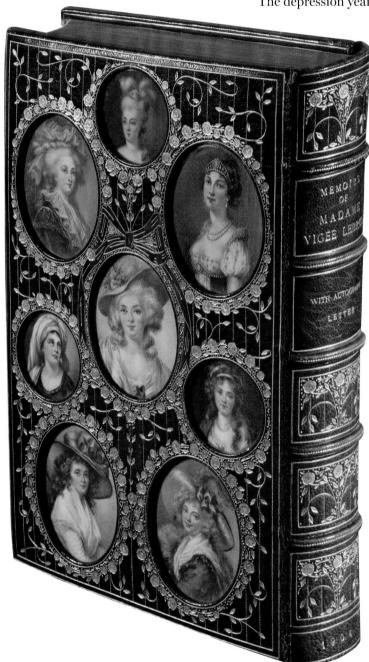

That changed with war. She burst into the limelight in 1941 with *That Hamilton Woman*, Alexander Korda's full-blown Hollywood treatment that, despite its perhaps distractingly lavish sets, costumes and grand gestures, has for many never been bettered. Starring Vivien Leigh and Laurence Olivier as Emma and Nelson, the film had the working title of 'The Enchantress', but this was altered to *Lady Hamilton* in Britain and, in the United States, to *That Hamilton Woman* as both more recognizable and, perhaps, more condemnatory.

Leigh was a bona fide superstar after *Gone with the Wind* (1939) and, after she and Olivier had married in August 1940, they were hot property. The costumes are rather Victorian and Leigh's look is too neat for Emma's flowing untidiness but, although she does not have Emma's full mid-life figure (which cinematic leading lady does?), she captures Emma's skittish playfulness and desire to be the centre of attention. Leigh's Emma is well-spoken, intelligent and youthfully flirtatious rather than vulgar. She is introduced through a discussion between Sir William and the French ambassador about the beautiful Romney portrait of Emma in a straw hat: as the Frenchman declares, 'no woman ever lived with such colouring, such godlike simplicity'. Sir William mentions Graham and Sir Harry but pre-empts criticism from his French *confrère* by pointing to a classical bust and saying, it is 'still beautiful, despite its past'.

As in *The Divine Lady*, a hefty scene is made of Emma's efforts to help Nelson's ships so they can

fight the Battle of the Nile. This, however, is a wartime film and, in the words of Olivier's biographer, 'blatant propaganda' about the Nazi threat.[17] Olivier's Nelson blusters that 'You will never make peace with Napoleon', and declares that he 'can never be master of the world until he has smashed us up – and believe me, gentlemen, he means to be master of the world': one must fight or die. Those of virtue in the film are the ones who support his view and Emma always champions his actions, encouraging him to war and smoothing his way in the Neapolitan court. She behaves as an ideal consort, even though she is married to another man. Nelson thinks of Emma as he dies. 'His last thoughts were of you, milady,' explains Captain Hardy.

The film was created by Korda in answer to Churchill's request for anti-Nazi films. Korda was already in the pay of the SIS (Secret Intelligence Service), the prime minister was keen to encourage morale-building entertainment that supported the war against Hitler and that would appeal to an American audience. However, before the USA entered the war on the Allied side in December 1941, the American government had banned belligerent propaganda. The British Ministry of Information also expressed the view that it should be left to 'the American government and people to make up their own minds'.[18] Film seemed to Churchill an ideal way around the ban. After a disastrous pro-intervention documentary that angered the US authorities, Korda recalled an old plan to create an Emma and Nelson film, which he had hoped would be a vehicle for his wife, Merle Oberon. Its setting of fighting a hated dictator would provide an excellent and suggestive parallel with

contemporary events, but it had to look as if it had come from Hollywood to avoid any suggestion of British manipulation.

Unfortunately, when Korda sent the early parts of the script to the censors at the Motion Picture Producers and Distributors of America, they paid little attention to the politics. Instead, they found that it failed the all-important moral code by which they judged films, since it appeared to condone adultery and no punishment was meted out to Nelson and Emma for their extra-marital affair. The writers were forced to insert a scene in which Nelson's

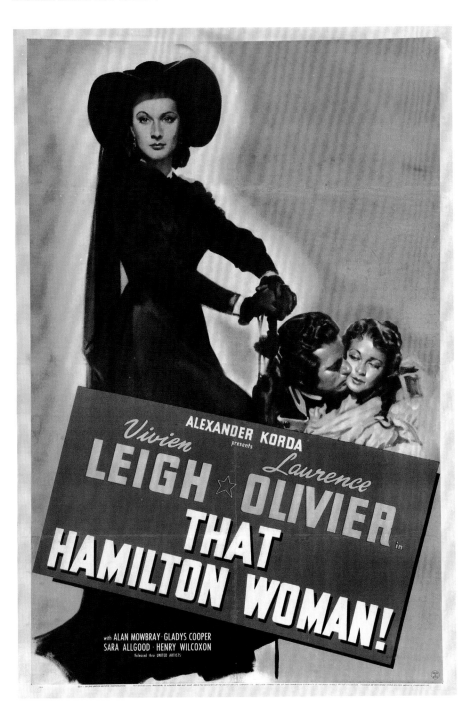

Poster for the feature film *That Hamilton Woman*, directed by Alexander Korda, 1941 Jean Johnson Kislak Collection 2010.104.00.0001

EPILOGUE: EMMA HAMILTON IN FICTION AND FILM

clergyman father condemns the liaison and Nelson confesses that it 'is a wicked, inexcusable thing to do'. But this still was not enough. The film ultimately escaped the wrath of the censors by adding in scenes at the beginning and end of Emma as an old drunk, arrested in Calais for stealing wine, fallen low and obviously punished for her bad behaviour. Retribution was meted out to Emma, but not to Nelson. While the beginning and end were thus a censorial sop, the Lady Hamilton revealed in between was supposed to be an admirable one, courageous and always pursuing British interests. The press pack suggested that reporters interview their local British consul for 'comments on Lady Hamilton as one of the world's renowned beauties and a representative of the role that British womanhood has played in shaping the events of that country'.[19]

The film was successful at the British and American box offices and did well in Russia, becoming Stalin's favourite. But its blatant message hardly went unnoticed – the *Motion Picture Daily* dubbed it 'a propaganda film'.[20] The US Senate Committee on Interstate and Foreign Commerce took a dim view of some of the speeches, including Nelson grandstanding about the need to 'destroy' dictators and Captain Hardy criticizing 'neutrals' for failing to fight, so it decreed the film be investigated as pro-war propaganda. Korda played the innocent in assembling his evidence for the Committee but was saved from having to appear before it by American entry into the war following the Japanese bombing of Pearl Harbor on 7 December 1941. Churchill was characteristically delighted by *That Hamilton Woman*, the film in which he played such a hand. He watched it dozens of times, had his own copy and subjected guests at Chartwell to prolonged viewings, whether they liked it or not.

Since then, Emma and her romance with Nelson have continued to generate books and films. Dumas's *La San Felice* became an Italian film in 1941, one of the screenwriters being Vittorio Mussolini, son of the dictator. In 1968, there was a joint German-Italian film called *Lady Hamilton – Zwischen Schmach und Liebe* (between shame and love) based on the Dumas novel and starring Michèle Mercier in that role. In the opening scene, Emma is a shepherdess and a local youth tries to assault her, but her mother fights him off. Then Emma whips off her bodice while running to the lake – and Romney spots her. Rather excessively packed with sometimes gratuitous nudity, the film is a loose revision of Dumas and one that seems much more dated than both *The Divine Lady* and *That Hamilton Woman*. Other depictions of Emma include the 1973 film version of Terence Rattigan's sensitive play, *A Bequest to the Nation* (1970), renamed *The Nelson Affair* in the United States. In this, Glenda Jackson is a cool and sharp Emma, cleverer than she is often played. Interestingly, in the films, the Attitudes are downplayed or sometimes absent, whereas they occupy a central aspect in all the books about Emma. Perhaps the wonder and the fascination of the Attitudes is simply too difficult to show on film. For the viewers, part of the thrill was how Emma could

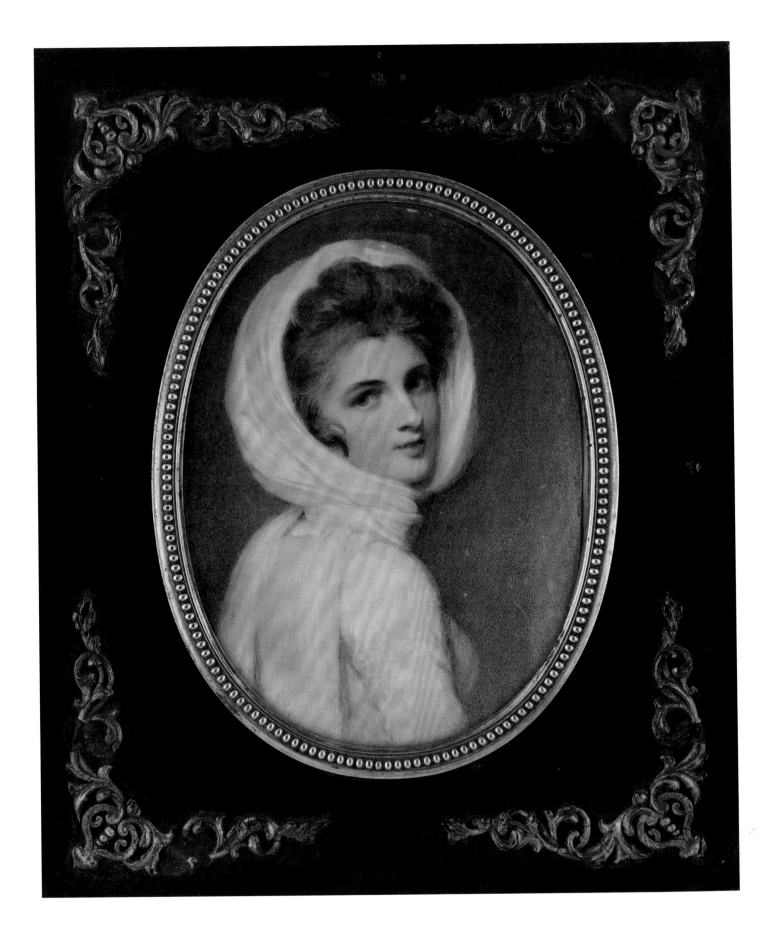

EPILOGUE: EMMA HAMILTON IN FICTION AND FILM

reveal feelings through a tiny movement of the face or body, in contrast to the boisterous acting style necessary in the noisy, crowded eighteenth-century theatre. Nowadays, with whole cinematic moments resting on the subtle flicker of a heroine's eye or mouth in the all-important close-up, we as audiences have perhaps become immune to what was, in her time, Emma's brilliant innovation.

A version of Emma even featured in romantic novelist Barbara Taylor Bradford's 1979 bestseller, *A Woman of Substance*. In this, Emma Harte, a young servant girl at the beginning of the twentieth century, is seduced by the local aristocrat but refuses to be cowed and instead becomes a department-store mogul. She designs a fashion line for her stores called 'Lady Hamilton'. The book became a television mini-series on Channel 4 in 1985. By the end, Emma is a dazzlingly successful international businesswoman, an option not open to the real Emma Hart. For, as her story – and that of so many mistresses – reveals, it was almost impossible in her day for a woman to have power if a man had not given it to her.

The most complex fictional representation of Emma is in Susan Sontag's *The Volcano Lover* (1992), a post-modern atmospheric evocation complete with shifting viewpoints and fragmentary monologues of the three-sided Hamilton–Nelson relationship from the Naples days to Emma's death, with a strong early focus on Sir William, to whom the title refers. Sontag's Emma is a good wife to Sir William. She is so enthusiastic about his interests that he feels 'the world had one person at the centre, unifying it' and when it comes to artistic endeavours, 'she helped him not just as a wife...but as a collaborator'. Critics call her vulgar – but she has her 'indefatigable gift for empathy' and Nelson is attracted by her 'warmth and directness that is never found in the world of courts'. Sontag has acute psychological insight into Emma, solving what has proved for her portrayers (especially the males) the great conundrum of her personality. As Sontag writes of her heroine, 'Ambition and the desire to please – these are not incompatible for a woman'.[21] For many authors, the problem is that Emma was both eager to capture Nelson and desirous to please nearly everyone she met, from Romney to Nelson to Maria Carolina, and that this is too much: she has to be either manipulative or innocently caring. In Sontag's world, she is both.

Although Sontag, like so many others, makes much of the Attitudes (describing them as something akin to a 'guess the pose' parlour game), she depicts Emma in her later years as trying to move away from the performance of her youth. At Merton in 1801, Emma staged 'The Favourite Sultana', detailed in a manuscript in Monmouth Museum. Emma dances for Nelson as a Sultana in pantaloons and square-toed slippers, accompanied by the admiral's nieces as Moorish ladies, various neighbours as 'Moors of Quality' and even her mother in costume in a fantasy Turkish tableau. Emma is both star of the show and making the ultimate offering to Nelson, the sultan, the king of the tableau.[22] 'The Favourite Sultana' goes to the heart of Emma Hamilton, about which Sontag was so acute. Her ambition and eagerness to please combined to

a stunning consequence, and one that eventually burnt itself out. As Sontag's Emma says, 'My life had great velocity. Then it was spent.'[23]

The notable critic Camille Paglia dismissed *The Volcano Lover* as pedestrian and criticized Sontag's 'incomprehension of any era before her own'. However, the novelist and screenwriter John Banville thought its Emma 'a splendid character, and Ms Sontag does her proud. She catches [her] gaiety, her cheerful vulgarity, her selfishness, her love of life, her cruelty. Nelson, too, is portrayed with vividness and subtle skill.'[24] Most of all, *The Volcano Lover*'s Emma is a spectacle, always on show. As Emma herself says in it, 'I could represent emotions with my body, with my face'.[25]

In the two centuries since her death, Emma has been revised and reinvented to fit the emphases of the period in which her story is being retold: variously a siren, a fallen woman, a virtuous defender of the British at war and a 1980s businesswoman, at once the victim of eighteenth-century sexual mores and freed by them, sometimes a supporting figure, at others thrust to the front. She has been the subject of biographies, novels, films, television programmes and museum displays. Most of these have been celebrations of Nelson or exhibitions of the artists – Romney, Reynolds, Lawrence, and lesser lights – who either immortalized her beauty or, like James Gillray, lampooned the equally celebrated *ménage à trois* in which she was the female object of desire. This book – which will certainly not be the last on her – is distinguished by being published to accompany the first major exhibition to focus on her alone as a British and European celebrity, and the worlds in which she lived. Emma had various qualities attributed to her throughout her life – kindness, greed, vulgarity, beauty, dignity, strength, weakness – but her most enduring characteristic was plasticity. It was this that charmed George Romney in his studio – and enabled her to play so many roles, both in her staged performances and her life: mistress, ambassadress, high-society wife, fallen woman. That she has been recreated so inventively since her death is fitting – her body generated spectacle in life and long after her death. If she represented the emotions of her own time 'with my body, with my face', then she has come to be deployed to represent our emotions ever since.

As the essays in this volume have shown, Emma Hamilton's life was vivid, full and spectacular, carving an arc across the era of Nelson and Napoleon from rags to riches and back again. The eighteenth century saw dramatic plunges from wealth to ruin, but few were as headlong as hers – she burned brightly, yet she fell sharply. Happily, the fine portraits, many of the best included in this book, still capture her in her youth – the time when Romney referred to her as his 'sun' and her life of public drama had barely begun. It was a life in which she was constantly on stage – until the very end. It would surely please her that she remains the object of our fascination.

Notes

Full publication details for works cited in abbreviated form can be found in the Bibliography.

Introduction (pp. 8–31)

1 Anon., *The Naval Review*, 1 (1931), p. 347.
2 Emma used different forenames – Amy and Emma – and surnames – Hart, Lyon, Hamilton – at different moments in her life. In order to avoid confusion, she is referrred to by her forename, Emma, throughout this book. Emma's mother assumed the surname 'Cadogan' rather than acquiring it through marriage.
3 See Sichel, *Emma Lady Hamilton*; Fraser, *Beloved Emma*; Williams, *England's Mistress*.
4 See, for instance, Alfred Thayer Mahan, *The Influence of Sea Power upon the French Revolution and Empire, 1793–1812* (London, 1892).
5 Czisnik, *Horatio Nelson*.
6 Kerr, *The Sailor's Nelson*, p. 8.
7 Pettigrew, *Memoirs of the Life of Vice-Admiral Lord Viscount Nelson*, vol. 1, p. x.
8 Mahan, *Life of Nelson*, p. 319.
9 Czisnik, *Horatio Nelson*, p. 67.
10 Mahan, *Life of Nelson*, p. 330.
11 D'Auvergne, *Dear Emma*, p. 5.
12 Sherrard, *Life of Emma Hamilton*, p. 328.
13 Mahan, *Life of Nelson*, p. 329.
14 D'Auvergne, *Dear Emma*, p. 5.
15 Mahan, *Life of Nelson*, pp. 393–94.
16 Letter from Melesina Trench, October 1800, quoted in Fraser, *Beloved Emma*, p. 258.
17 Sichel, *Emma Lady Hamilton*, p. 27.
18 Czisnik, *Horatio Nelson*, p. 61.
19 Davis and Capuano (eds), *Hamilton Letters*, pp. 1, 229.
20 Fothergill, *Sir William Hamilton*, pp. 197, 219.
21 Kidson, in Dunkelman (ed.), *The Enchantress*, p. 28.
22 Cross, *Striking Likeness*, p. 120.
23 Perry, *Spectacular Flirtations*, p. 27.
24 Vickery, *Gentleman's Daughter*, p. 52.
25 See Greig, *Beau Monde*.
26 Letter from Lady Elizabeth Foster, quoted in Amber Ludwig, 'Becoming Emma Hamilton: portraiture and self-fashioning in late Enlightenment Europe', PhD dissertation, Boston University, 2012, p. 81; Tours, *Life and Letters*, quoted on p. 91; Lord Bristol, quoted in Fraser, *Beloved Emma*, p. 156.
27 Tours, *Life and Letters*, p. 158, letter from Melesina St George, 10 October 1800.
28 Morrison, *Hamilton and Nelson Papers*, vol. 1, p. 159.
29 Sherrard, *Life of Emma Hamilton*, p. 26.
30 D'Auvergne, *Dear Emma*, pp. 34, 50.
31 D'Auvergne, *Dear Emma*, p. 48.
32 Sherrard, *Life of Emma Hamilton*, p. 88.
33 Mahan, *Life of Nelson*, p. 320; Sherrard, *Life of Emma Hamilton*, p. 10.
34 Mahan, *Life of Nelson*, p. 324.
35 D'Auvergne, *Dear Emma*, p. 109.
36 Long, *Memoirs of Lady Hamilton*, pp. 16, 34.
37 D'Auvergne, *Dear Emma*, p. 5; Mahan, *Life of Nelson*, p. 319.
38 D'Auvergne, *Dear Emma*, p. 5.
39 Ibid.
40 Ibid., pp. 6, 284.
41 Morrison, *Hamilton and Nelson Papers*, vol. 1, p. 86, letter from Emma to Charles Greville, 22–27 June 1784.
42 Ludwig, op. cit., p. 171.
43 D'Auvergne, *Dear Emma*, p. 88.
44 Letter from William Hamilton, quoted in Mahan, *Life of Nelson*, p. 324.
45 Morrison, *Hamilton and Nelson Papers*, vol. 1, p. 208, letter from Emma to Charles Greville, 19 April 1795.
46 Sichel, *Emma Lady Hamilton*, p. 6.
47 Mahan, *Life of Nelson*, p. 317.
48 Elaine Chalus, 'Fanning the flames: women, fashion and politics', in Potter (ed.), *Women, Popular Culture and the Eighteenth Century*.
49 Amber Ludwig, 'Place and possession: Emma Hamilton at Merton, 1801–5', in Jennifer G. Germann and Heidi A. Strobel (eds), *Materializing Gender in Eighteenth-Century Europe* (Farnham and Burlington, VT, 2016), p. 93.
50 Byrne, *Perdita*, p. 2.
51 Morrison, *Hamilton and Nelson Papers*, vol. 1, pp. 125–26, letter from Emma to Sir William Hamilton, 10 January 1787.

Chapter 1 (pp. 32–61)

1 Emma's mother, Mary Lyon, was a close and supportive presence through much of her daughter's life in London, Italy and at Merton Place. Although universally liked and admired, she has rarely entered the historical spotlight.
2 Henry Fielding, *An Enquiry into the Causes of the Late Increase of Robbers* (London, 1751), p. 116.
3 Henry Fielding, *The Covent Garden Journal* 1:35 (13 August 1752), p. 137.
4 Frederick A. Pottle (ed.), *Boswell's London Journal, 1762–1763* (London, 1950), p. 84.
5 *Nocturnal Revels: or, the History of King's-Place, and other Modern Nunneries*, 2nd edn (2 vols, London, 1779), vol. 1, p. 17.
6 Pettigrew, *Memoirs of Nelson*, vol. 2, pp. 593–94. Pettigrew knew the Budds.
7 Angelo, *Reminiscences of Henry Angelo*, vol. 2, p. 241.
8 Pettigrew, *Memoirs of Nelson*, vol. 2, p. 594; Crouch, 'Jane Powell, c. 1761–1831'.
9 Joseph Knight, 'Robinson, Mary (1758–1800)', *Dictionary of National Biography* (London, 1897).
10 *Town and Country Magazine*, 1776, p. 349.
11 Madame Le Brun, *Memoirs of Madame Vigée Lebrun*, trans. Lionel Strachey (New York, 1903), p. 66.
12 Angelo, *Reminiscences*, vol. 2, pp. 236, 238.
13 *Nocturnal Revels*, op. cit., vol. 2, pp. 21–22.
14 Sichel, *Emma Lady Hamilton*, p. 46.
15 See Syson, *Doctor of Love*.
16 James Graham, *A Lecture on the Generation, Increase, and Improvement of the Human Species!* (London, 1783), p. 14.
17 Peter Cunningham (ed.), *The Letters of Horace Walpole, Earl of Orford* (9 vols, London, 1861–66), vol. 7, p. 427.
18 *St James's Chronicle*, 28 April–1 May 1781.
19 Angelo, *Reminiscences*, vol. 1, p. 127.
20 *Morning Post and Daily Advertiser*, 11 July 1780.

21 S. Lloyd, 'Richard Cosway, 1742–1821', *Oxford Dictionary of National Biography* (Oxford, 2004).
22 *London Chronicle*, 5 December 1789.
23 Anon. [Francis Oliver], *Memoirs of Lady Hamilton*, pp. 40–43.
24 Pettigrew, *Memoirs of Nelson*, vol. 2, p. 596; Jeaffreson, *Lady Hamilton and Lord Nelson*, vol. 1, pp. 28–40. Sichel dissented, however (*Emma Lady Hamilton*, pp. 46–49).
25 Angelo, *Reminiscences*, vol. 2, pp. 242, 61, and vol. 1, p. 127.
26 www.historyofparliamentonline.org/volume/1754-1790/member/fetherstonhaugh-sir-henry-1754-1846.
27 Morrison, *Hamilton and Nelson Papers*, vol. 1, p. 178.
28 Ibid., vol. 1, letter 113 (10 January 1782).
29 Sichel, *Emma Lady Hamilton*, pp. 50–51.
30 Ibid., pp. 53, 73, 76.
31 Jeaffreson, *Lady Hamilton and Lord Nelson*, vol. 1, p. 56.
32 Greville to Sir William Hamilton, 3 December 1785: Morrison, *Hamilton and Nelson Papers*, vol. 1, p. 109.

Chapter 2 (pp. 62–93)

1 Gamlin, *George Romney and His Art*, p. 165; Kidson, *George Romney*, vol. 3, p. 664.
2 Quoted in Kidson, *George Romney*, vol. 3, p. 664.
3 Whitley, *Artists and their Friends in England*, vol. 1, pp. 266–67.
4 Quoted in Charles Robert Leslie, *Life and Times of Sir Joshua Reynolds, with notices of some of his contemporaries* (2 vols, London, 1865), vol. 1, p. 291.
5 Kidson, *George Romney*, vol. 1, p. 16.
6 The two portraits are on loan to Brooks's Club, St James's, London.
7 Kidson, *George Romney 1734–1802*, p. 88.
8 Kidson, *George Romney*, vol. 1, cat. 471, p. 226; Mannings, *Sir Joshua Reynolds*, vol. 2, cat. 1334, fig. 1351.
9 Nadia Tscherny, '"Persons and property": Romney's society portraiture', in Kidson (ed.), *Those Delightful Regions of Imagination*, p. 53.
10 Mannings, *Sir Joshua Reynolds*, vol. 1, p. 567. The painting was engraved by Francesco Bartolozzi in 1792.
11 Painted in 1781, Romney's portrait of Emily Pott is now in the Metropolitan Museum of Art, New York; Kidson, *George Romney*, vol. 2, cat. 1049, p. 471.
12 Mannings, *Sir Joshua Reynolds*, vol. 1, p. 566.
13 Tim Clayton, 'Figures of fame: Reynolds and the printed image', in Postle (ed.), *Joshua Reynolds*, p. 55.
14 Martin Postle, 'Factions and fictions: Romney, Reynolds and the politics of patronage', in Kidson (ed.), *Those Delightful Regions of Imagination*, p. 82.
15 Ibid.
16 Whitley, *Artists and their Friends in England*, vol. 1, p. 393.
17 Kidson, *George Romney*, vol. 2, p. 503.
18 Ibid., p. 531.
19 Kidson, *George Romney 1734–1802*, p. 167.
20 Hayley, *Life of George Romney*, pp. 70, 101–2, 312.
21 David A. Cross, 'The "Admiral of the

Blues": Romney, depression and creativity', in Kidson, *Those Delightful Regions of Imagination*, p. 65.

22 Ibid., p. 66.

23 Kidson, *George Romney 1734–1802*, p. 23.

24 Kidson, *George Romney*, vol. 3, p. 683.

25 Ibid., p. 677.

26 Whitley, *Artists and their Friends in England*, vol. 2, p. 89.

27 Hayley, *Life of George Romney*, p. 102.

28 William Hayley, *The Triumphs of Temper*, 2nd edn (London, 1781), pp. x, xi.

29 Ibid., p. xi.

30 Quoted in Kidson, *George Romney 1734–1802*, p. 165.

31 Hayley, *Life of George Romney*, pp. 120–21.

32 Kidson, *George Romney 1734–1802*, p. 184.

33 Hayley, *Life of George Romney*, p. 165. Giovanni (later Sir John) Gallini was a well-known London musical impresario at the time.

Chapter 3 (pp. 108–37)

1 For an excellent summary of the complex negotiations between Greville and Hamilton, see Constantine, *Fields of Fire*, pp. 133–53. On Naples during this period, see Jenkins and Sloan, *Vases and Volcanoes*.

2 Emma Hart to Charles Greville, 30 April 1786, in Morrison, *Hamilton and Nelson Papers*, vol. 1, p. 114.

3 Emma Hart to Charles Greville, 22 July 1786, in ibid., pp. 116–17.

4 Ibid., p. 117.

5 Emma Hart to Charles Greville, 1 August 1786, in ibid., p. 118.

6 Emma Hart to Charles Greville, 1 August 1786, in ibid., p. 118.

7 Emma Hart to Charles Greville, 1 August 1786, in Morrison, *Hamilton and Nelson Papers*, vol. 1, p. 119.

8 Emma Hamilton to Charles Greville, 16 September 1794, in ibid., p. 194.

9 Goethe, *Italian Journey*, p. 183; p. 188.

10 Anna Riggs Lady Miller, *Letters from Italy, describing the manners, customs, antiquities, paintings, &c. of that country, in the years 1770 and 1771, to a friend residing in France* (3 vols, Dublin, 1776), vol. 2, pp. 274–75.

11 Calaresu, 'From the street to stereotype'.

12 Gordon, 'Subverting the secret of Herculaneum'.

13 Moore, 'Sir William Hamilton's volcanology'.

14 Emma Hart to Charles Greville, 4 August 1787, in Morrison, *Hamilton and Nelson Papers*, vol. 1, p. 131.

15 Pierre François Hugues d'Hancarville (ed.), *Antiquités Etrusques, Grecques et Romaines, tirées du Cabinet de M. William Hamilton* (4 vols, Naples, dated 1766–67, but printed later).

16 Kelly, *Society of Dilettanti*.

17 Goethe, *Italian Journey*, p. 315.

18 William Hamilton, *Observations on the Volcanos of the Two Sicilies* (2 vols, Naples, 1776); William Hamilton, *Supplement to the Campi Phlegræi Being An Account Of The Great Eruption Of Mount Vesuvius In The Month Of August 1779* (Naples, 1779).

19 William Hamilton to Charles Greville,

22 October 1782, British Library, Add. MSS 41197, f. 112.

20 Emma Hart to Charles Greville, 4 August 1787, in Morrison, *Hamilton and Nelson Papers*, vol. 1, p. 132.

21 Emma Hamilton to Charles Greville, 2 June 1793, in ibid., p. 177.

22 William Hamilton to Charles Greville, 26 May 1786, in ibid., p. 140.

23 William Hamilton to Joseph Banks, 6 April 1790, quoted in Edward Smith, *The Life of Sir Joseph Banks, President of the Royal Society: With Some Notices of His Friends and Contemporaries* (London, 1911), p. 200.

24 Fraser, *Beloved Emma: The Life of Emma, Lady Hamilton* (repr., New York, 2004), p. 141.

25 Ibid., p. 159.

26 Frederick Hervey, 4th Earl of Bristol, to William Hamilton, 21 December 1791, in Morrison, *Hamilton and Nelson Papers*, vol. 1, p. 159.

27 Lady Elizabeth Vassall Fox Holland, *The Journal of Elizabeth Lady Holland* (1791–1811), ed. Giles Stephen Holland Fox-Strangways, Earl of Ilchester (2 vols, London, 1908), vol. 1, p. 242.

28 Quoted in Williams, *England's Mistress*, p. 180.

29 Emma Hart to Charles Greville, 4 August 1787, in Morrison, *Hamilton and Nelson Papers*, vol. 1, p. 132.

30 Ibid.

31 William Hamilton to Charles Greville, 2 March 1790, in ibid., p. 142.

32 See, for example, Giuseppe Nicolini, 'Sei Ariette. Con Accompagnamento. Di Giuseppe Niccolini. Dedicate. a S. E. Miledi Hamilton', *c.* 1800, GEN MSS 23, Box 2, volume v, Beinecke Library, Yale University; 'Libro Quinto. Raccolta Di Terzetti. Composti Da Varii Autorii. Per Uso Di. S.E. Miledi Hamilton. In Napoli', *c.* 1790s, GEN MSS 23, Box 3, volume VIII, Beinecke Library, Yale University.

33 Minto (ed.), *Life and Letters*, vol. 2, pp. 365–66.

34 Rauser, 'Living statues and neoclassical dress in late eighteenth-century Naples'; Gordon Williams, *A Dictionary of Sexual Language and Imagery in Shakespearean and Stuart Literature*, (3 vols, London, 1994), vol. 2, pp. 1077–78. Emma seems to have introduced this unique synthesis to the European public, likely becoming the model for Goethe's Luciana in *Elective Affinities* (1809). However, there were precedents. On the one hand were the richly ornamented *tableaux vivants*, popular in the French theatre, which recreated scenes from literature and painting. On the other hand were 'posture molls' – naked women who retained rigid poses so that men could gawk at them – well-known characters in brothels and in literature.

35 Holland, op. cit., vol. 1, p. 243.

36 Francesco Serao, *Della tarantola o sia falangio di Puglia lezioni accademiche* (Naples, 1742); '[Review of] Delle Delizie Tarentine libri quattro opera postuma di Tommaso Niccolò d'Aquino Patrizio della Città di Taranto (Naples 1771)', *Nuovo giornale di letterati d'Italia*, 1 (February 1773), pp. 288–354.

37 Henry Swinburne, *Travels in the Two Sicilies by Henry Swinburne, Esq. In the Years 1777, 1778, 1779, and 1780*, 2nd edn (4 vols, London, 1790), vol. 1, p. 60.

38 Espinchal, *Journal d'émigration du comte d'Espinchal*, p. 89.

39 Swinburne, op. cit., vol. 1, p. 60.

40 D'Hancarville, op. cit., vol. 4, p. 181.

41 Swinburne, op. cit., vol. 1, pp. 392–93; Joseph Cooper Walker, *Historical Memoir on Italian Tragedy, from the Earliest Period to the Present Time* (London, 1799), p. xxxvii.

42 Serao, op. cit.; Johann Hermann von Riedesel, *Travels Through Sicily and That Part of Italy Formerly Called Magna Graecia, and a Tour Through Egypt: With an Accurate Description of Its Cities, and the Modern State of the Country*, trans. J. R. Forster (London, 1773), pp. 214–15; Swinburne, op. cit., vol. 1, p. 393.

43 Carabelli, *In the Image of Priapus*; Kelly, *Society of Dilettanti*, pp. 243–57.

44 Emma Hamilton to Joseph Banks, 31 May 1797, quoted in Smith, op. cit., p. 203.

45 Emma Hamilton to Greville, 2 June 1793, in Morrison, *Hamilton and Nelson Papers*, vol. 1, p. 177.

46 Emma Hart to Charles Greville, 22 June 1784, in ibid., p. 86.

47 Minto (ed.), *Life and Letters*, vol. 2, pp. 364–65.

Chapter 4 (pp. 138–59)

1 Angelo, *Reminiscences of Henry Angelo*, vol. 2, p. 236.

2 Ibid., vol. 2, p. 239.

3 Demi-rep (from 'demi-reputable') was a term frequently used during this period to signify a woman who had worked as a prostitute.

4 Angelo, *Reminiscences of Henry Angelo*, vol. 2, p. 237.

5 Samuel Johnson, *A Dictionary of the English Language* (2 vols, London, 1755–56), vol. 1, 'Attitude', n.p.

6 Rooney, *Living Screens*.

7 Quoted Rauser, 'Living statues and neoclassical dress in late eighteenth-century Naples', p. 476.

8 Morrison, *Hamilton and Nelson Papers*, vol. 1, p. 133.

9 Goethe, *Italian Journey*, pp. 315–16.

10 See John Brewer, *A Sentimental Murder: Love and Madness in the Eighteenth Century* (London, 2004).

11 James Boaden, *Memoirs of the Life of John Philip Kemble* (2 vols, London, 1825), vol. 1, p. 144.

12 Pointon, *Strategies for Showing*, p. 216.

13 *The World*, 5 February 1787.

14 Goethe, *Italian Journey*, p. 208.

15 Horace Walpole to Lord Stafford, 25 August 1771, in W. S. Lewis *et al.* (eds), *Horace Walpole's Correspondence*, vol. 35 (New Haven, 1973), pp. 343–44.

16 Holmström, *Monodrama, Attitudes, Tableaux Vivants*, p. 115.

17 Charles Nicoullaud (ed.), *Memoirs of the Comtesse de Boigne 1781–1814* (London and New York, 1907), p. 100.

18 Trench, *Remains of the Late Mrs Richard Trench*, pp. 107, 108.

19 By 1800, Hamilton was wearing her hair short in the fashionable 'antique' or 'Titus' style, indicating her willingness to manipulate her body image and

presumably her performance. See Trench, *Remains of the Late Mrs Richard Trench*: '[h]er hair (which by-the-bye is never clean) is short, dressed like an antique', p. 107.

20 Nicoullaud (ed.), op. cit., pp. 100–101.

21 Sontag, *Volcano Lover*, p. 145.

22 See account by Lady Elizabeth Foster in Dorothy Margaret Stuart, *Dearest Bess: The Life and Times of Lady Elizabeth Foster* (London, 1955), p. 59.

23 *Morning Post*, 18 November 1797.

24 Minto (ed.), *Life and Letters*, vol. 2, p. 364.

25 *A new edition considerably enlarged, of Attitudes faithfully copied from nature: and humbly dedicated to all admirers of the grand and sublime* (London, 1807).

26 *Gentleman's Magazine*, 71 (April 1801), p. 298.

27 Minto (ed.), *Life and Letters*, vol. 2, p. 365.

Chapter 5 (pp. 174–99)

1 Kennedy, *Nelson and His Captains*, p. 152

2 Fraser, *Beloved Emma*, p. 206.

3 Kennedy, *Nelson and His Captains*, p. 46.

4 NMM, DAV/2/7, Fanny to Davison, 11 April 1799.

5 See Knight, *Pursuit of Victory*, p. 334.

6 NMM DAV/2/7, Fanny to Davison, 11 April 1799; and DAV/2/31, Fanny to Davison, 2 March 1801.

7 See Knight, *Pursuit of Victory*, p. 352.

8 Gérin, *Horatia Nelson*, p. 9.

9 NMM, DAV/2/27, Fanny to Davison, 5 February 1801.

10 Harrison, *Life of…Nelson*, vol. 2, p. 270. This biography was written under Emma's guidance.

11 Quoted by Oman, *Nelson*, p. 498.

12 Vickery, *Behind Closed Doors*, pp. 83ff and 153.

13 See Gérin, *Horatia Nelson*, pp. 55–56.

Chapter 6 (pp. 200–27)

1 Numerous English papers republished the notice first printed in the *Gazette de France* on 20 January, for example, *Hereford Journal* (1 February 1815): 'Calais Jan. 17 – The celebrated Emma, widow of Sir Wm. Hamilton, *died* here yesterday. This lady had been intimately connected with Lord Nelson. By a codicil to his will, written an hour before the battle of Trafalgar, he confirmed all the legacies he had made to her Ladyship. This document was found in the possession of Lady Hamilton and pursuant to her last request, her body will be conveyed to England.'

2 Letter to Mrs Bolton, quoted by Fraser, *Beloved Emma*, p. 294.

3 *Morning Post*, 2 January 1804; 28 November 1803.

4 *Morning Post*, 21 December 1803.

5 *Morning Post*, 24 June 1805.

6 Appendix to Sichel, *Emma Lady Hamilton*, letter from Nelson to Lady Hamilton, 23 September 1801, p. 581.

7 At Lady Barrymore's masquerade, for example, where Emma dressed as a gypsy, she was required to sing duets with Mrs Billington (a professional

singer), *Morning Post*, 24 June 1805. At an entertainment hosted by the Marquis of Abercorn, Emma had sung and 'obligingly exhibited all her wonted fascination of graceful attitude', *Morning Post*, 5 March 1805. At the Marchioness of Hertford's assembly in 1807, Emma was recorded as singing several airs (*Morning Post*, 4 March 1807) and at a party for the Princess of Wales in 1808 Emma sang and performed her Attitudes (*Morning Post*, 25 April 1808).

8 Lady Bessborough noted to her lover Lord Granville Leveson-Gower that 'Lady Hamilton did her attitudes beautifully, notwithstanding her enormous size – at least, the grave ones; she is too large for Bacchante.' Quoted in Fraser, *Beloved Emma*, p. 300.

9 Views reported to Mrs Creevey and noted in a letter from Mrs Creevey to her husband, 1805, published in Tours, *Life and Letters*, p. 221.

10 Tours, *Life and Letters*, 8 October 1805, p. 218.

11 Ibid.

12 NMM, JOD/14, codicil to Nelson's will, 21 October 1805.

13 Tours, *Life and Letters*, p. 223.

14 Ibid.

15 Imprisonment for debt in Britain was only significantly reduced, but not abolished, by the Insolvent Debtors Act of 1869.

16 *Morning Post*, 2 February 1813.

17 Emma, Lady Hamilton, Her sale, 8 July 1813: 'A Catalogue of the Elegant Household furniture… the property of a Lady of Distinction'.

18 Tours, *Life and Letters*, p. 253.

19 *Whitehall Evening Post or London Intelligencer*, 17–19 January 1769.

20 For more on Lady Derby and the other women mentioned here, see Greig, *Beau Monde*, Chapter six.

21 Letter from Lady Sarah Lennox to Lady Susan O'Brien, Goodwood, 14 May 1781, in Countess of Ilchester and Lord Stavordale (eds), *Life and Letters of Lady Sarah Lennox 1745–1826* (London, 1902), vol. 2, pp. 9–10.

22 Letter from Countess Spencer to Georgiana, Duchess of Devonshire, 19 October 1793, reproduced in Bessborough (ed.), *Georgiana*, p. 203.

Epilogue (pp. 246–71)

1 Tours, *Life and Letters*, p. 65.

2 *Morning Post*, 26 January 1815.

3 For more on Emma and Horatia's relationship, see Williams, *England's Mistress*, pp. 340–50.

4 Gérin, *Horatia Nelson*, p. 65.

5 Ibid., p. 175.

6 Emma to Nelson, 8 September 1798, BL Add. MSS 34989, ff. 4–7.

7 For more on these novels and their versions of Nelson and Emma, see Williams, 'Nelson and women: marketing representations and the female consumer', in David Cannadine (ed.), *Admiral Lord Nelson: Context and Legacy* (Basingstoke, 2005), pp. 67–92.

8 Robert Southey, *Life of Nelson* (2 vols, London, 1813).

9 Anon. [Francis Oliver], *Memoirs of Lady Hamilton*, p. iv.

10 Ibid., pp. 10, 12, 14, 35, 54, 116.

11 *The Nautical Magazine; or Naval Chronicle for 1840*, pp. 887–88.

12 Thackeray, *Vanity Fair*, pp. 119–20, 598, 643. In Greek historical myth Clytemnestra murdered her husband, Agamemnon, King of Mycenae, on his return from the Trojan War, though traditionally with an axe.

13 Dumas, *Lovely Lady Hamilton*, pp. 87, 18, 87, 93, 96, 143, 233, 244, 248, 262.

14 Alexandre Dumas, *The Neapolitan Lovers*, trans. R. S. Garnett (London, 1916), pp. 12, 157, 248, 360.

15 Alexandre Dumas, *Souvenirs d'une favorite* (Paris, 1865), pp. 37, 785, 809, 810.

16 Barrington, *Divine Lady*, p. 476.

17 Lewis, *Real Life of Laurence Olivier*, p. 186.

18 2 September 1940, Ministry of Information (US Division), Sidney Bernstein Papers, Imperial War Museum.

19 *That Hamilton Woman* pressbook, BFI Files, VAN 65.

20 Cited in Stephen Mintz and Randy W. Roberts (eds), *Hollywood's America: United States History Through its Films* (New York, 1993), p. 418.

21 Sontag, *Volcano Lover*, pp. 179, 180, 195, 237.

22 'The Favourite Sultana', 1801, Monmouth Museum, E206.

23 Sontag, *Volcano Lover*, p. 496.

24 Paglia, *Vamps and Tramps*, p. 353; *New York Times*, 9 August 1992.

25 Sontag, *Volcano Lover*, p. 496.

Selected Bibliography

Angelo, Henry, *Reminiscences of Henry Angelo, with Memoirs of his late Father and Friends*, 2 vols, London, 1828, 1830

Anon. [Francis Oliver], *Memoirs of Lady Hamilton*, London, 1815

Barrington, E., *The Divine Lady: A Romance of Nelson and Emma Hamilton*, London, 1924

Bessborough, Earl of (ed.), *Georgiana: Extracts from the Correspondence of Georgiana, Duchess of Devonshire*, London, 1955

Byrne, Paula, *Perdita: The Life of Mary Robinson*, London, 2004

Calaresu, Melissa, 'From the street to stereotype: urban space, travel and the picturesque in late eighteenth-century Naples', *Italian Studies* 62:2 (2007), pp. 189–203

Carabelli, Giancarlo, *In the Image of Priapus*, London, 1996

Chalus, Elaine, 'Elite women, social politics, and the political world of the late eighteenth century', *Historical Journal* 43:3 (2000), pp. 669–97

Coltman, Viccy, 'Sir William Hamilton's vase publications (1766–1776): a case study in the reproduction and dissemination of antiquity', *Journal of Design History* 14:1 (2001), pp. 1–16

Colville, Quintin, and Davey, James (eds), *Nelson, Navy and Nation: The Royal Navy and the British People 1688–1815*, London, 2013

Constantine, David, *Fields of Fire: A Life of Sir William Hamilton*, London, 2001

Cross, David A., *A Striking Likeness: The Life of George Romney*, Aldershot, 2000

Crouch, K. A., 'Jane Powell, c. 1761–1831', Oxford Dictionary of National Biography, Oxford, 2004

Czisnik, Marianne, *Horatio Nelson: A Controversial Hero*, London, 2005

D'Auvergne, Edmund B., *The Dear Emma, The Story of Emma Lady Hamilton, her Husband and her Lovers*, London, 1936

Davis, John A., and Capuano, Giovanni (eds), *The Hamilton Letters: The Naples Dispatches of Sir William Hamilton*, London, 2008

Dumas, Alexander, *The Lovely Lady Hamilton*, trans. H. L. Williams, London, 1903

Dunkelman, Arthur (ed.), *The Enchantress: Emma, Lady Hamilton*, exh. cat., New York, 2011

Eger, Elizabeth, and Peltz, Lucy, *Brilliant Women: 18th Century Bluestockings*, London, 2008

Espinchal, Joseph-Thomas-Anne, Comte d', *Journal d'émigration du comte d'Espinchal: publié d'après les manuscrits originaux*, Paris, 1912

Fothergill, Brian, *Sir William Hamilton, Envoy Extraordinary*, London, 1969

Fraser, Flora, *Beloved Emma: The Life of Emma, Lady Hamilton*, London, 1986

Gamlin, Hilda, *George Romney and His Art*, London, 1894

Gatrell, Vic, *The First Bohemians: Life and Art in London's Golden Age*, London, 2013

Gérin, Winifred, *Horatia Nelson*, Oxford, 1970

Goethe, J. W., *Italian Journey [1786–1788]*, trans. W. H. Auden and Elizabeth Mayer, Harmondsworth, 1970

Gordon, Alden R., 'Subverting the secret of Herculaneum: archaeological espionage in the Kingdom of Naples', in Victoria C. Gardner Coates and Jon L. Seydl, (eds), *Antiquity Recovered: The Legacy of Pompeii and Herculaneum*, Los Angeles, 2007, pp. 37–57

Greig, Hannah, *The Beau Monde: Fashionable Society in Georgian London*, Oxford, 2013

Harrison, James, *The Life of the Right Honourable Horatio Lord Viscount Nelson*, 2 vols, London, 1806

Holmström, Kirsten Gram, *Monodrama, Attitudes, Tableaux Vivants: Studies on Some Trends of Theatrical Fashion 1770–1815*, Stockholm, 1967

Jeaffreson, J. C., *Lady Hamilton and Lord Nelson: An Historical Biography*, 2 vols, London, 1888

Jenkins, Ian, and Sloan, Kim, *Vases and Volcanoes: Sir William Hamilton and His Collection*, exh. cat., London, 1996

Kelly, Jason M., *The Society of Dilettanti: Archaeology and Identity in the British Enlightenment*, New Haven and London, 2009

Kennedy, Ludovic, *Nelson and His Captains*, 3rd edn, London, 2001

Kerr, Mark, *The Sailor's Nelson*, London, 1932

Kidson, Alex, *George Romney 1734–1802*, exh. cat., London and Princeton, NJ, 2002

—, *George Romney: A Complete Catalogue of His Paintings*, 3 vols, New Haven and London, 2015

—, (ed.), *Those Delightful Regions of Imagination: Essays on George Romney*, New Haven and London, 2002

Knight, Roger, *The Pursuit of Victory: The Life and Achievement of Horatio Nelson*, London, 2005

Hayley, William, *The Life of George Romney*, London, 1809

Lada-Richards, Ismene, '"Mobile Statuary": Refractions of pantomime dancing from Callistratus to Emma Hamilton and Andrew Ducrow', *International Journal of the Classical Tradition* 10:1 (2004), pp. 3–37

Lewis, Roger, *The Real Life of Laurence Olivier*, London, 1996

Lincoln, Margarette (ed.), *Nelson and Napoléon*, exh. cat., London, 2005

Long, W. H., *Memoirs of Lady Hamilton*, London, 1892

Ludwig, Amber, 'Becoming Emma Hamilton: portraiture and self-fashioning in late Enlightenment Europe', PhD dissertation, Boston University, 2012

Mahan, Alfred Thayer, *The Life of Nelson: The Embodiment of the Sea Power of Great Britain*, repr., Ithaca, NY, 2001

Mannings, David, *Sir Joshua Reynolds: A Complete Catalogue of His Paintings*, 2 vols, New Haven and London, 2000

Minto, Countess of (ed.), *Life and Letters of Sir Gilbert Elliot, First Earl of Minto from 1751 to 1806*, 3 vols, London, 1874

Moore, D. T., 'Sir William Hamilton's volcanology and his involvement in *Campi Phlegræi*', *Archives of Natural History* 21:2 (1994), pp. 169–93

Morrison, Alfred, *The Collection of Autograph Letters and Historical Documents Formed by Alfred Morrison: The Hamilton and Nelson Papers*, 2 vols, London, 1893–94

Oman, Carola, *Nelson*, London, 1947

Paglia, Camille, *Vamps and Tramps: New Essays*, New York, 1994; London, 1995

Perry, Gill, *Spectacular Flirtations: Viewing the Actress in British Art and Theatre, 1768–1820*, New Haven and London, 2007

Pettigrew, Thomas Joseph, *Memoirs of the Life of Vice-Admiral Lord Viscount Nelson*, London, 2 vols, 1849

Pointon, Marcia, *Strategies for Showing: Women, Possession, and Representation in English Visual Culture 1665–1800*, Oxford, 1997

Pop, Andrei, 'Sympathetic spectators: Henry Fuseli's Nightmare and Emma Hamilton's Attitudes', *Art History* 34:5 (2011), pp. 934–57

Postle, Martin (ed.), *Joshua Reynolds: The Creation of Celebrity*, exh. cat., London, 2005

Potter, Tiffany (ed.), *Women, Popular Culture, and the Eighteenth Century*, Toronto, 2012

Preston, Carrie J., *Modernism's Mythic Pose: Gender, Genre, Solo Performance*, Oxford, 2011

Rauser, Amelia, 'Living statues and neoclassical dress in late eighteenth-century Naples', *Art History* 38:3 (2015), pp. 462–87

Rooney, Monique, *Living Screens: Melodrama and Plasticity in Contemporary Film and Television*, London, 2015

Russell, Gillian, *Women, Sociability and Theatre in Georgian London*, Cambridge, 2007

Schachenmayr, Volker, 'Emma Lyon, the Attitude, and Goethean performance theory', *New Theatre Quarterly* 13:49 (1997), pp. 3–17

Sherrard, O. A., *A Life of Emma Hamilton*, London, 1927

Sichel, Walter S., *Emma Lady Hamilton: From New and Original Sources and Documents*, London, 1905

Sontag, Susan, *The Volcano Lover: A Romance*, New York and London, 1992

Southey, Robert, *Life of Nelson*, 2 vols, London, 1813

'Surely no person was ever so happy as I am': Emma Hamilton's Path to Fame, exh. cat., Philadelphia, 2007

Syson, Lydia, *Doctor of Love: James Graham and His Celestial Bed*, Richmond, 2008

Thackeray, W. M., *Vanity Fair*, ed. John Carey, London, 2001

Tours, Hugh, *The Life and Letters of Emma Hamilton*, London, 1963

[Trench, Melesina], *The Remains of the Late Mrs Richard Trench*, London, 1862

Vickery, Amanda, *Behind Closed Doors: At Home in Georgian England*, New Haven and London, 2009

—, *The Gentleman's Daughter: Women's Lives in Georgian England*, London, 2006

White, Colin (ed.), *Nelson: The New Letters*, Woodbridge, 2005

Whitley, William T., *Artists and their Friends in England 1700–1799*, 2 vols, London, 1928

Williams, Kate, *England's Mistress: The Infamous Life of Emma Hamilton*, London, 2006

Picture Credits

List of Contributors

Dr Quintin Colville is Curator of Naval History at the National Maritime Museum, London. After studying Modern History at Magdalen College, Oxford, he completed his PhD at the V&A and the Royal College of Art. He has held research fellowships at the University of Oxford, the Institute of Historical Research and the National Maritime Museum. He was lead curator of the NMM's *Nelson, Navy, Nation* gallery, its *Forgotten Fighters: The First World War at Sea* gallery and its special exhibition *Emma Hamilton: Seduction and Celebrity*. He has published on naval history, and the histories of gender and material culture.

Vic Gatrell is a member of the Cambridge Faculty of History and a Life Fellow of Gonville & Caius College, Cambridge. He was Professor of British History at the University of Essex 2003–8. He has been awarded the T. S. Ashton Prize by the Economic History Society, the Whitfield Prize of the Royal Historical Society for his *The Hanging Tree: Execution and the English People, 1780–1868* (1994), and both the Wolfson Prize for History and the PEN Hessell-Tiltman Prize for History for his *City of Laughter: Sex and Satire in Eighteenth-Century London* (2007). His recent *The First Bohemians: Life and Art in London's Golden Age* (2013) was listed for the Hessell-Tiltman Prize.

Dr Hannah Greig is a senior lecturer in history at the University of York where she lectures on eighteenth-century British social, cultural and political history. Much of her research to date has focused on elite life in eighteenth-century London, the subject of her recent book, *The Beau Monde: Fashionable Society in Georgian London* (2013). Before moving to York she held academic posts at Balliol College, Oxford, and the Royal College of Art.

Dr Jason Kelly is the Director of the Indiana University-Purdue University Indianapolis Arts and Humanities Institute (IAHI) and an Associate Professor of British History. His research focuses on the intersections of art, science and philosophy. He is the author of *The Society of Dilettanti* (2010) and his articles have been published in the *Journal of British Studies*, the *British Art Journal*, the *Walpole Society*, and elsewhere. He is currently preparing a book on Nicholas Revett and Georgian Neoclassicism.

Dr Margarette Lincoln is a Visiting Fellow at Goldsmiths, University of London. She was Deputy Director of the National Maritime Museum, Greenwich, London, from 2007 to 2015. Before taking up a museum career she was an academic, teaching English Literature and publishing widely in eighteenth-century studies. Her books include *Representing the Navy: British Sea Power 1750–1815* (2002), *Naval Wives and Mistresses 1745–1815* (2007) and *British Pirates and Society, 1680–1730* (2014). She also edited the catalogue for the Museum's special exhibition *Samuel Pepys: Plague, Fire, Revolution* (2015). She is currently working on a history of maritime London, 1750–1805.

Christine Riding is Head of Arts and Curator of the Queen's House at the National Maritime Museum. She was previously Curator of Eighteenth- and Nineteenth-century British Art at Tate Britain, where she curated major exhibitions such as *William Blake* (2000) and *William Hogarth* (2007), and was Deputy Editor of *Art History* (Journal of the Association of Art Historians). She is the author and editor of *Turner & the Sea* (2013), which was published to accompany a major exhibition at the National Maritime Museum, and editor of *Art and the War at Sea, 1914–1945* (2015).

Gillian Russell is Gerry Higgins Professor of Irish Studies at the University of Melbourne, Australia. She is the author of a number of works on British and Irish cultural history of the eighteenth century, focusing on theatre, war, sociability and print culture. Her book *Women, Sociability and Theatre in Georgian London* (2007) deals with the fashionable world with which Lady Hamilton was closely associated throughout her career.

Kate Williams is Professor of History at the University of Reading and the author of *England's Mistress: The Infamous Life of Emma Hamilton* (2006). Her other books include *Becoming Queen* (2008), an account of the early years of Queen Victoria, *Young Elizabeth: The Making of Our Queen* (2012), and *Josephine: Desire, Ambition, Napoleon* (2013). She appears regularly on TV and radio as a historical adviser.

Index

Page numbers in *italic* refer to illustrations